PARIS 360°

PARIS
360°

Photographs by Attilio Boccazzi-Varotto
Sketches by Luisa Romussi

RANDOM HOUSE

NEW YORK

Library of Congress Cataloging-in-Publication Data
Boccazzi-Varotto, Attilio.
[Parigi. English]
[Paris 360°. /photographs by Attilio Bocazzi-Varotto; sketches by Luisa Romussi.]
p. cm.
Captions in English.
ISBN 0-679-44285-5
1. Paris (France)—Pictorial works. 2. Photography, Panoramic.
I. Title.
DC707.8.B586 1999 99-17755
779'.994436—dc21

Manufactured in Italy by Mariogros, Turin

Random House website address: www.atrandom.com

2 4 6 8 9 7 5 3

FIRST AMERICAN EDITION

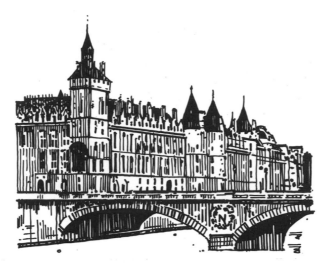

LA CONCIERGERIE

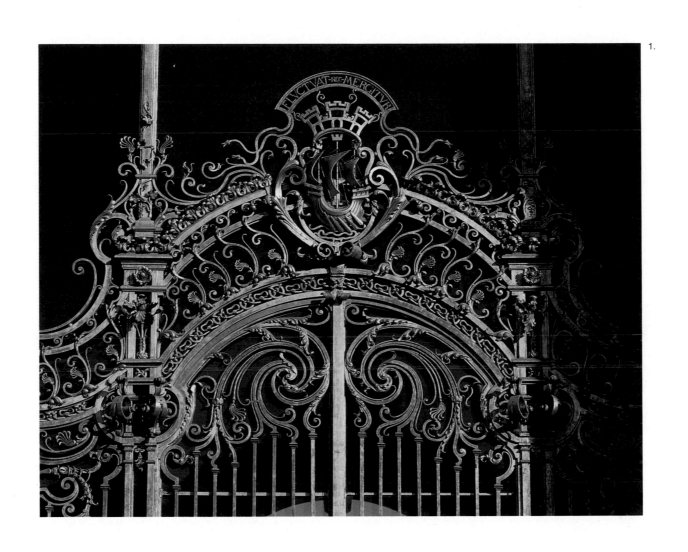

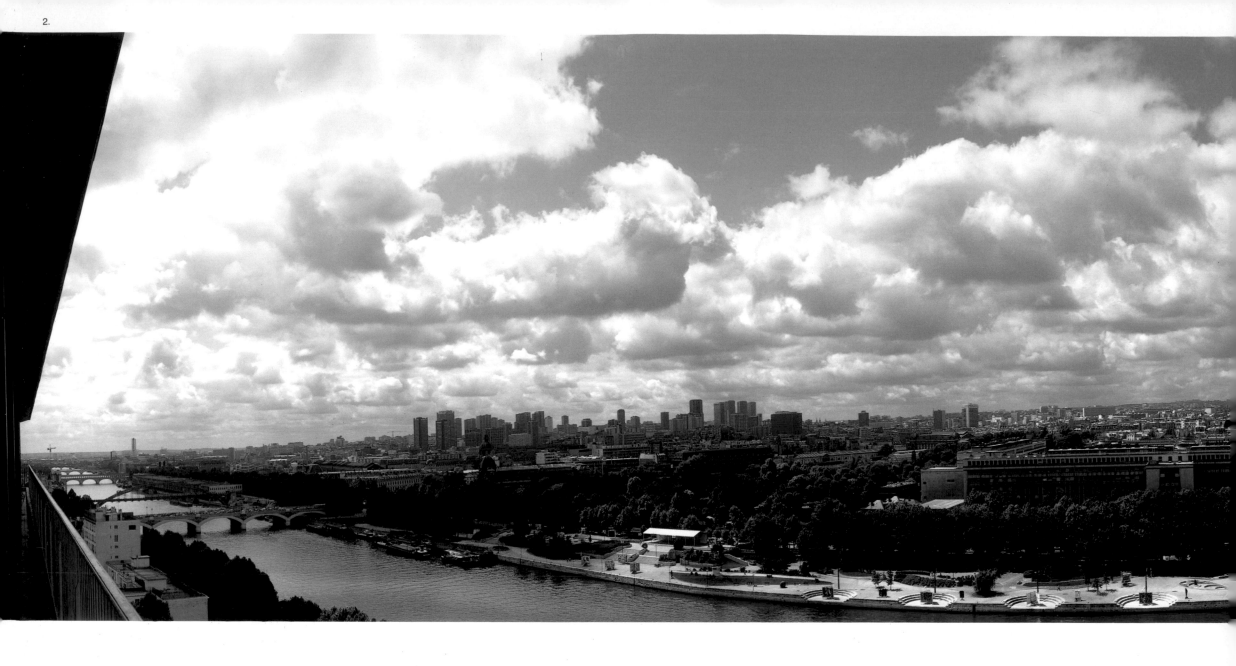

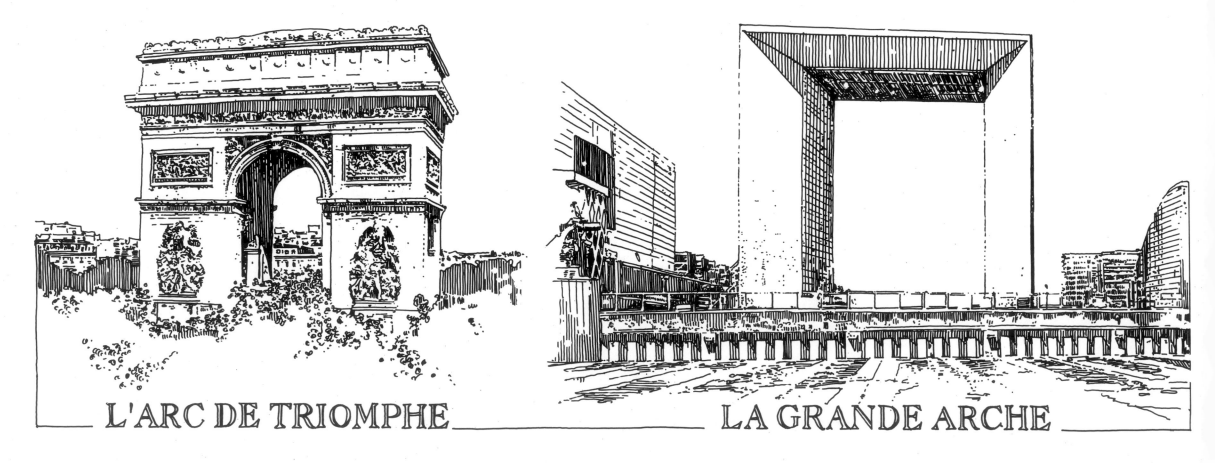

L'ARC DE TRIOMPHE LA GRANDE ARCHE

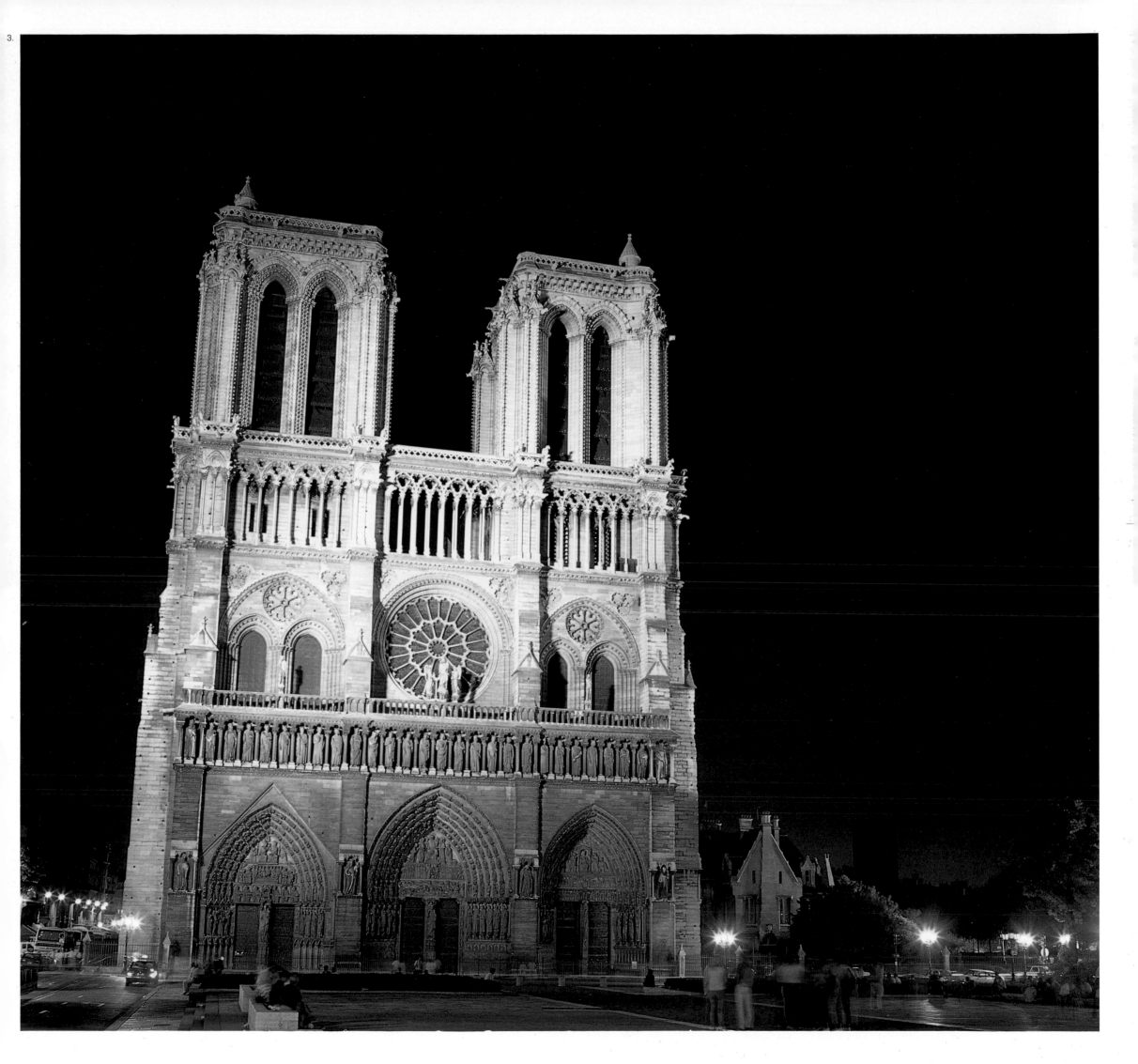

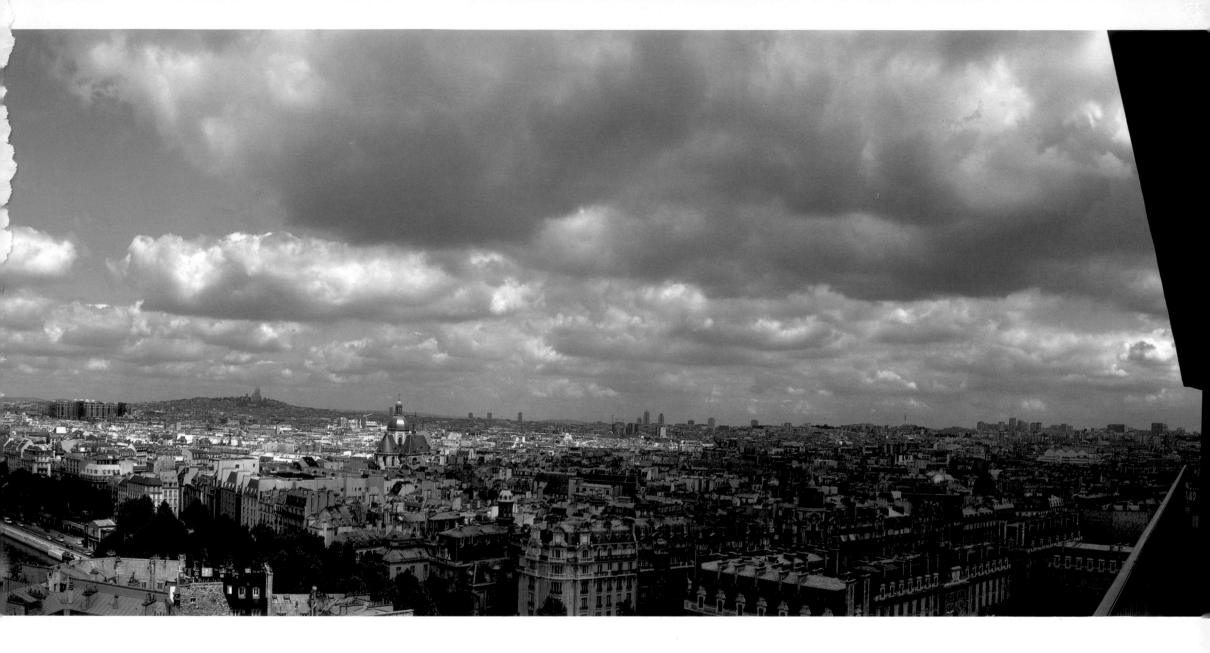

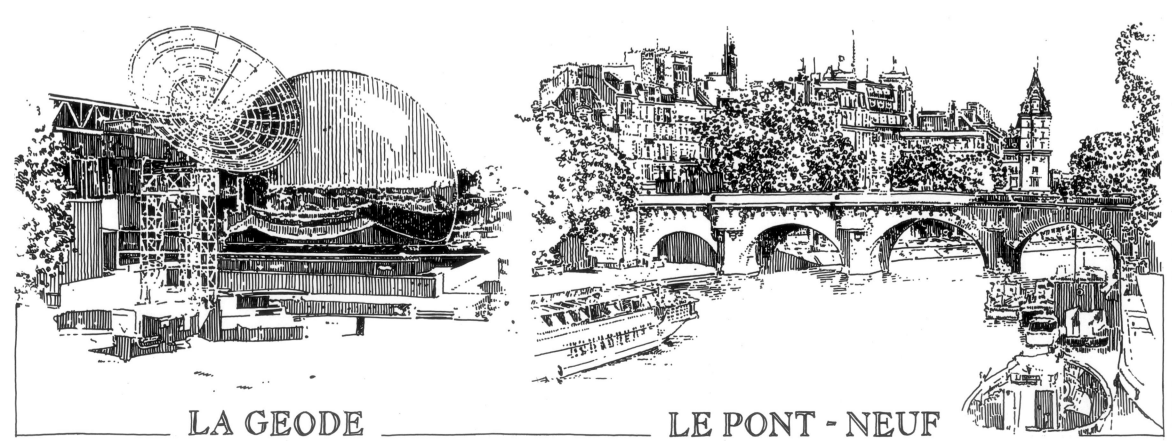

LA GEODE

LE PONT - NEUF

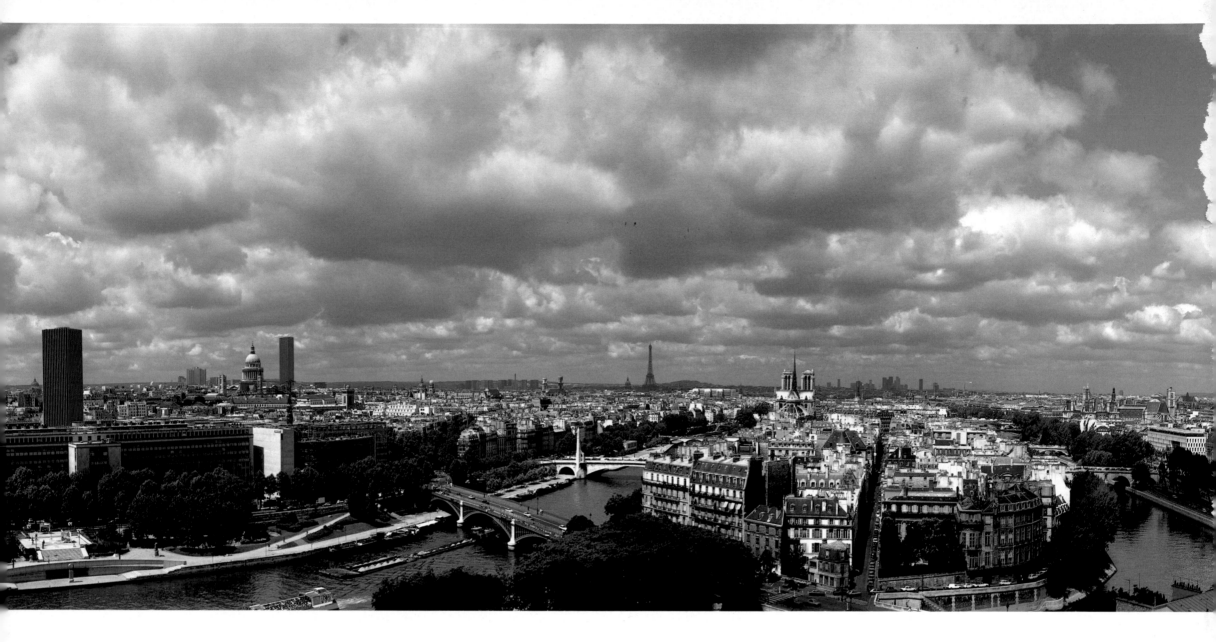

PALAIS BOURBON

LE SACRE - COEUR

CATHEDRALE
DE NOTRE DAME

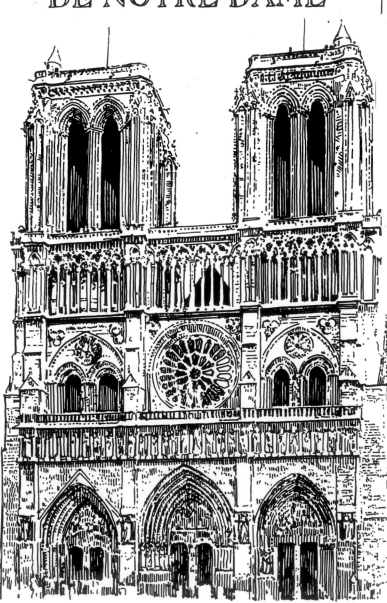
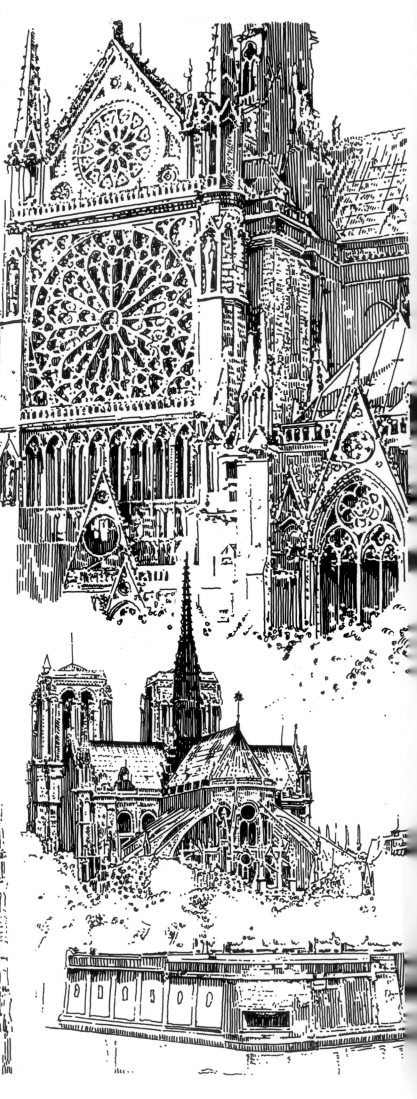

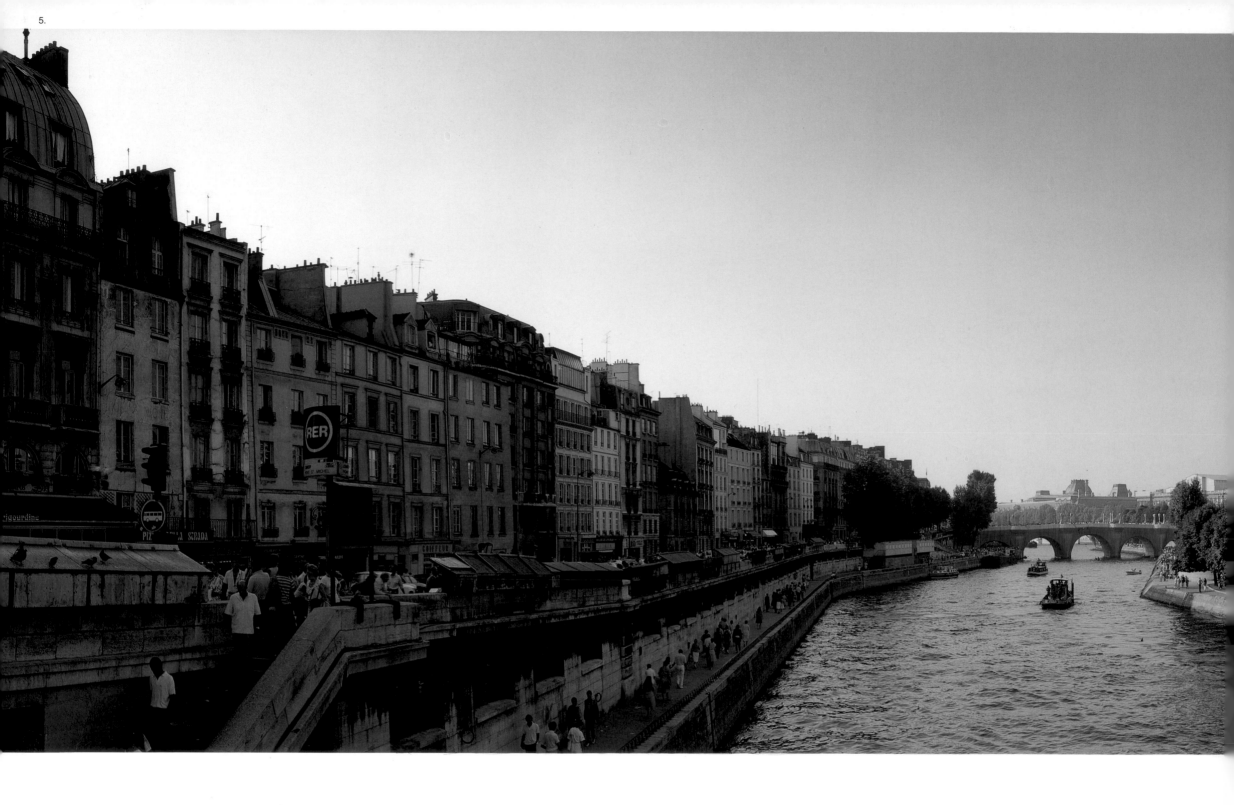

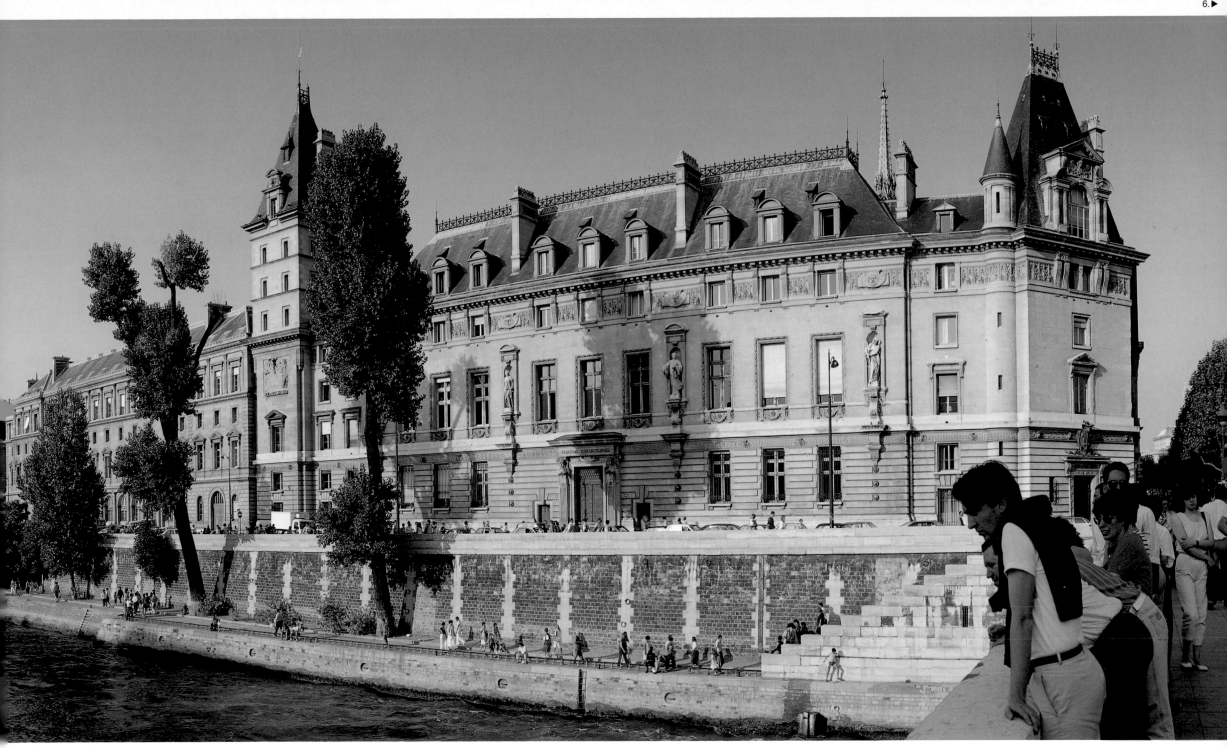

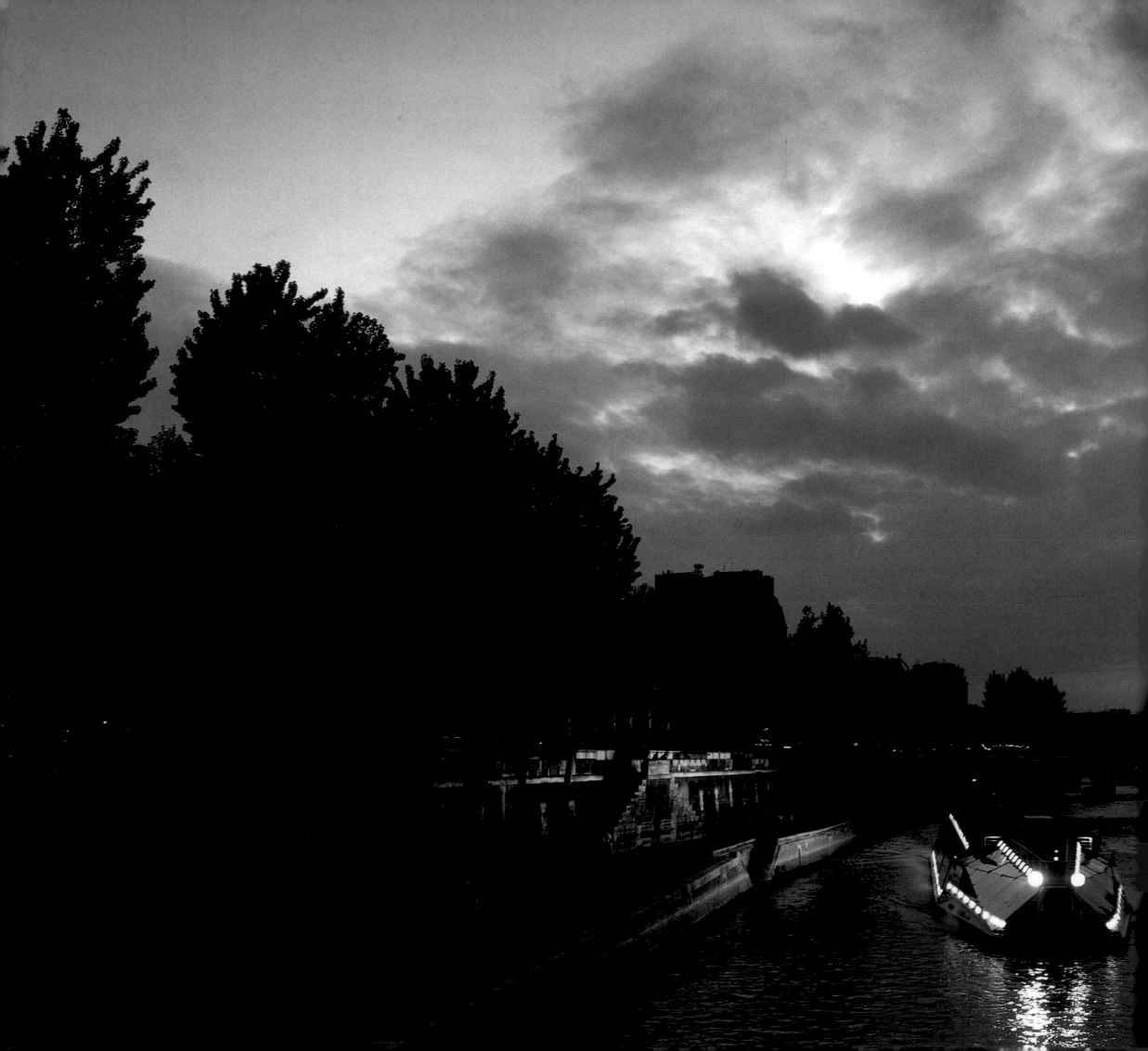

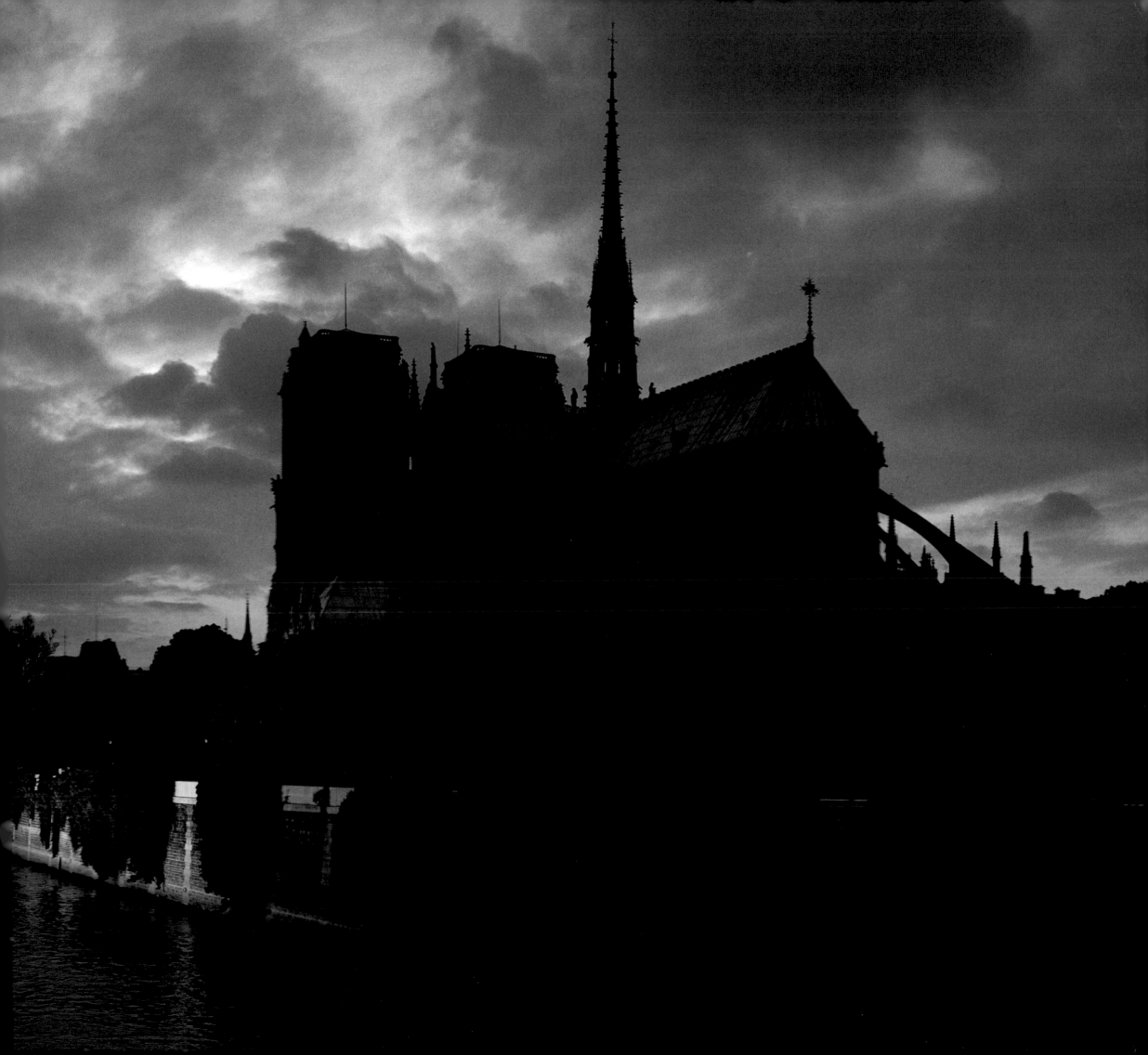

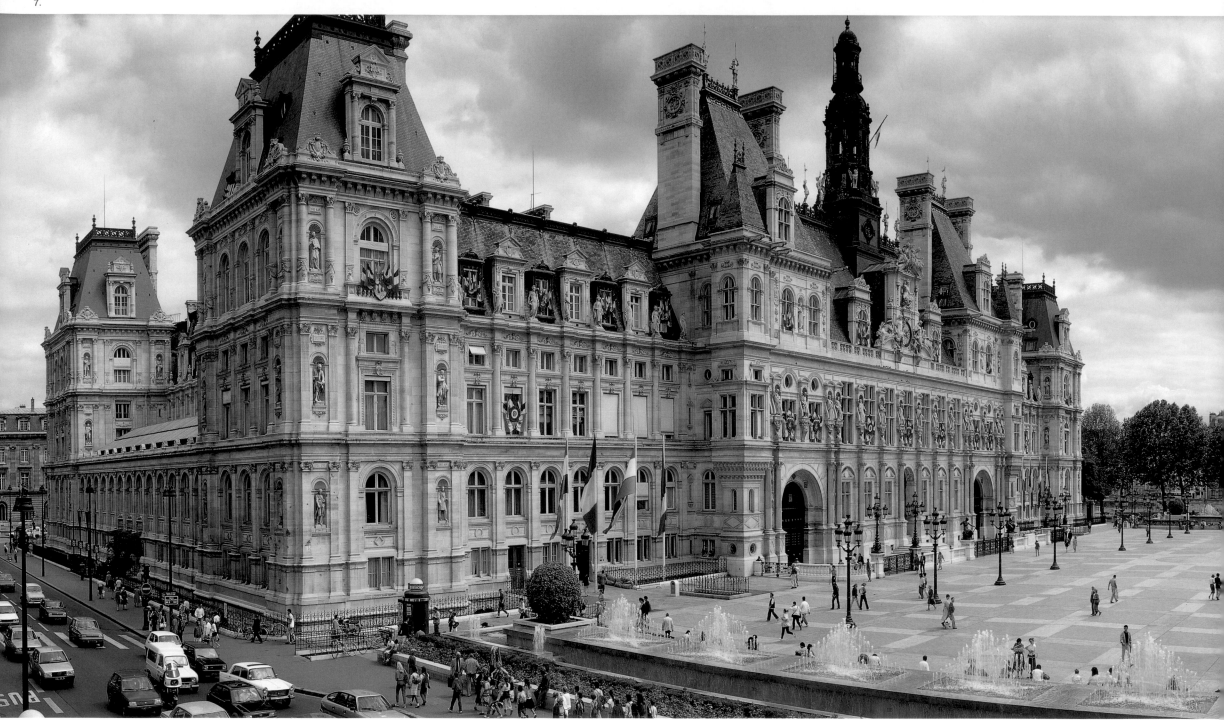

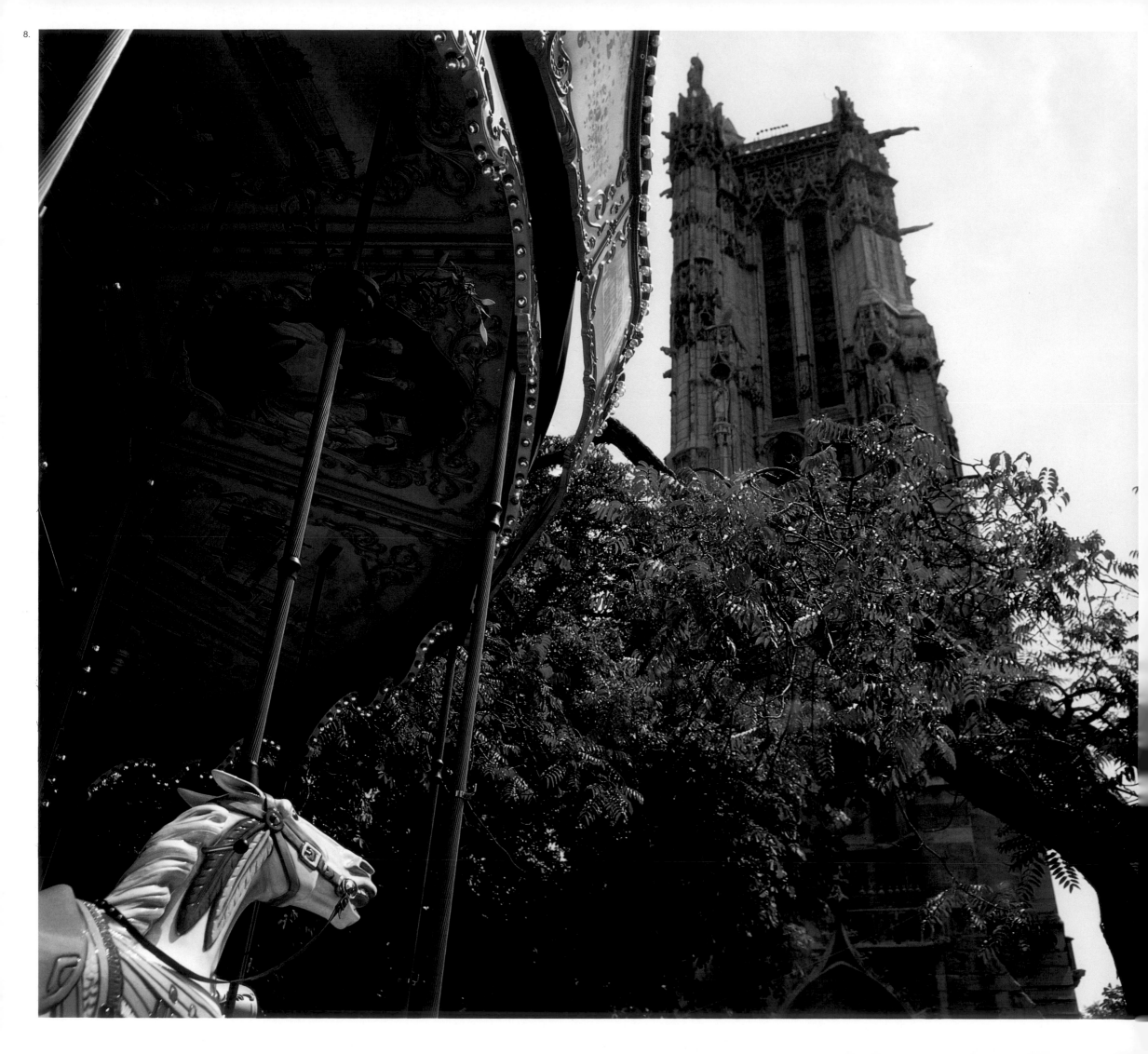

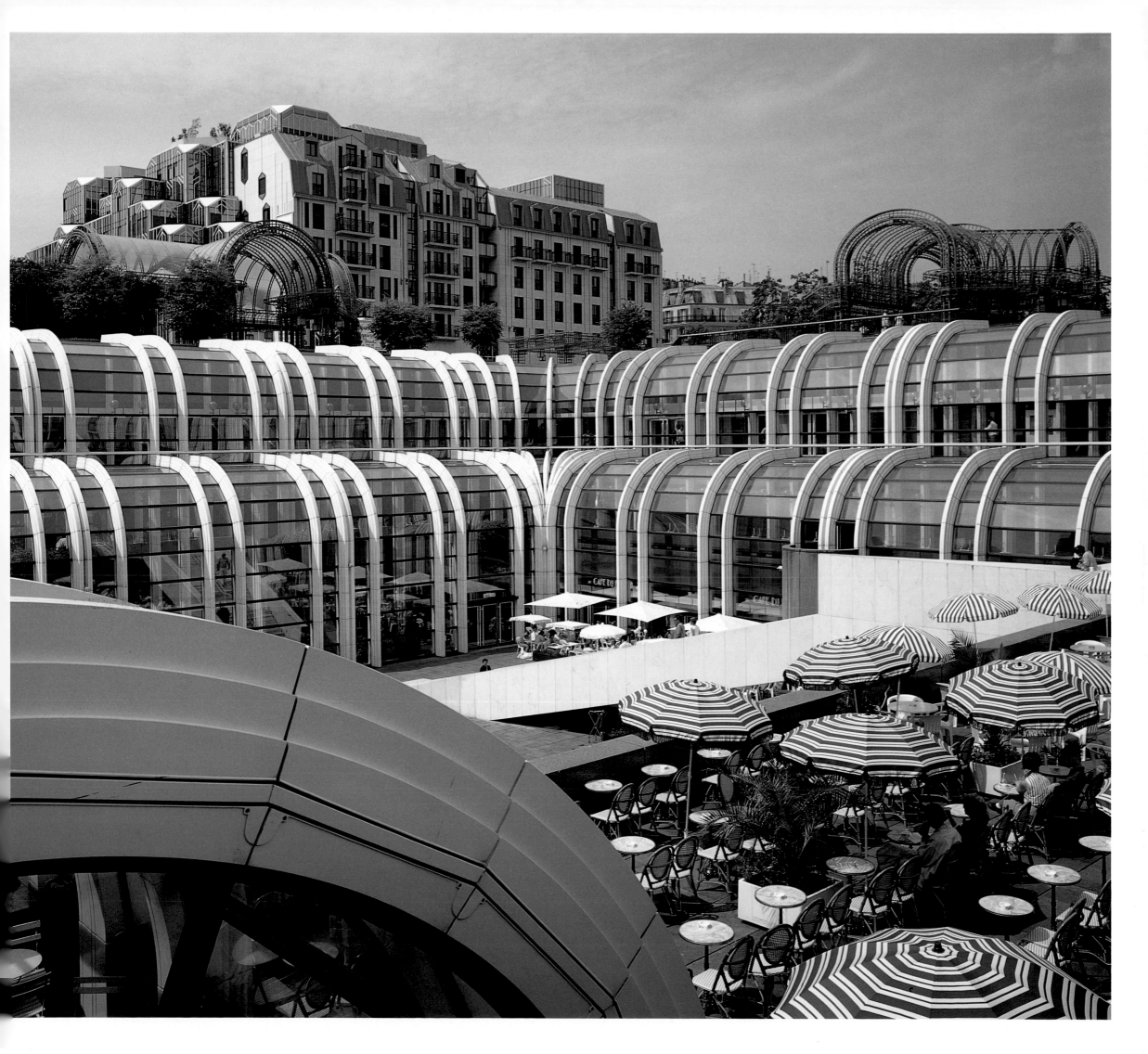

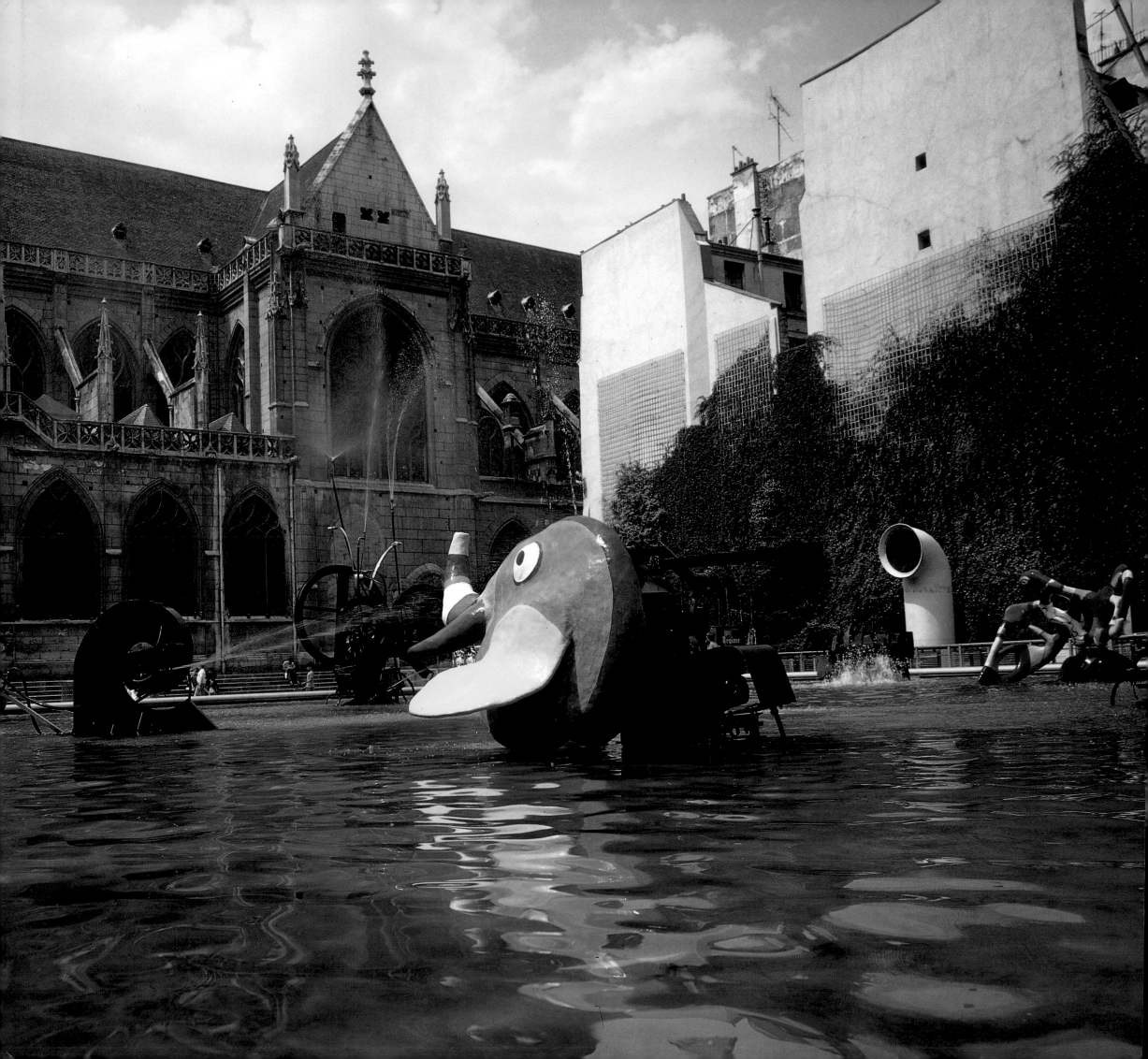

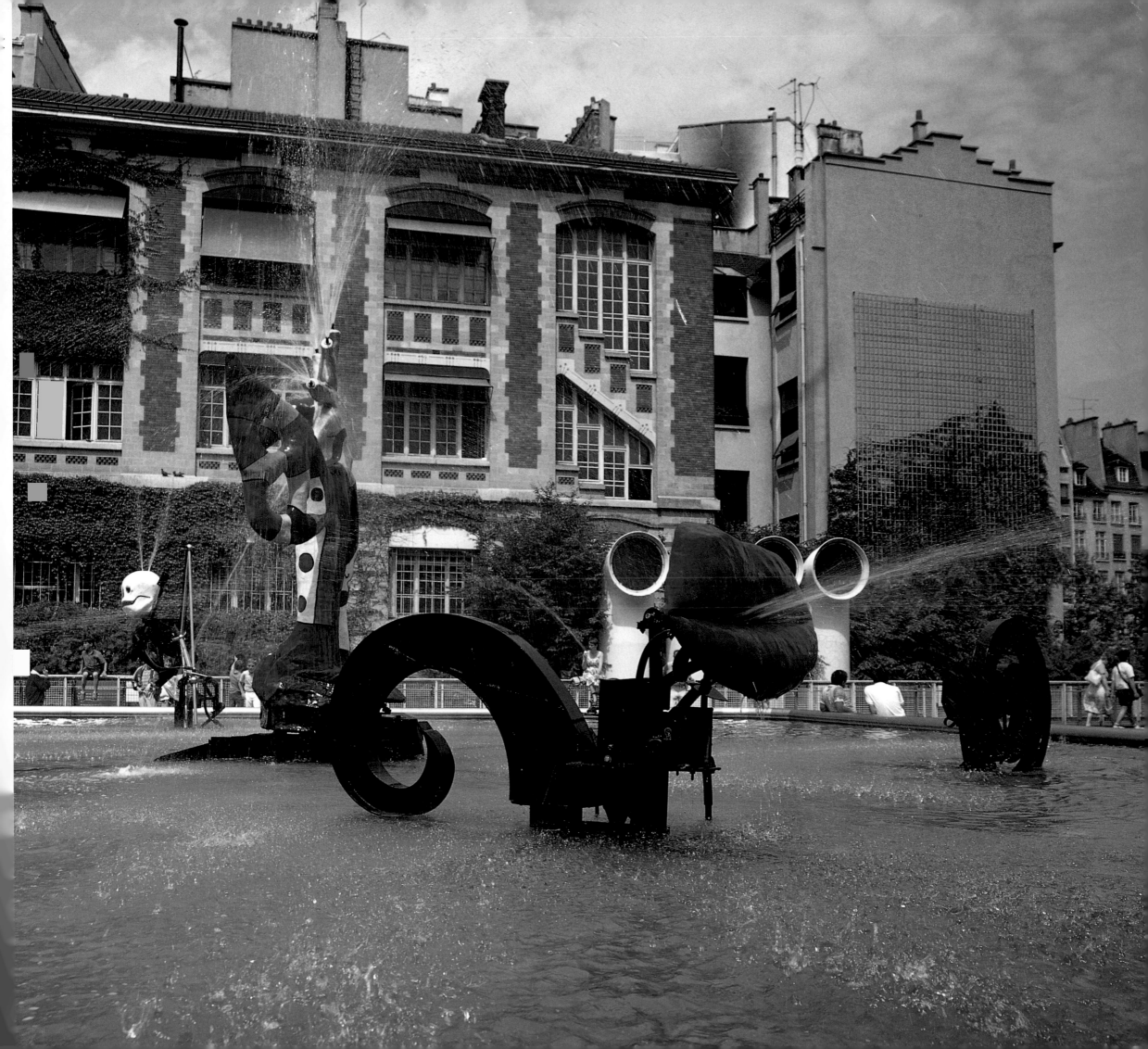

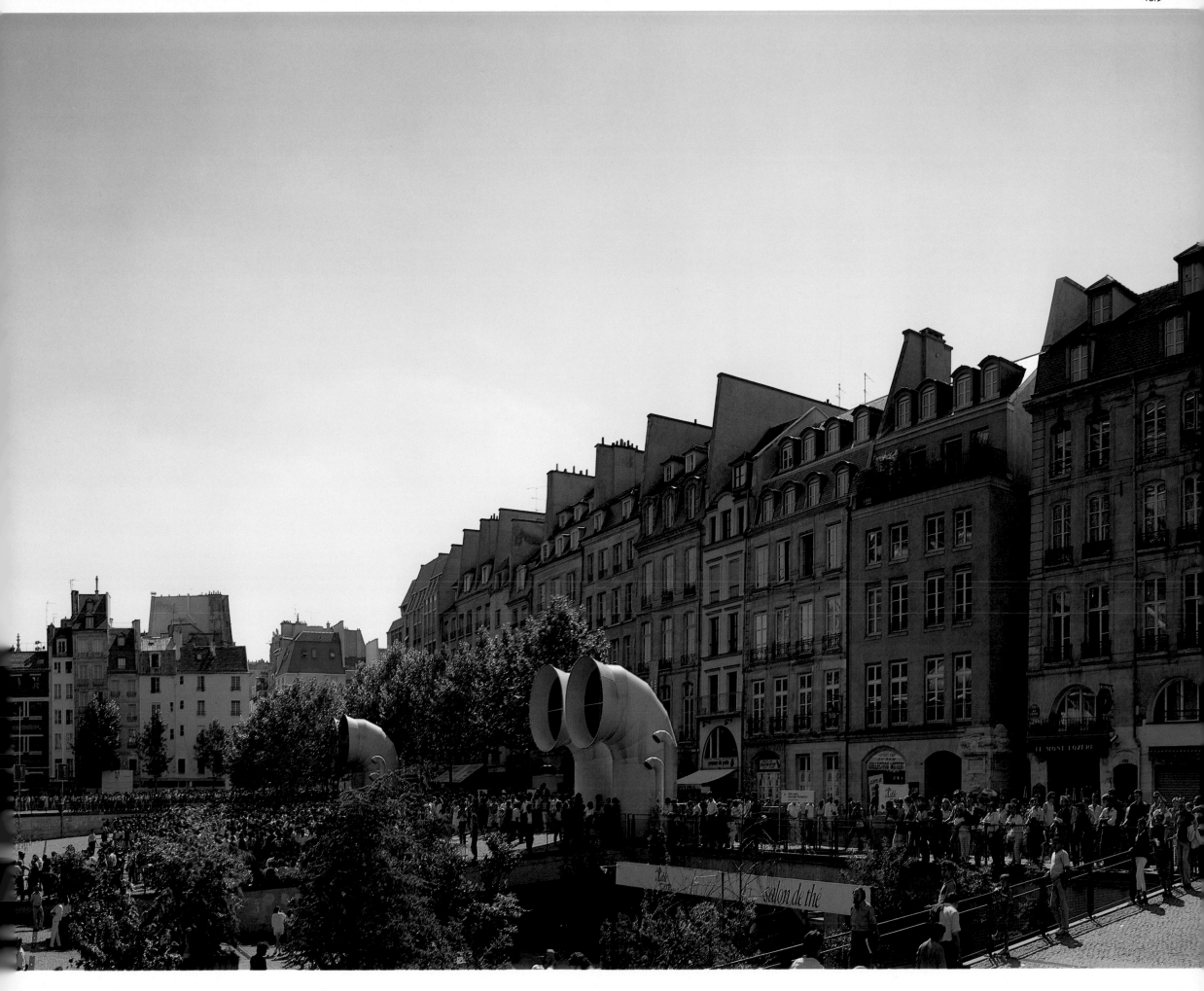

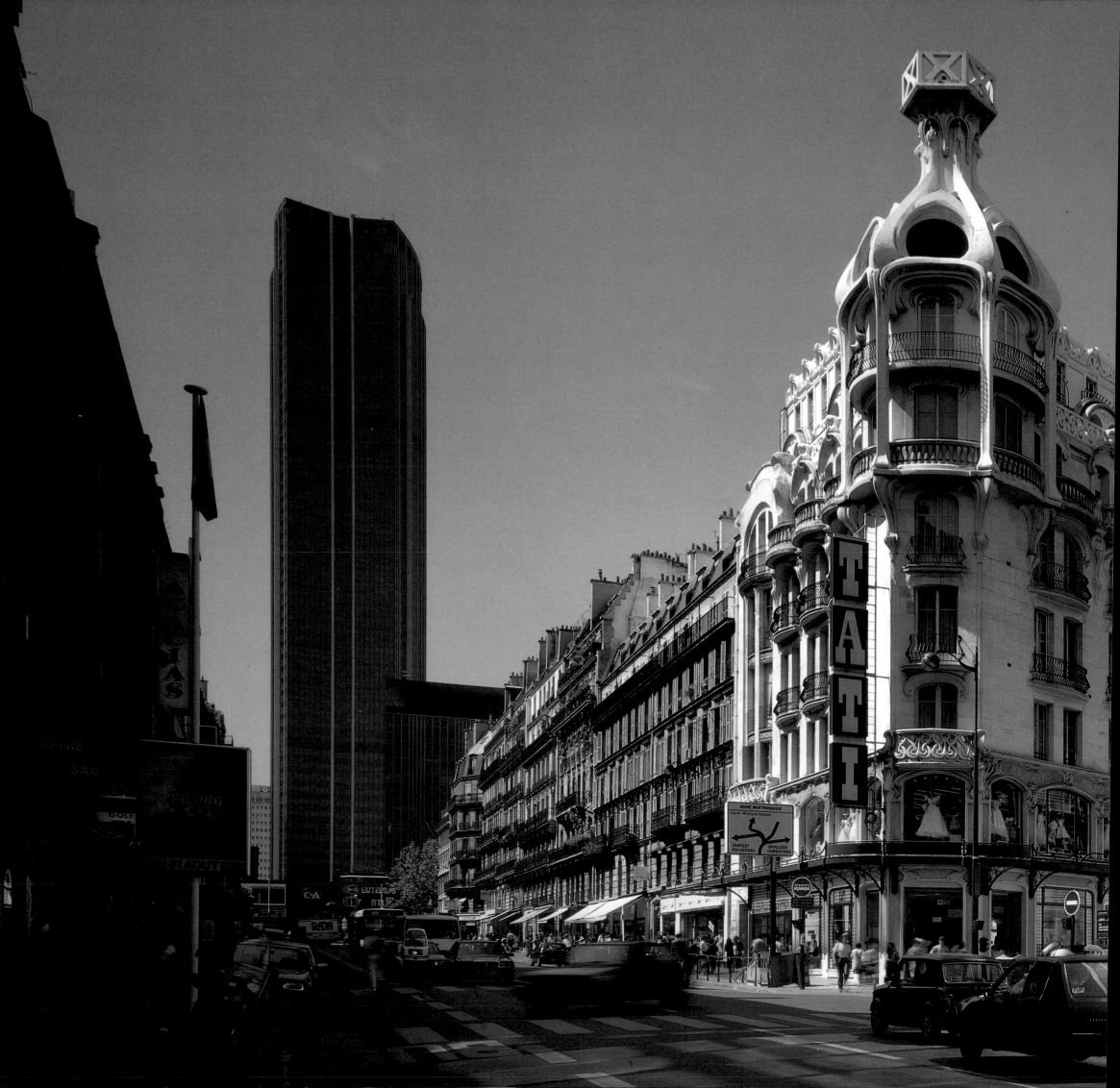

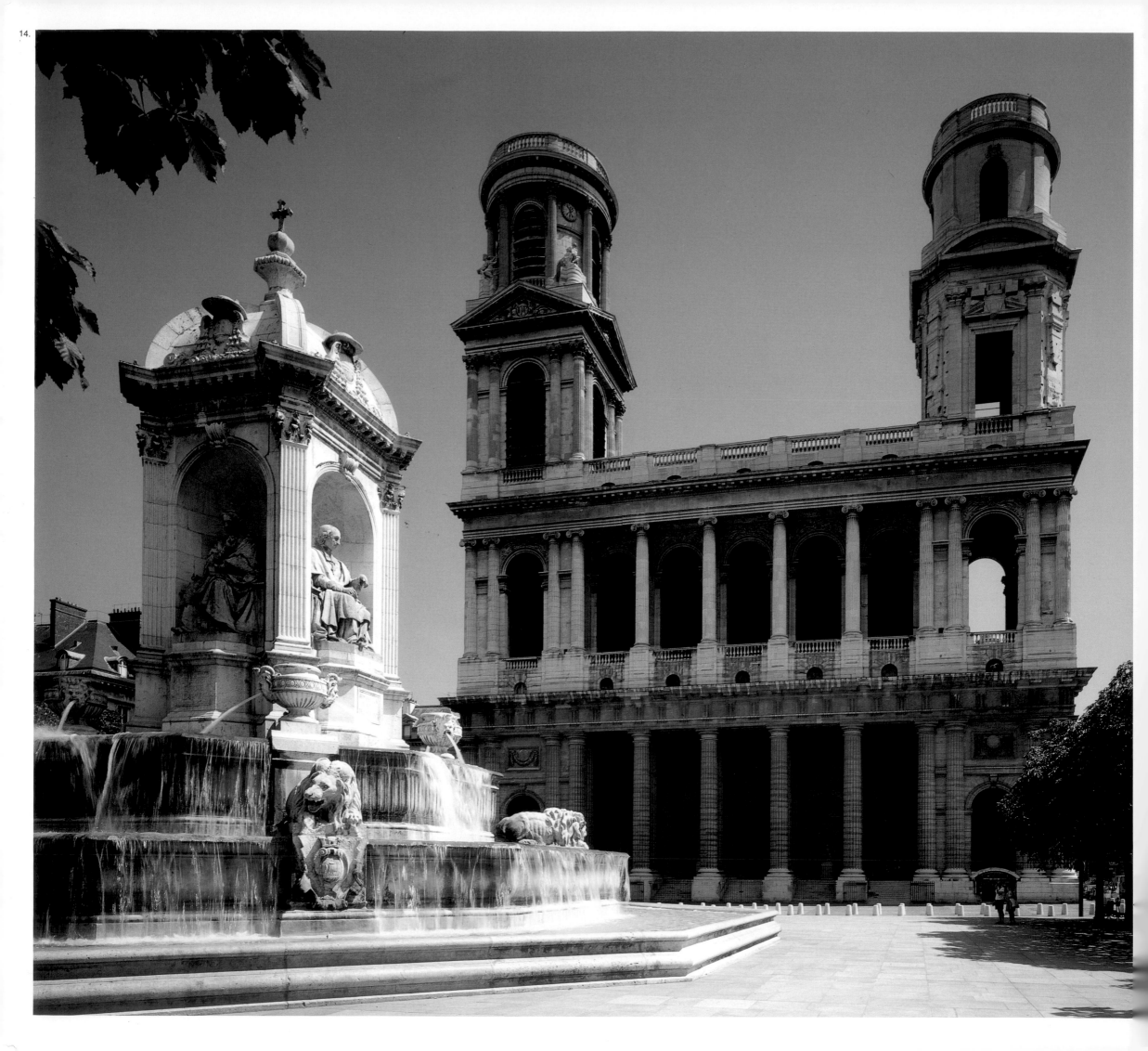

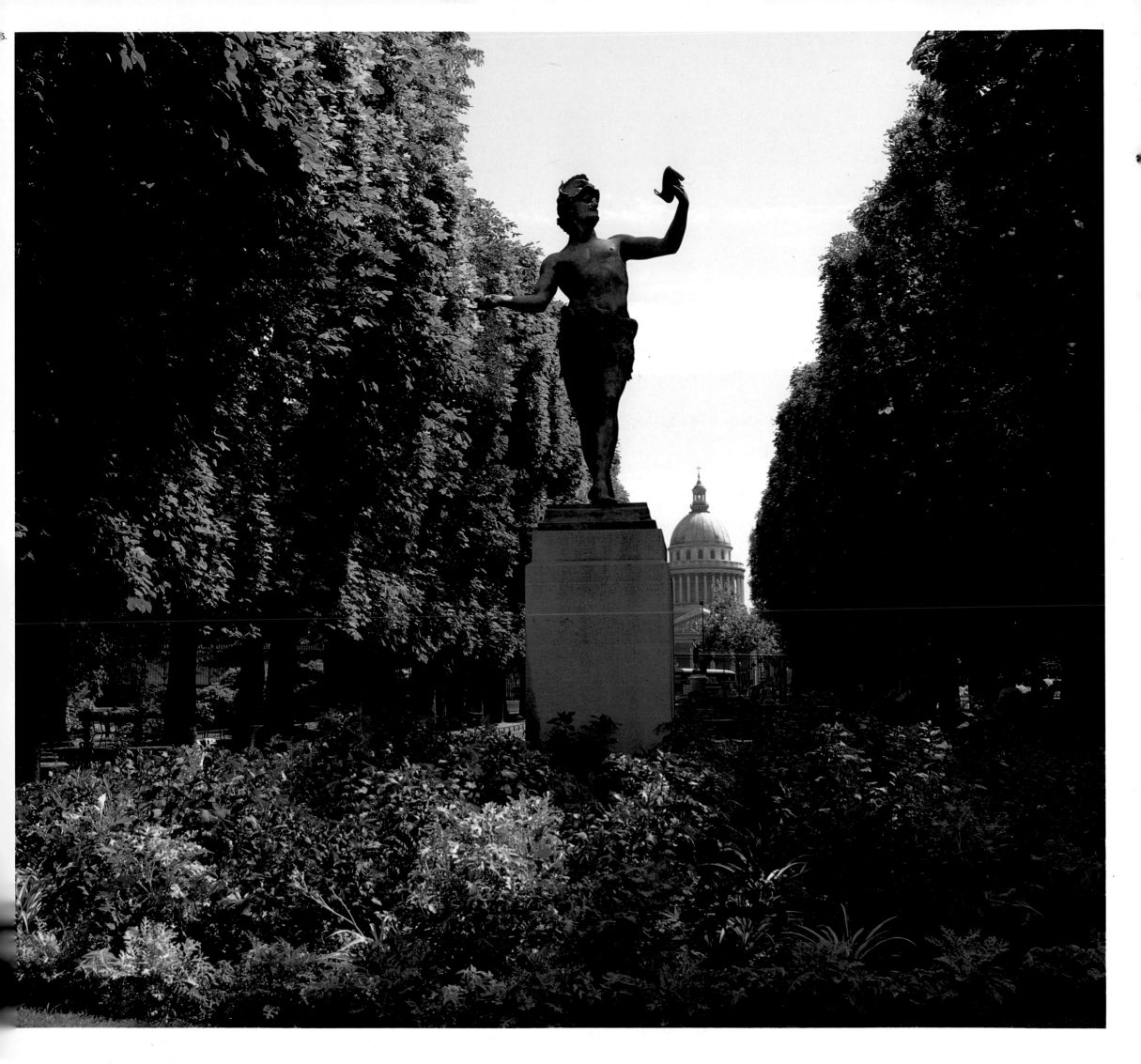

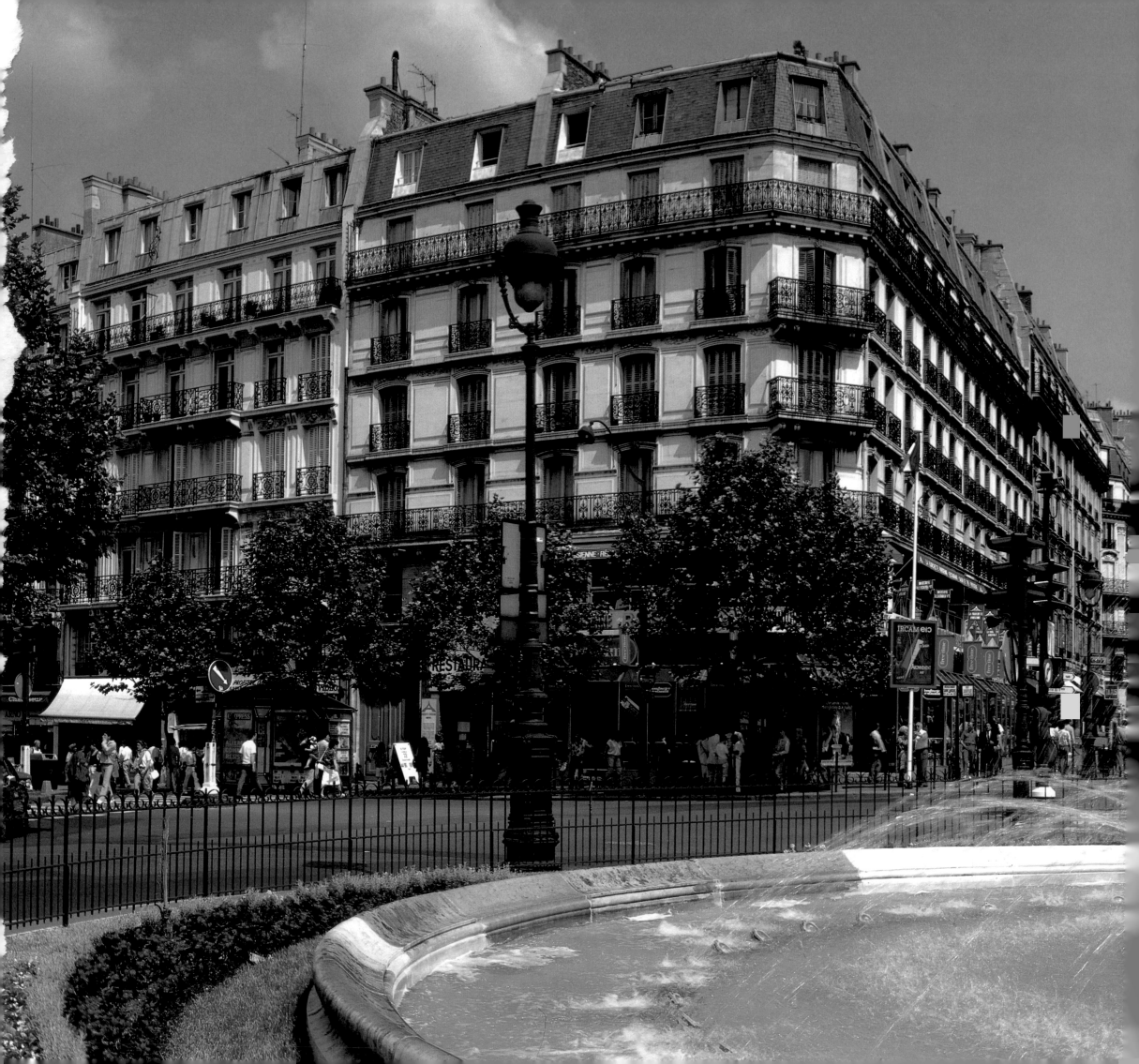

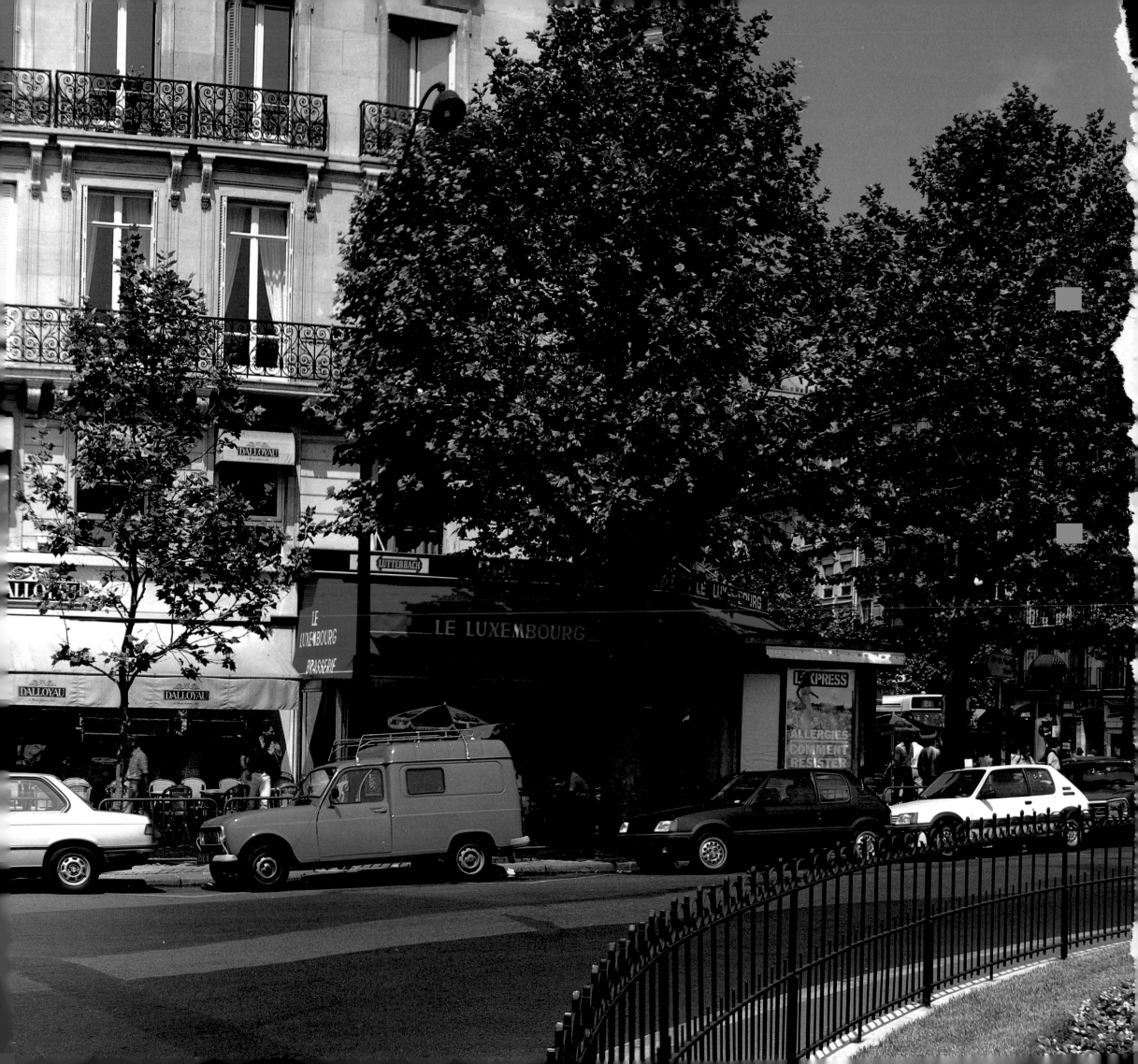

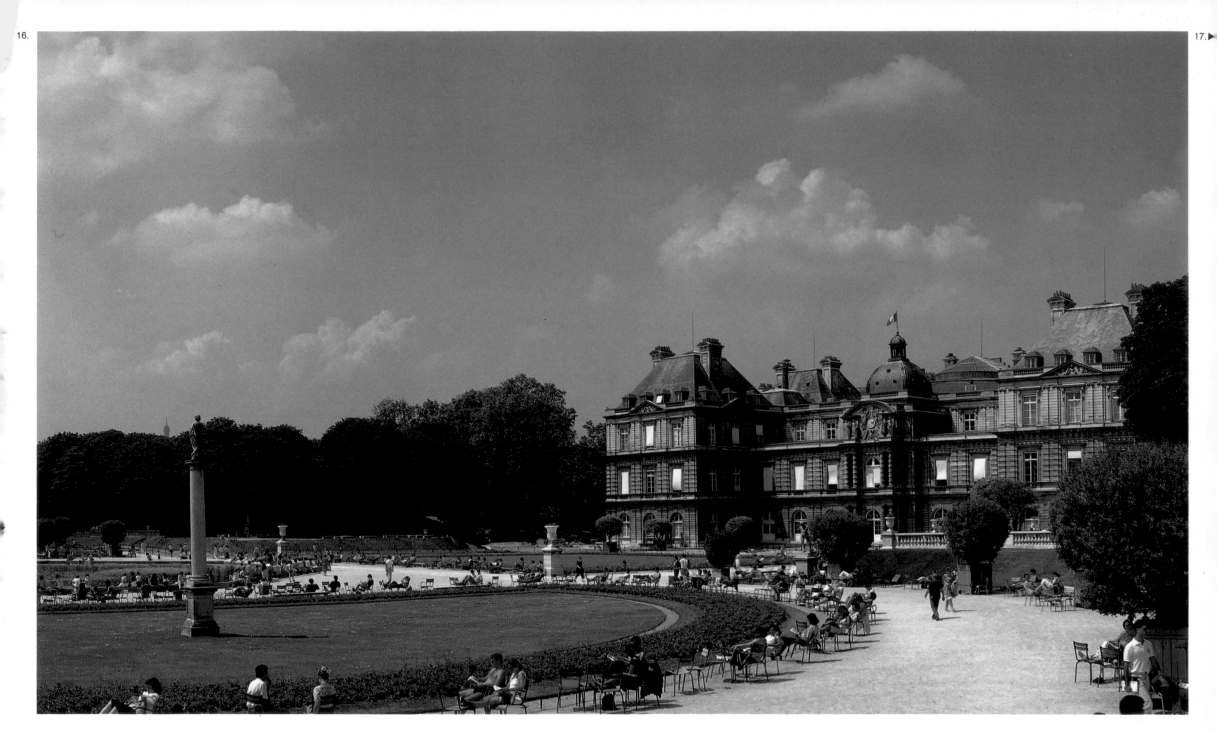

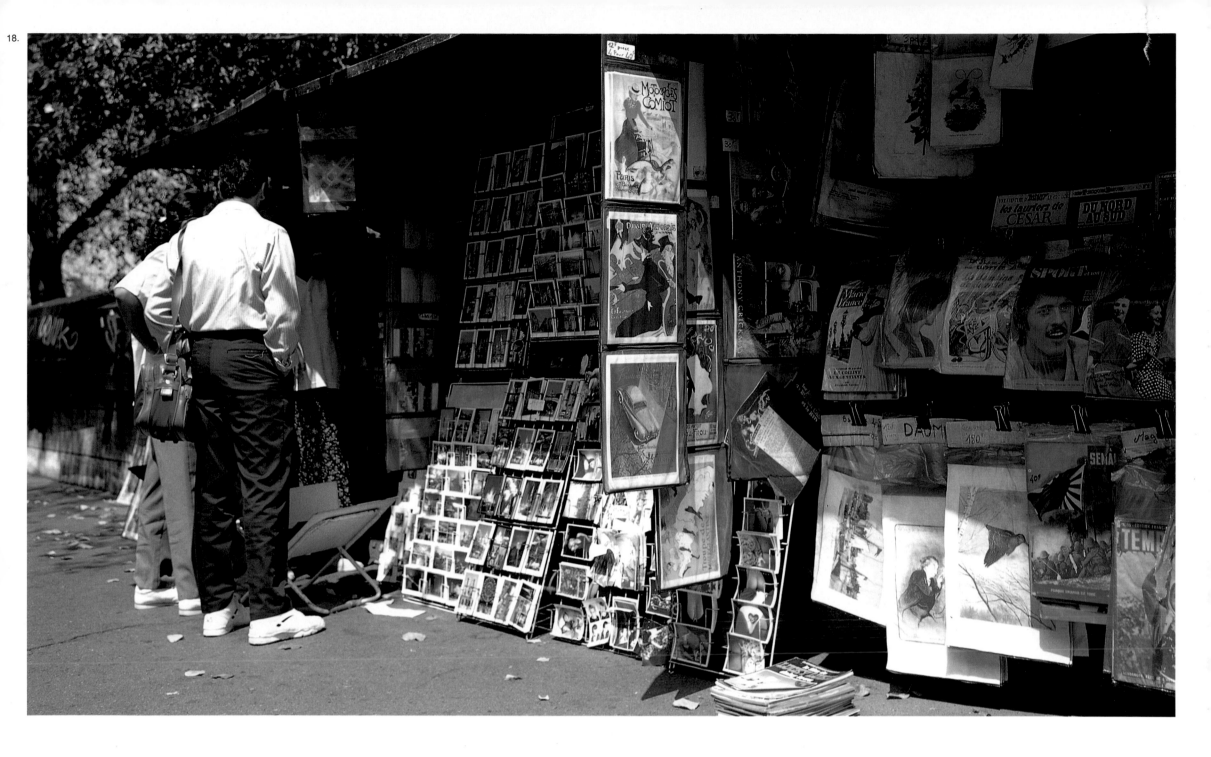

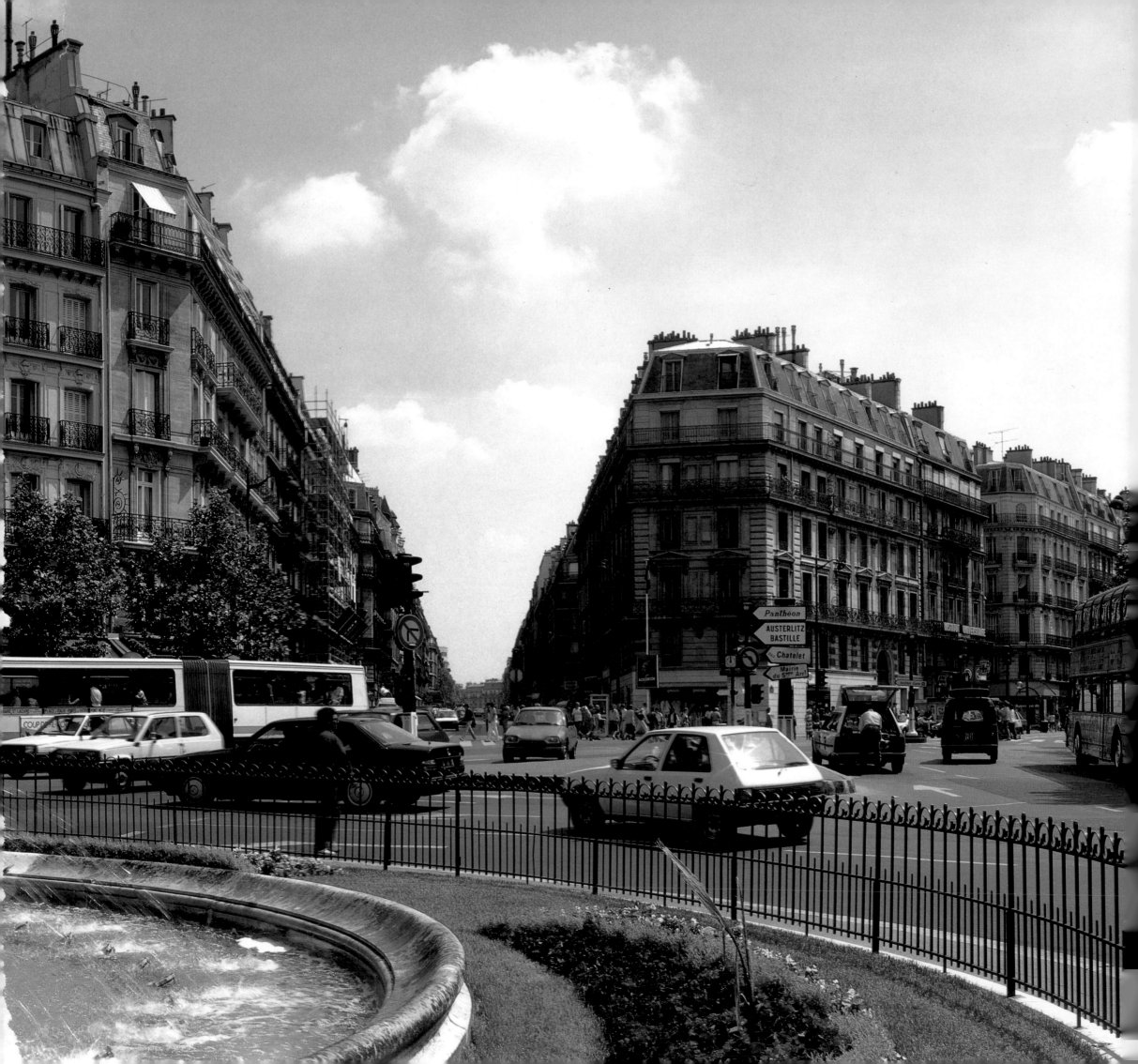

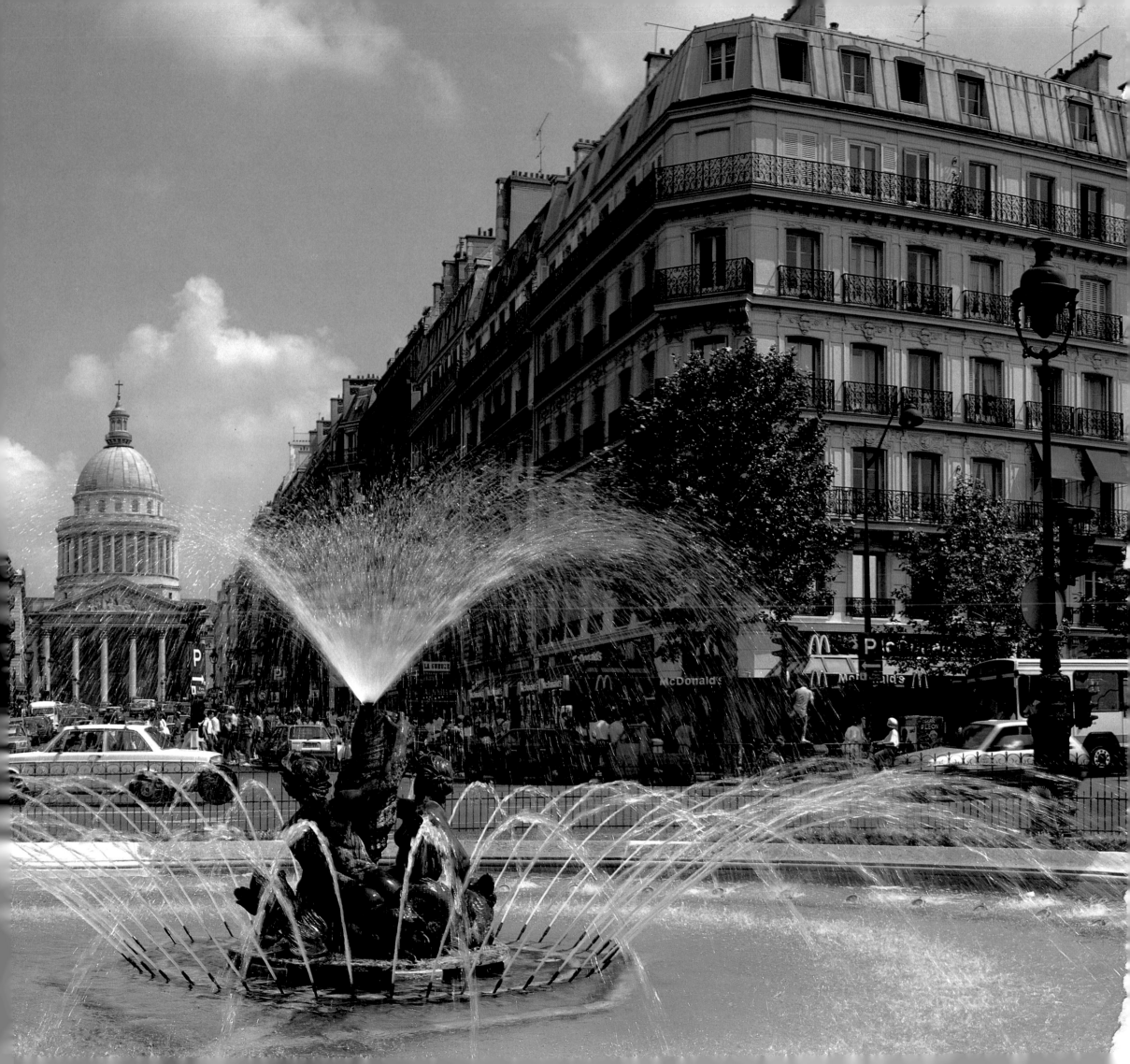

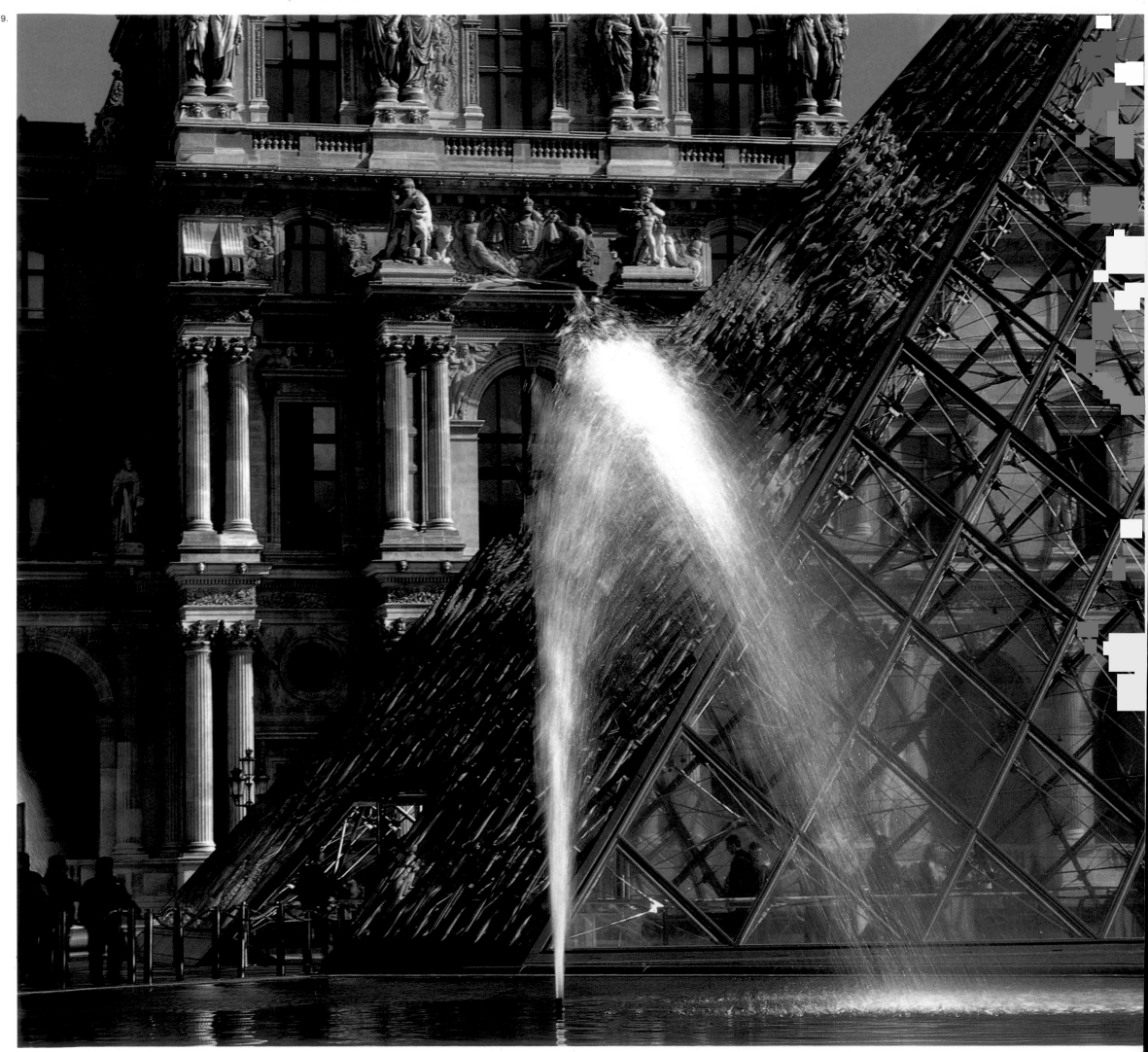

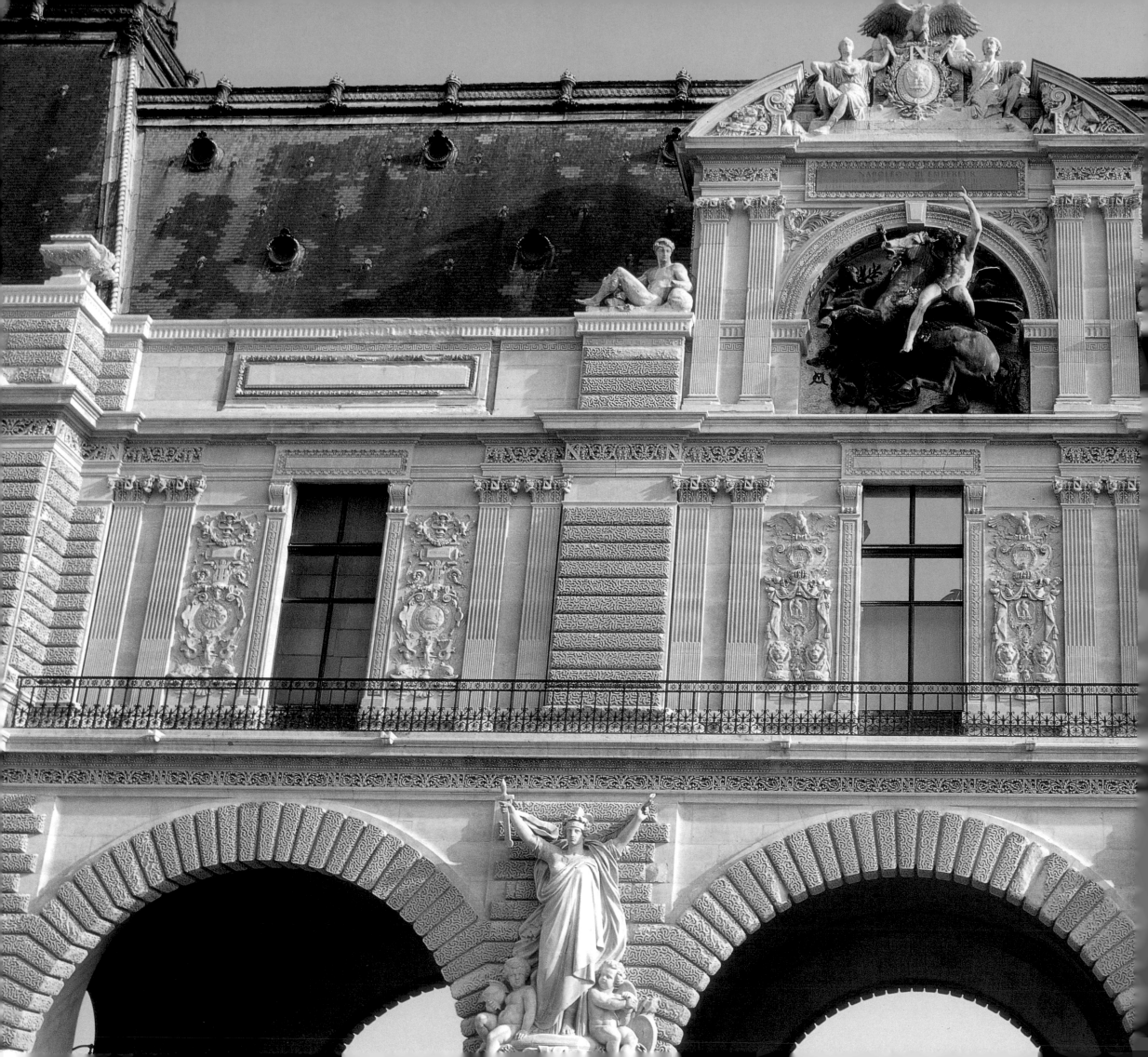

PALAIS DU LOUVRE

LA PYRAMIDE

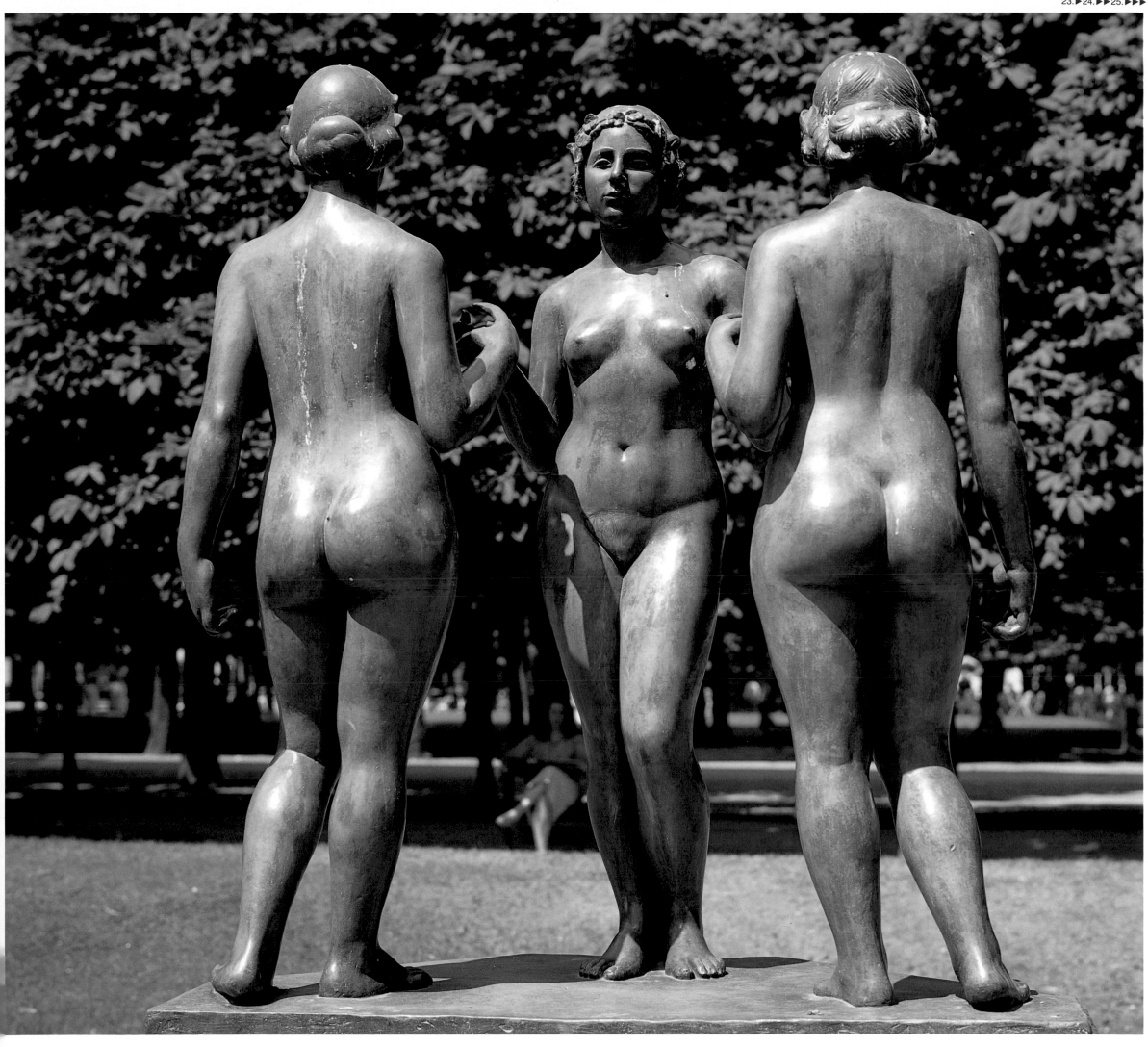

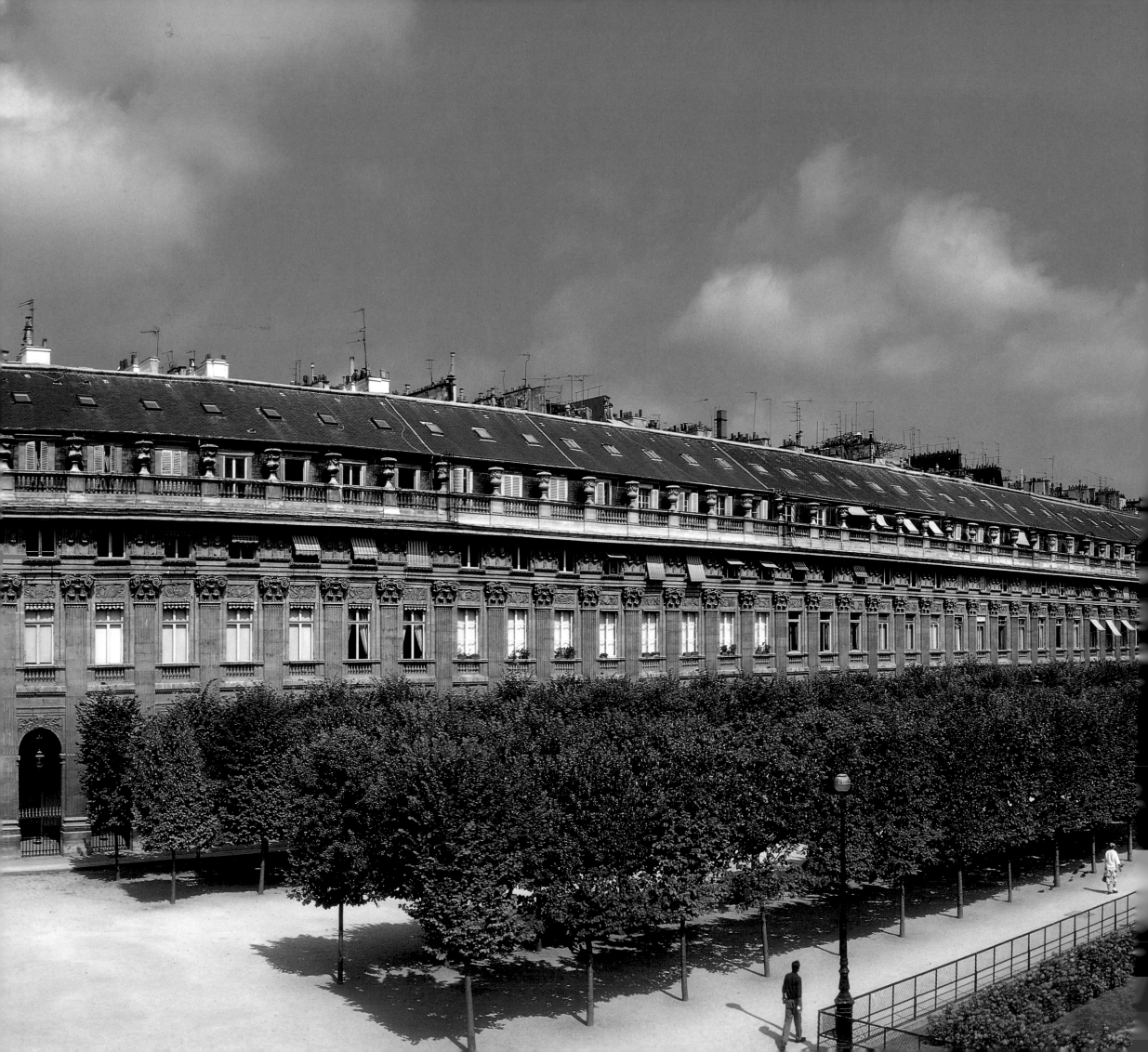

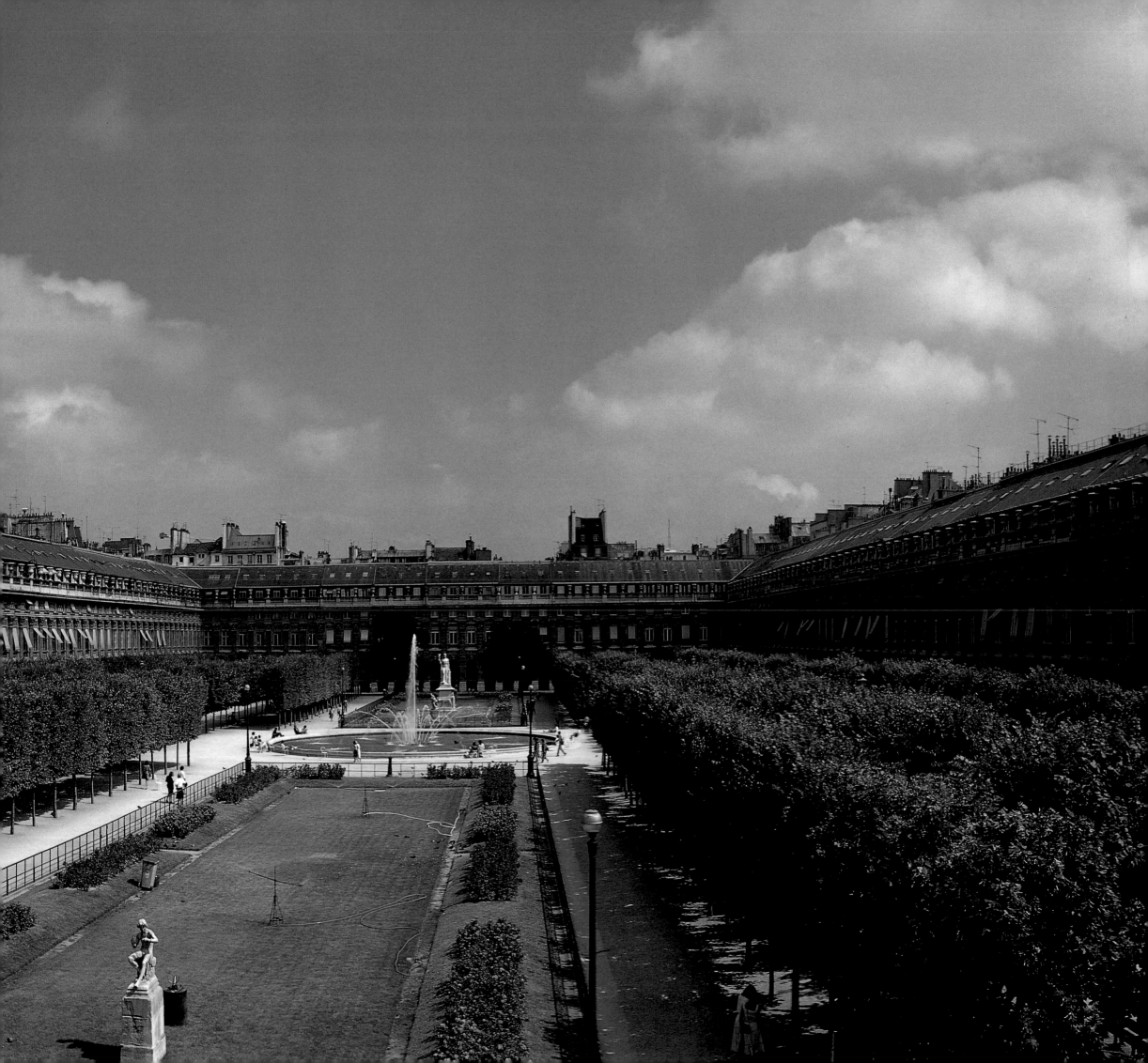

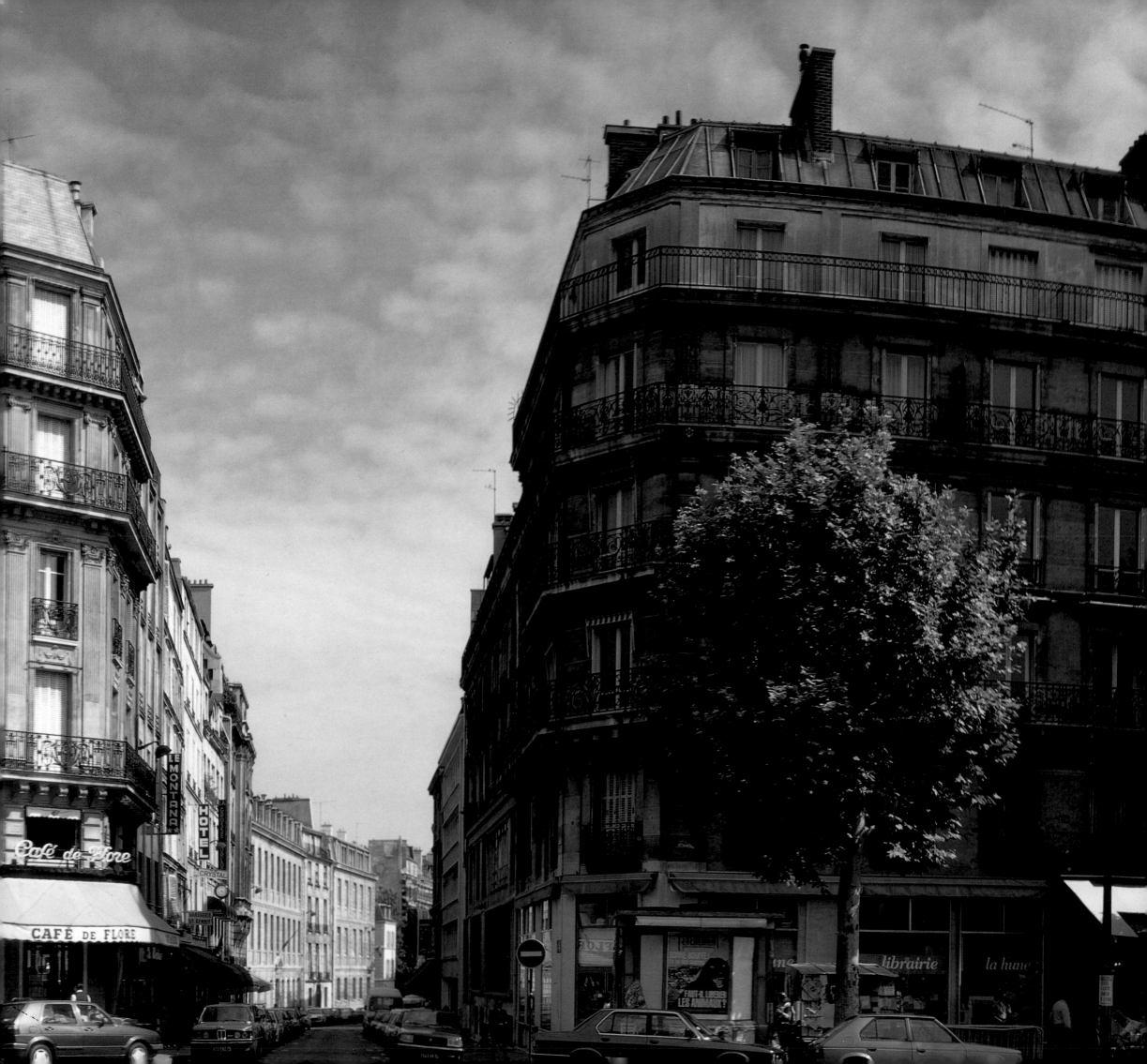

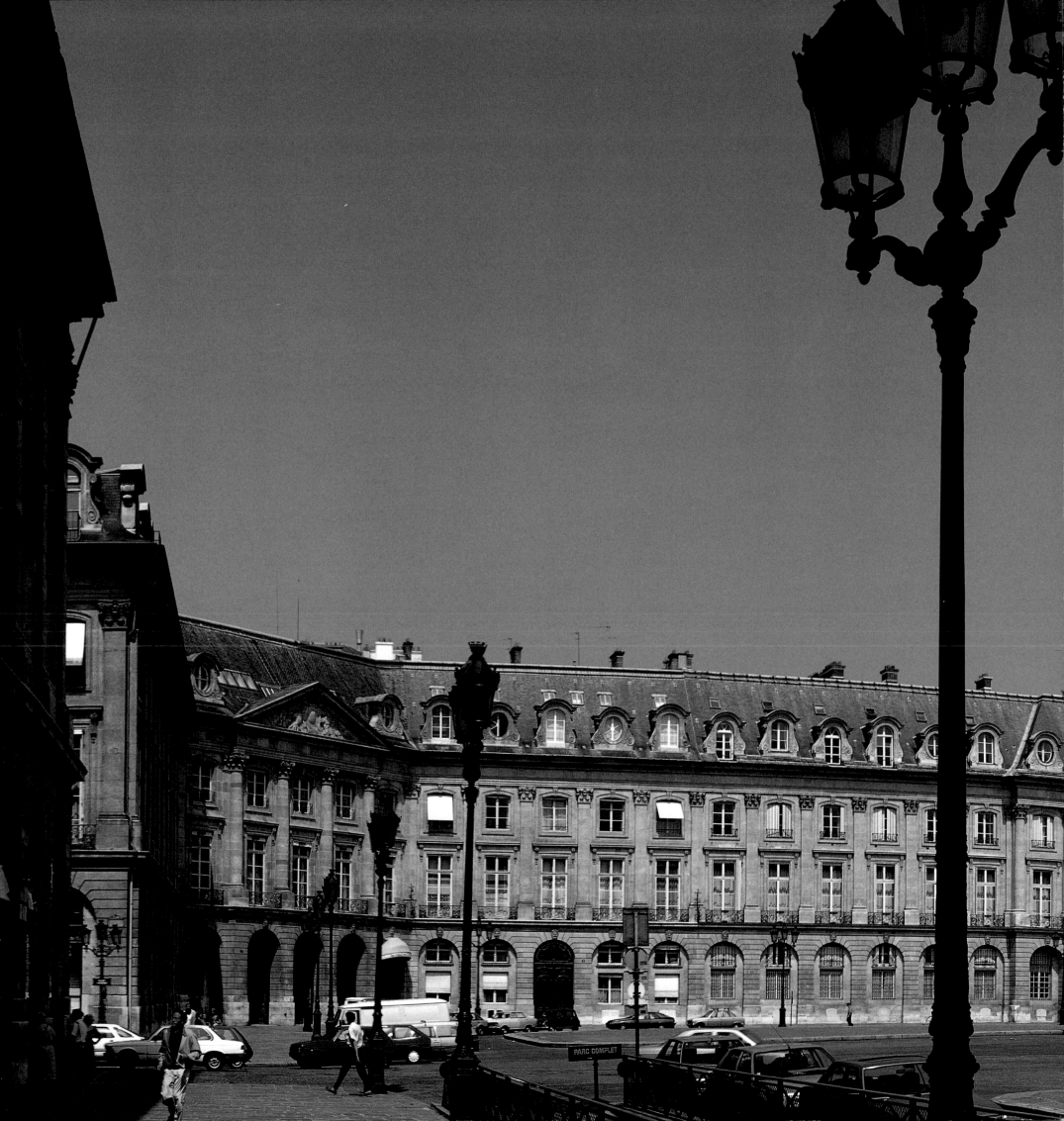

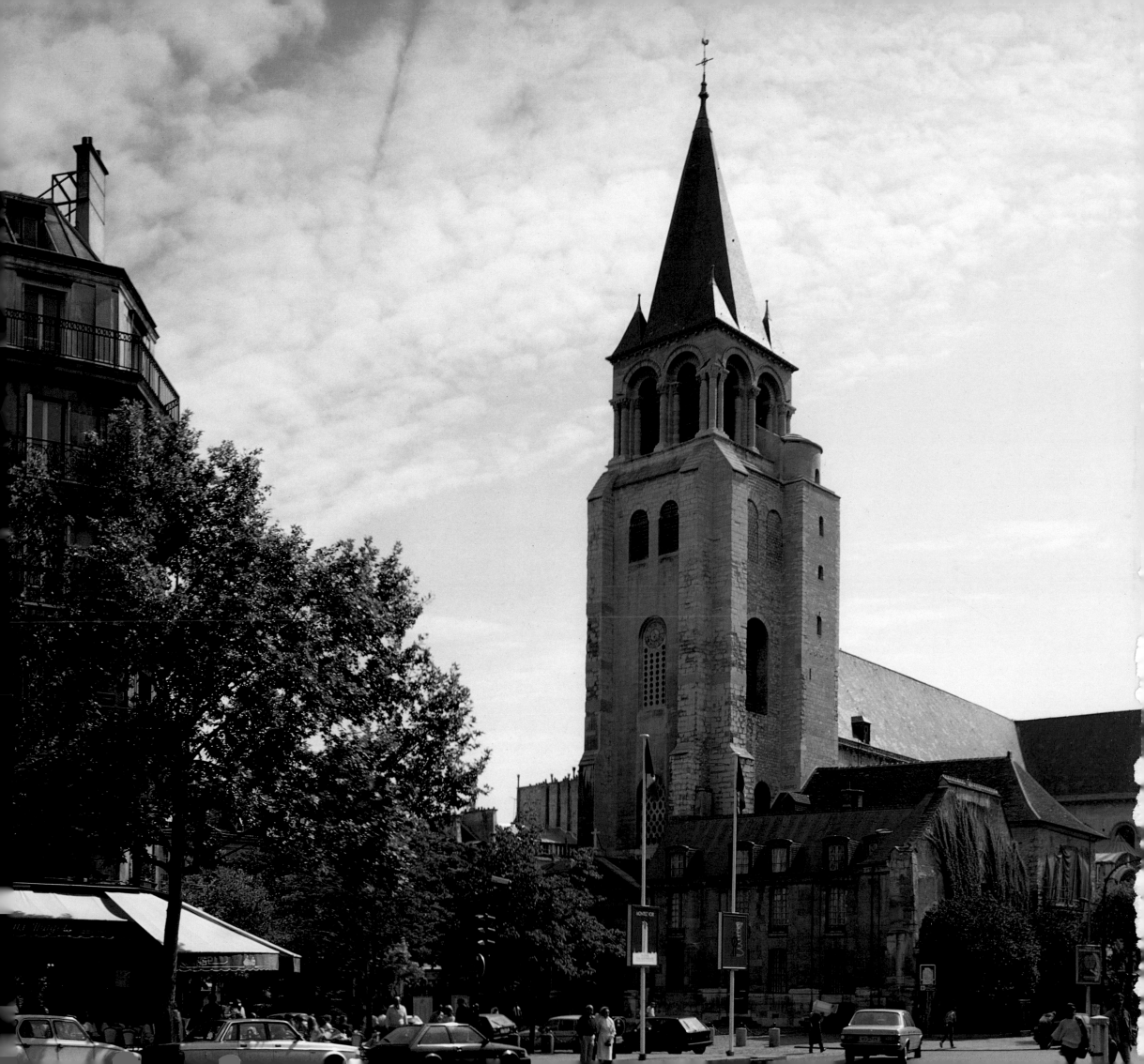

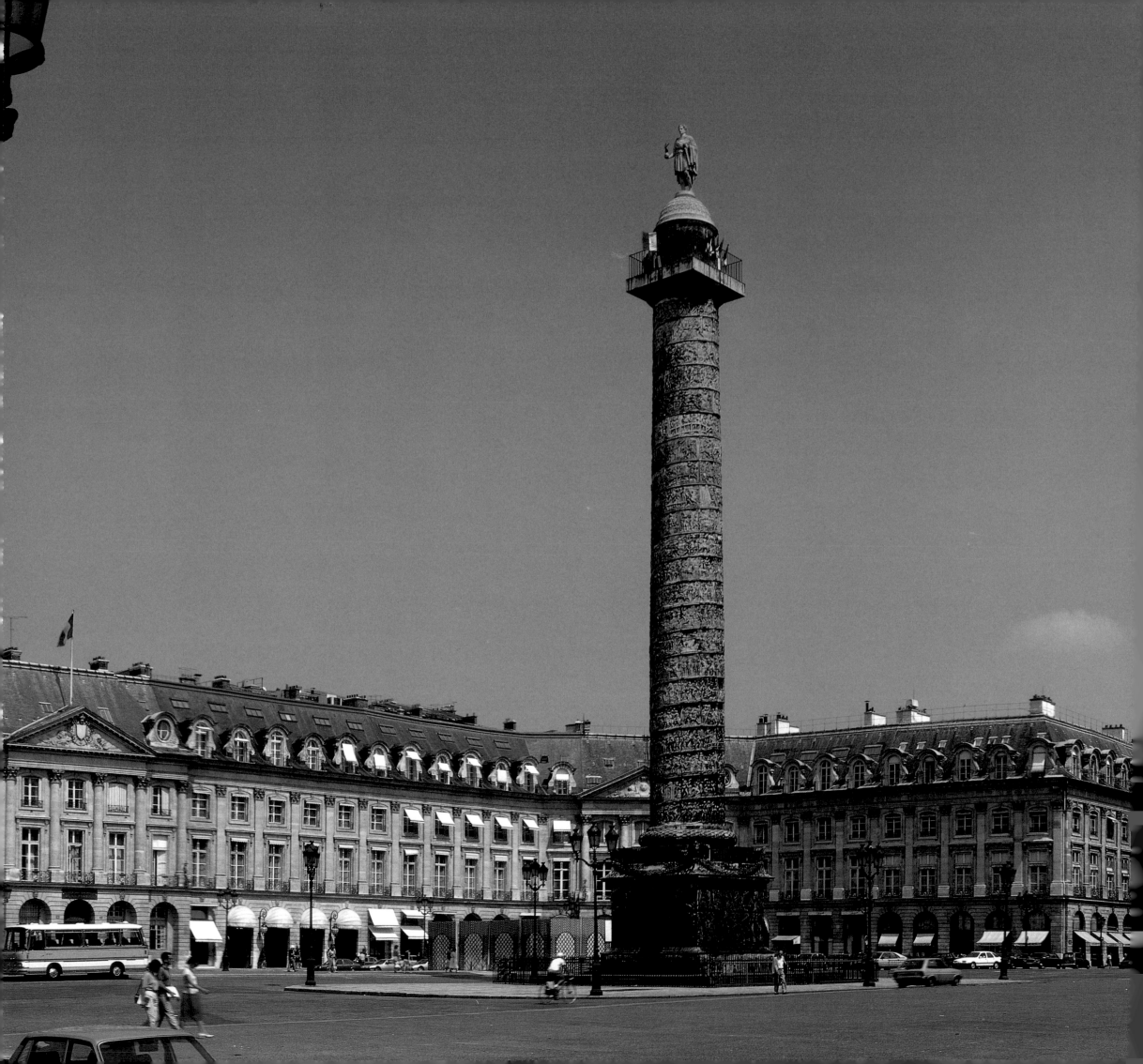

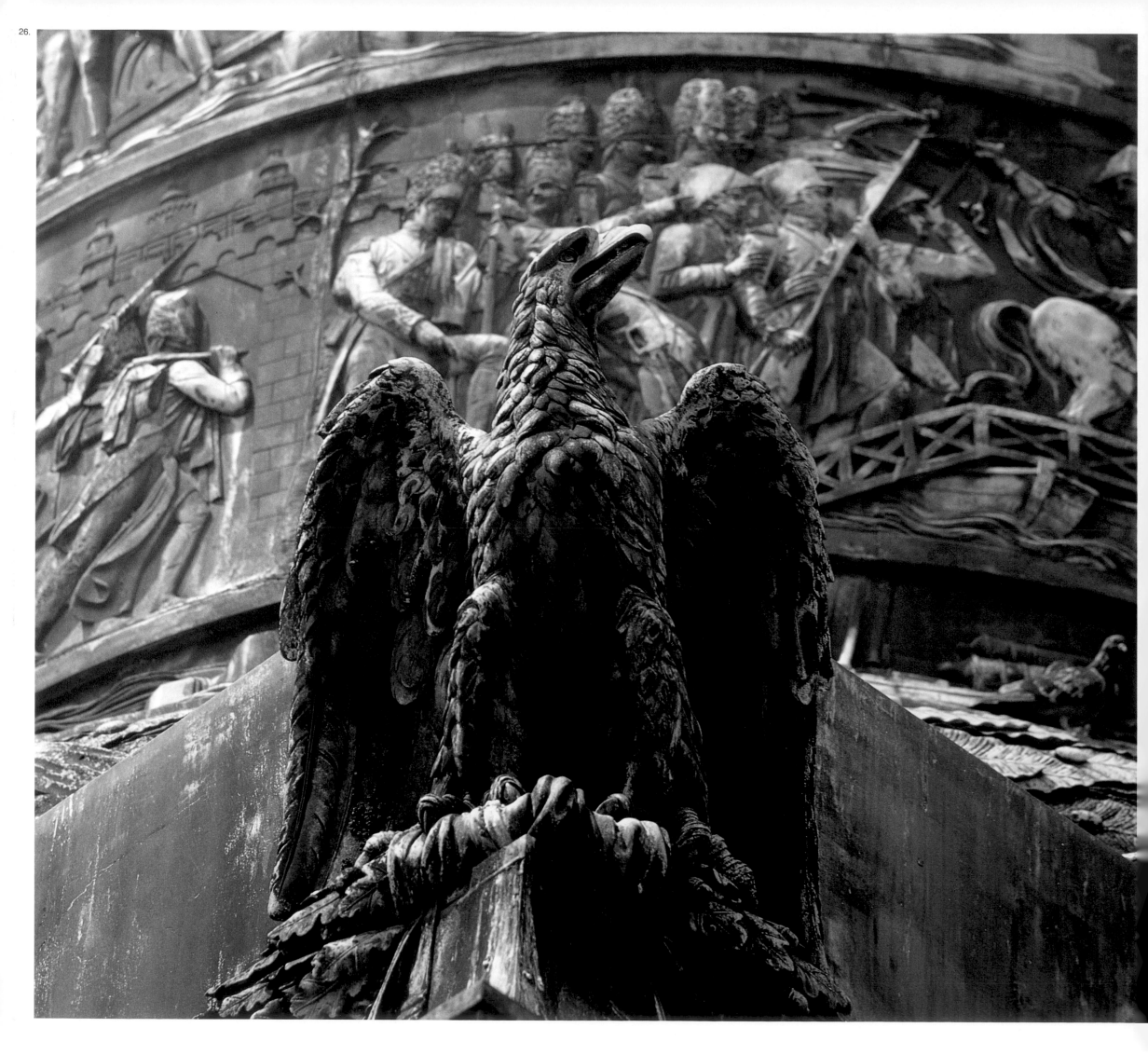

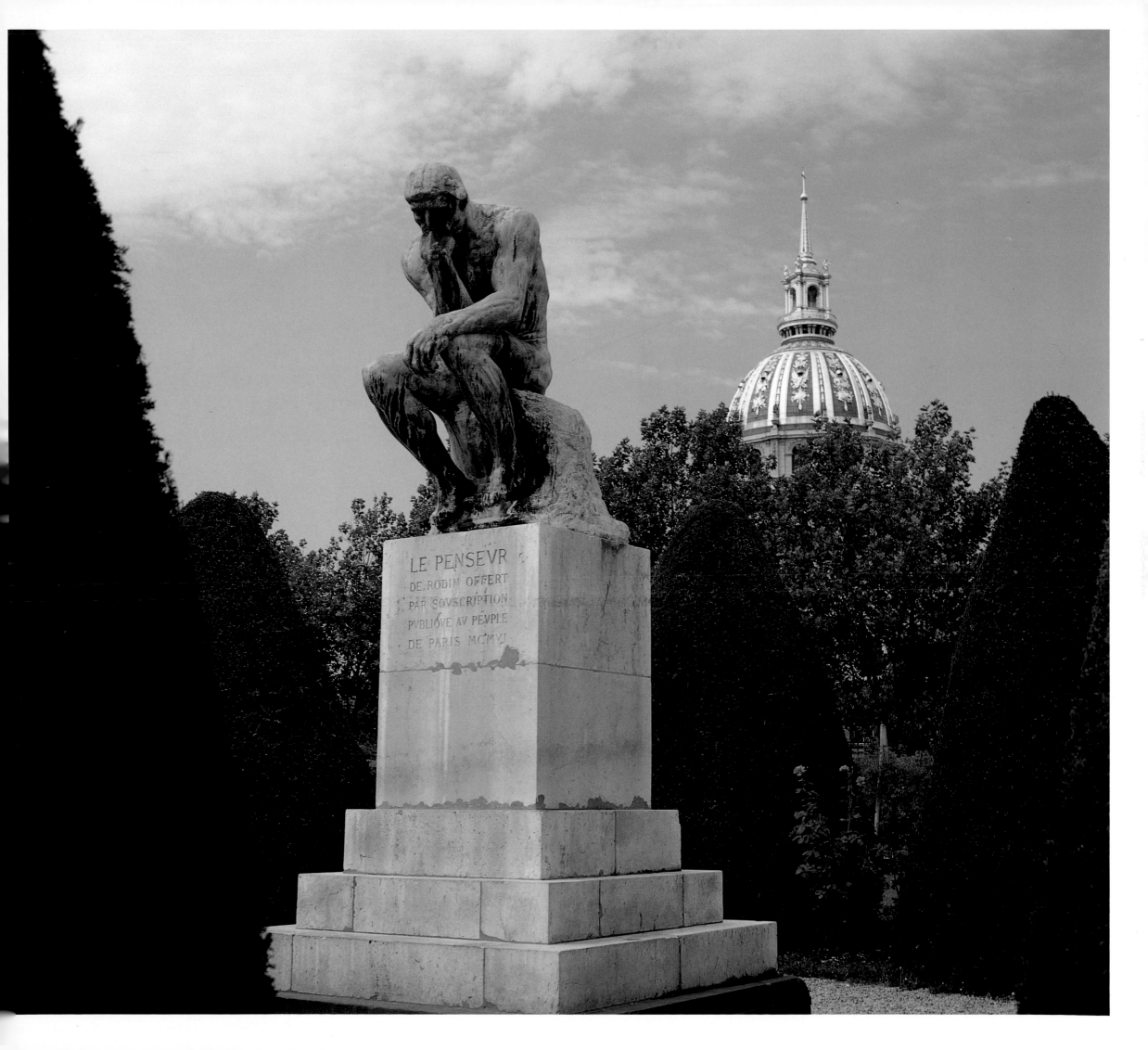

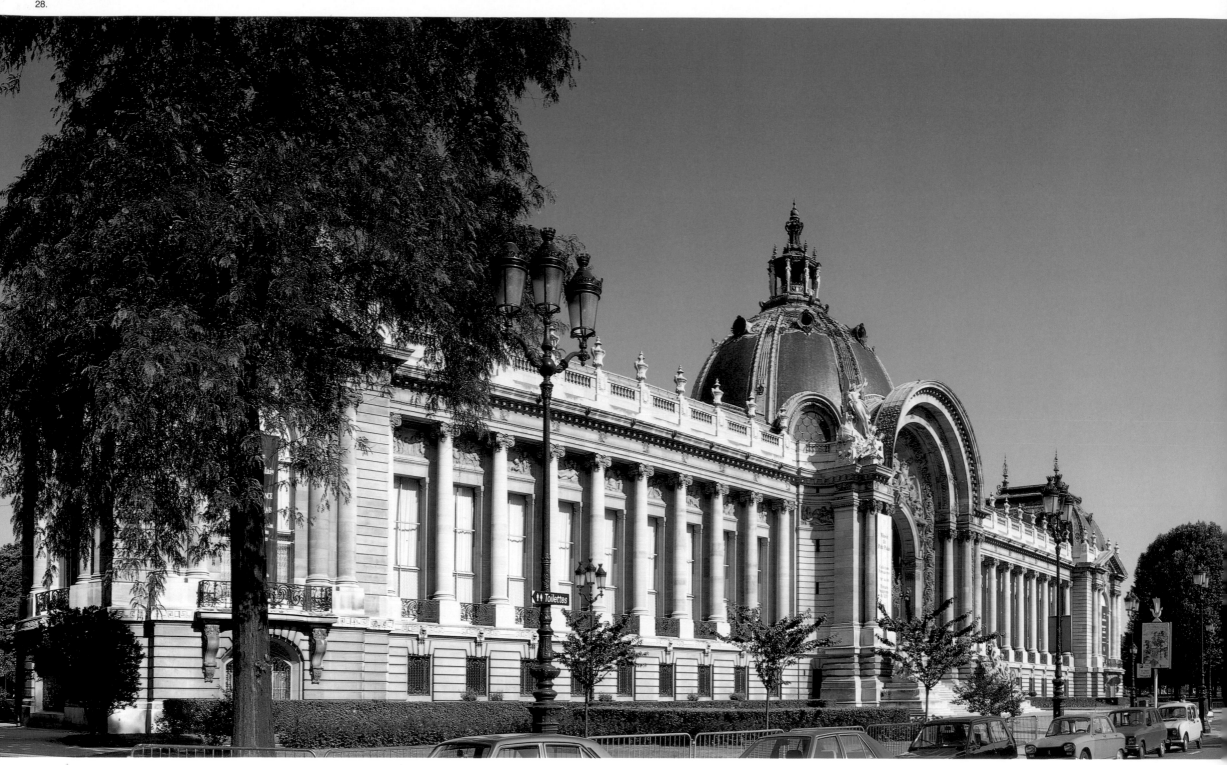

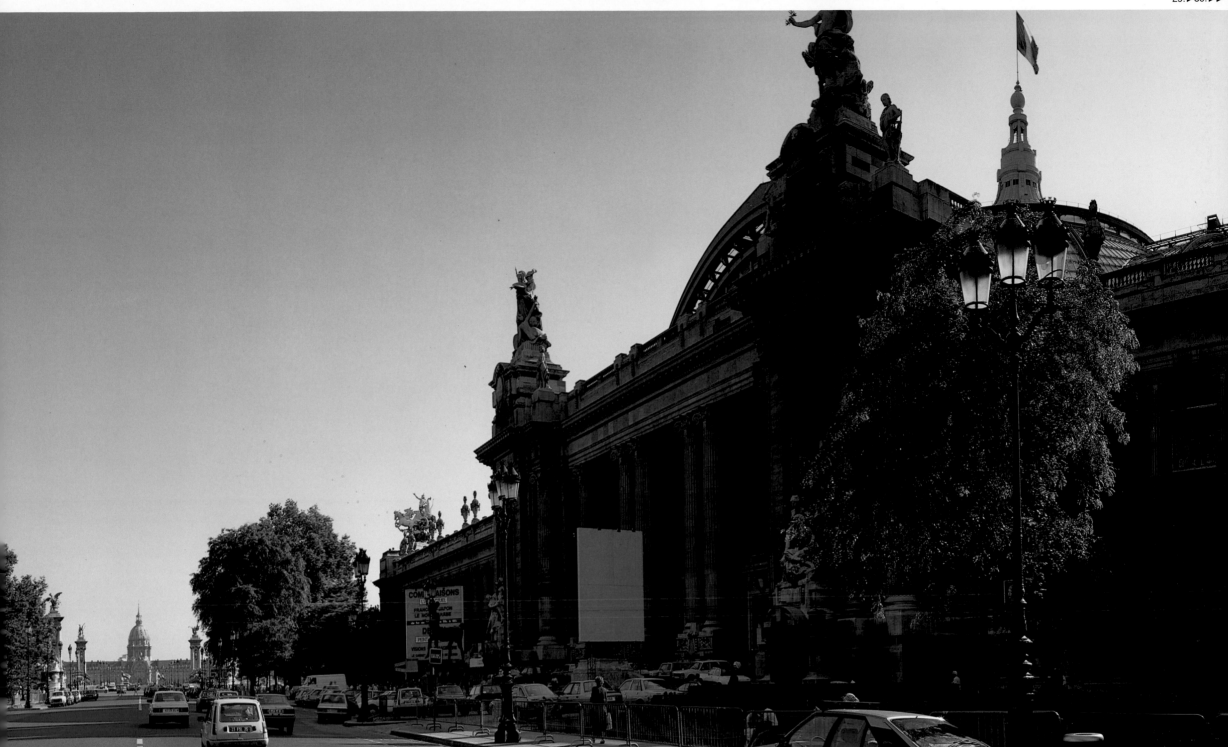

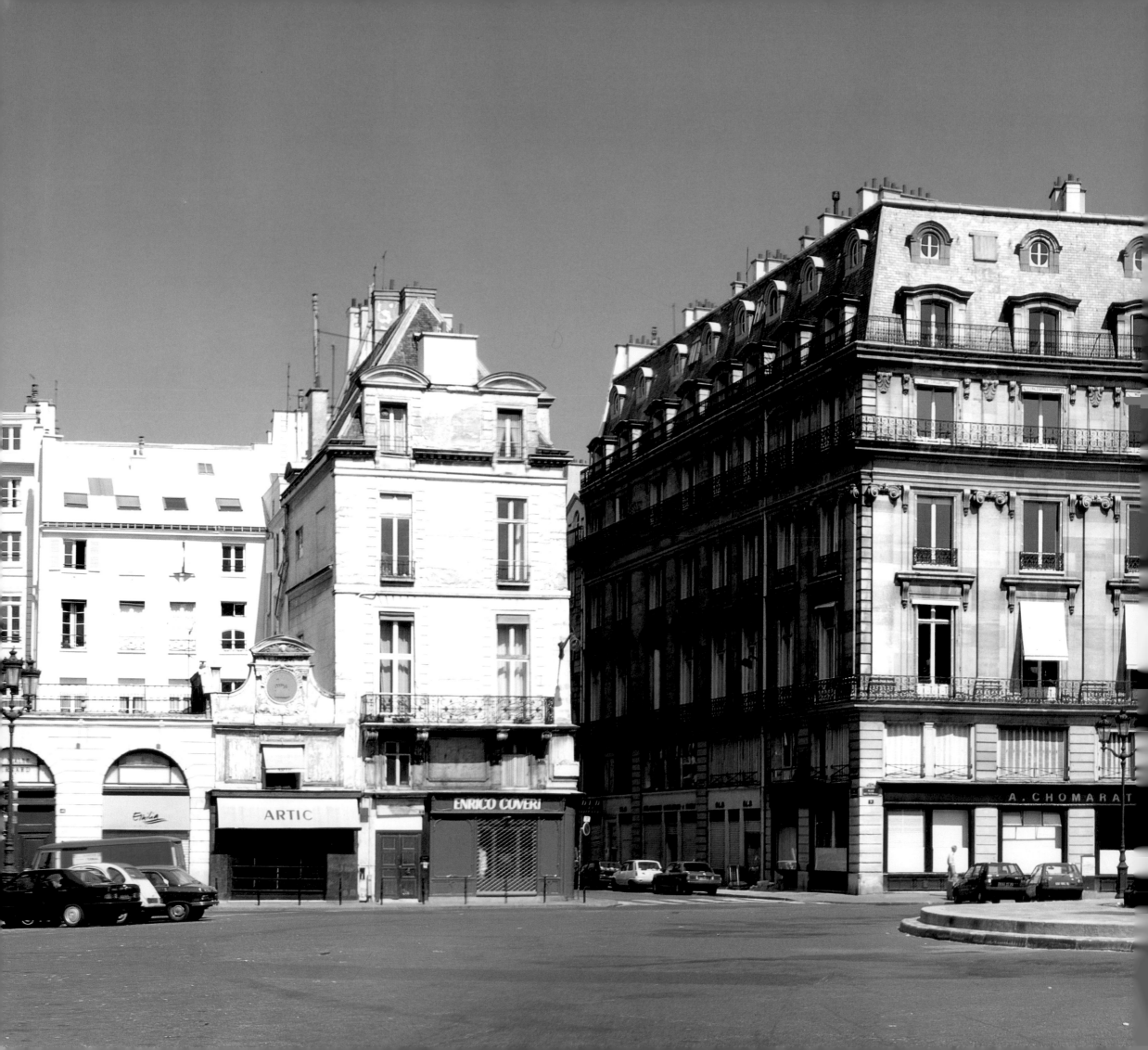

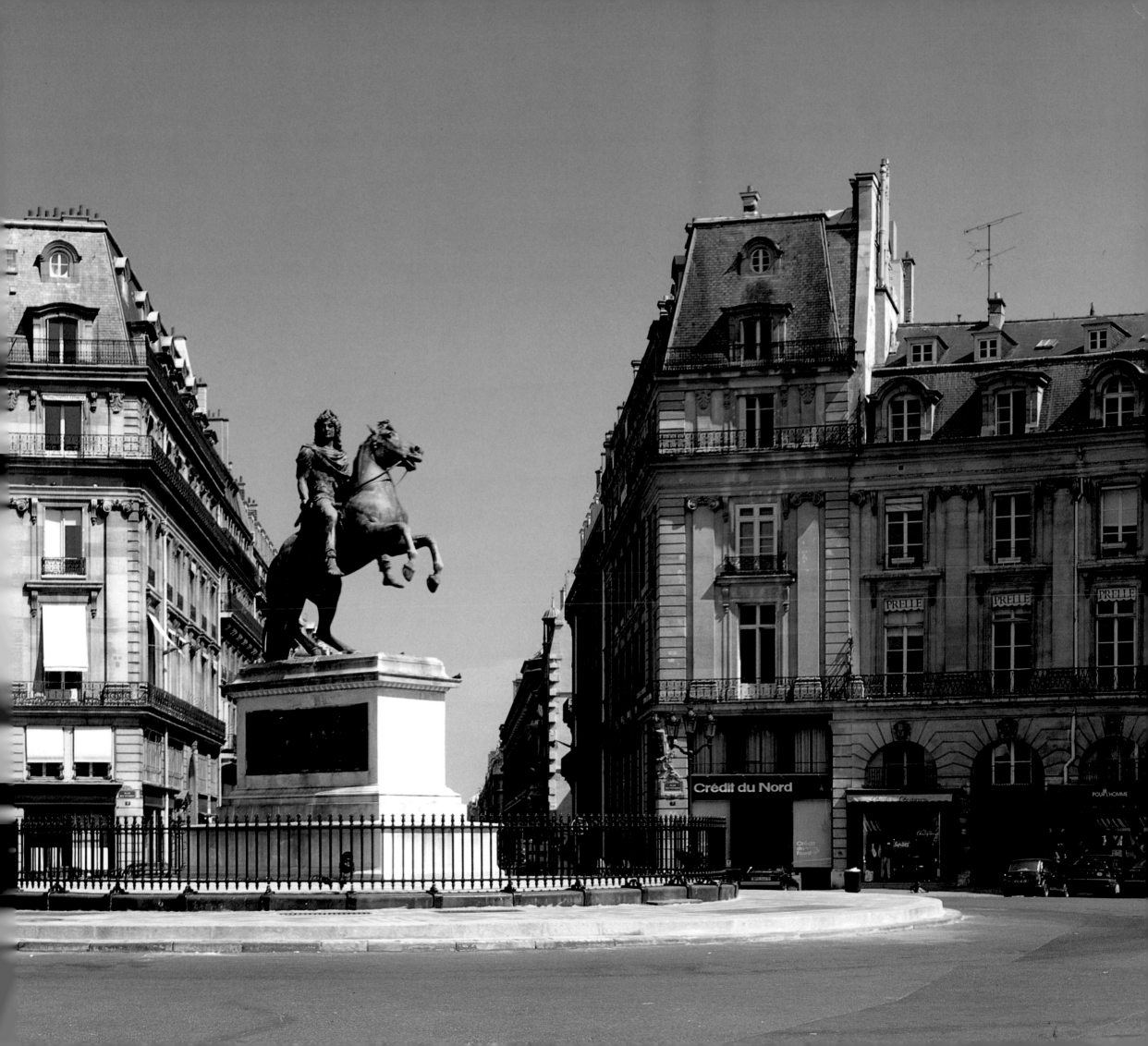

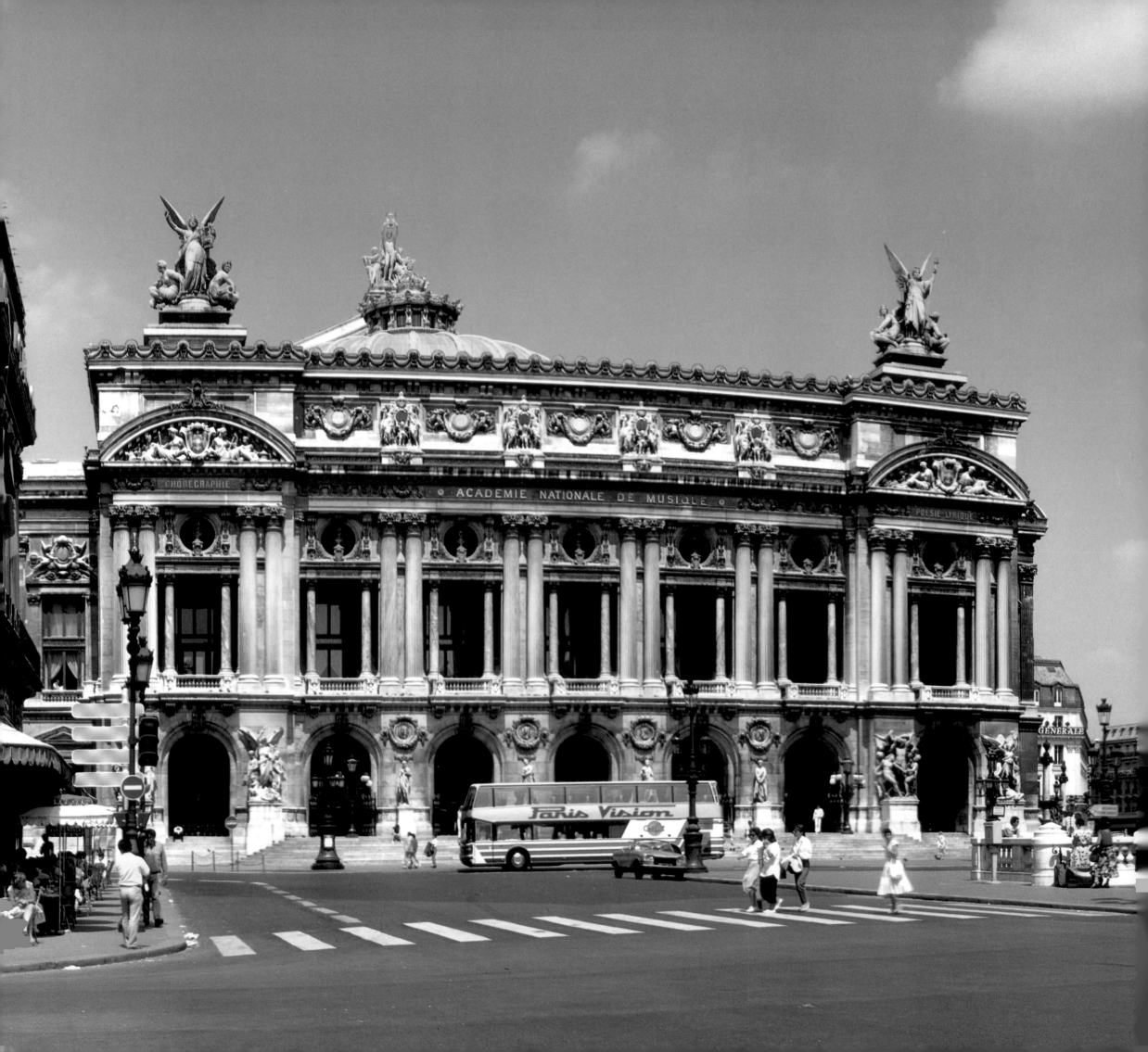

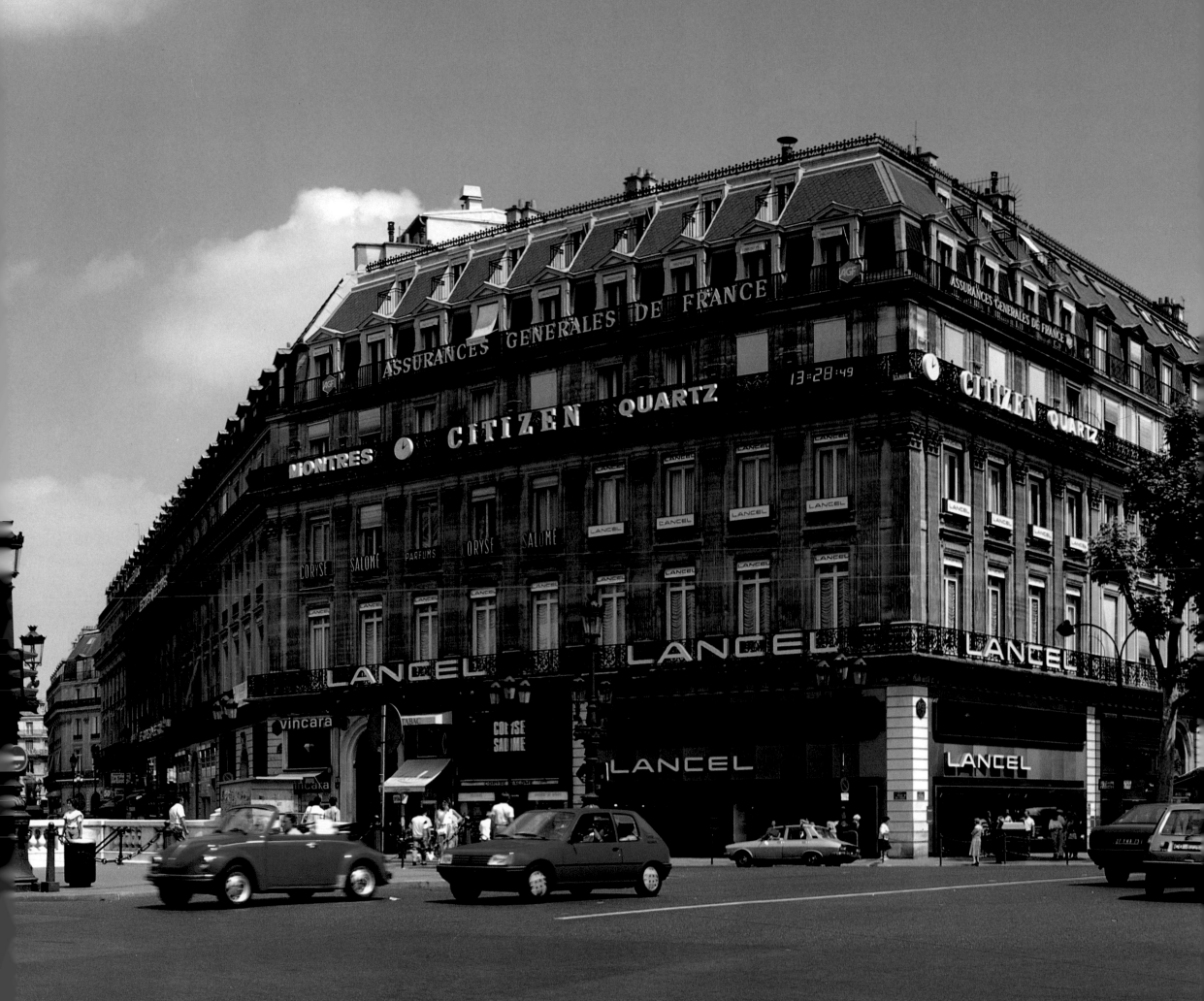

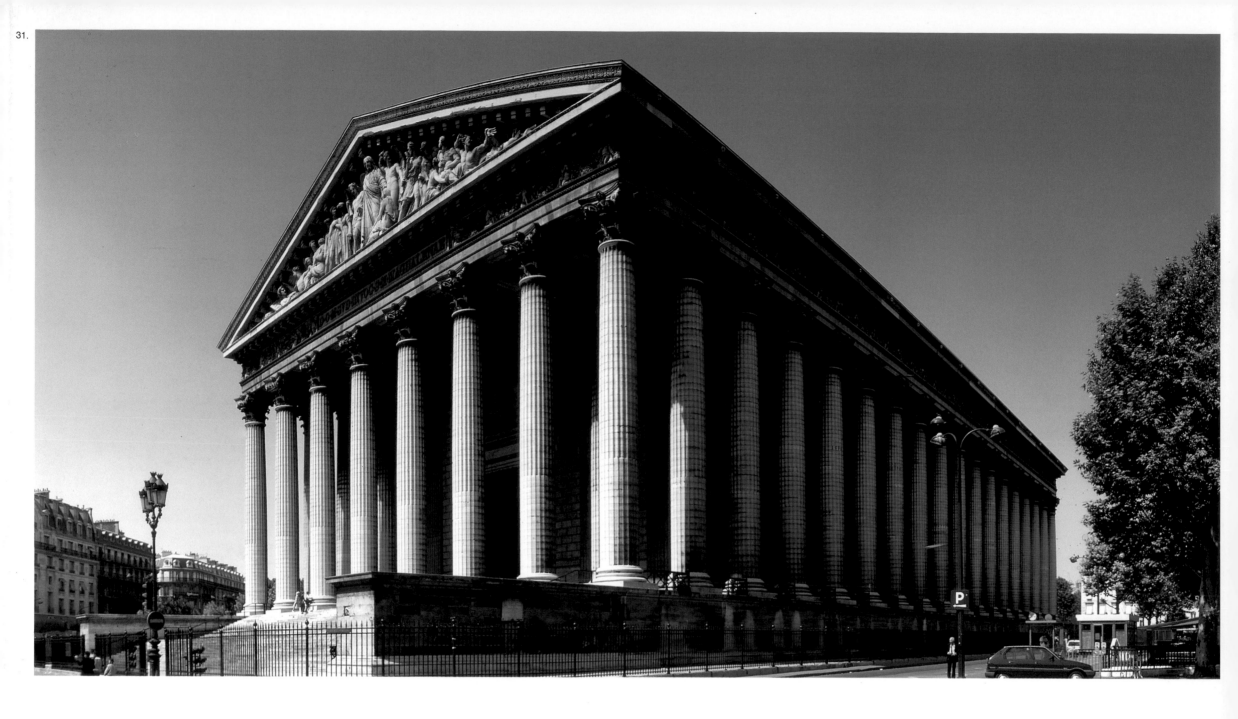

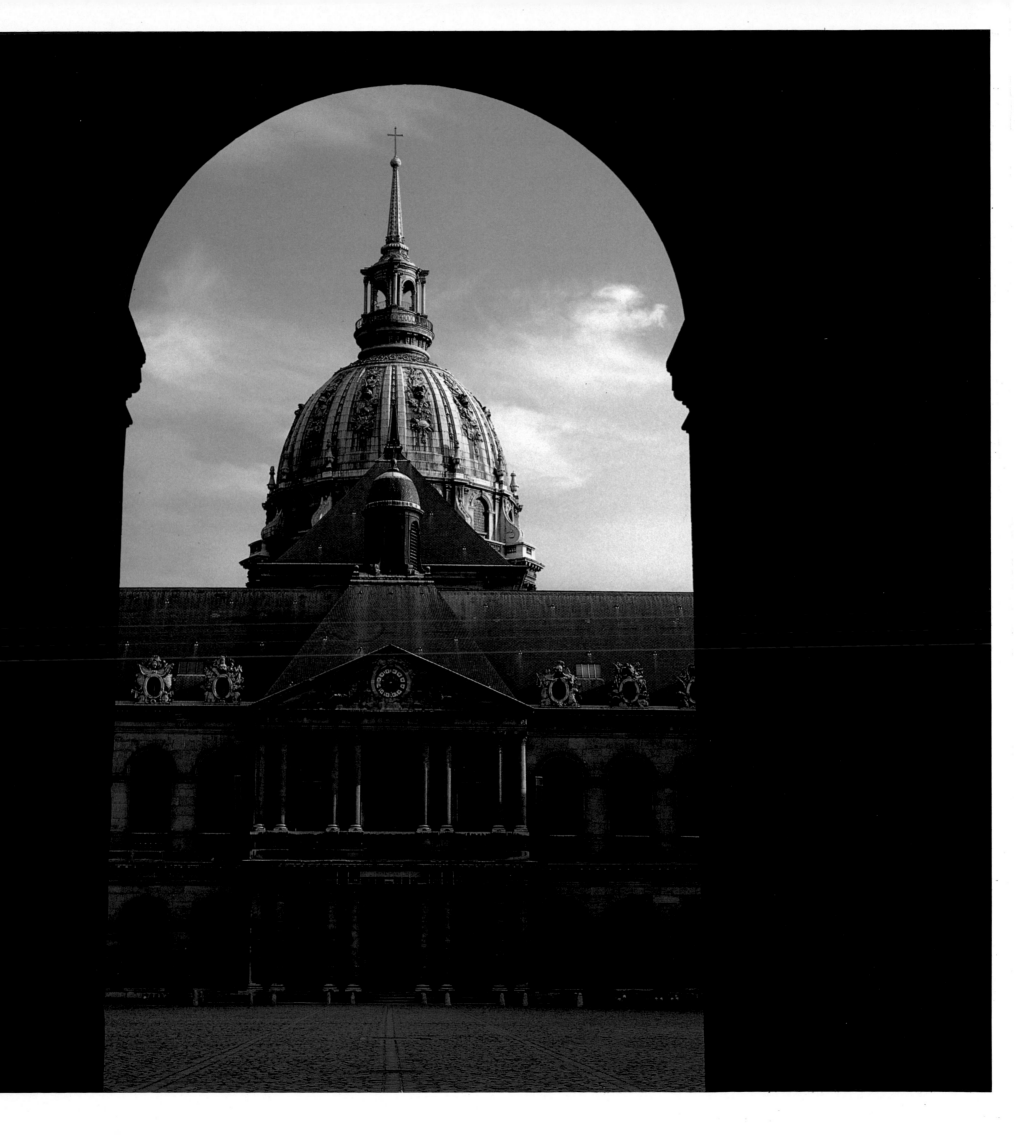

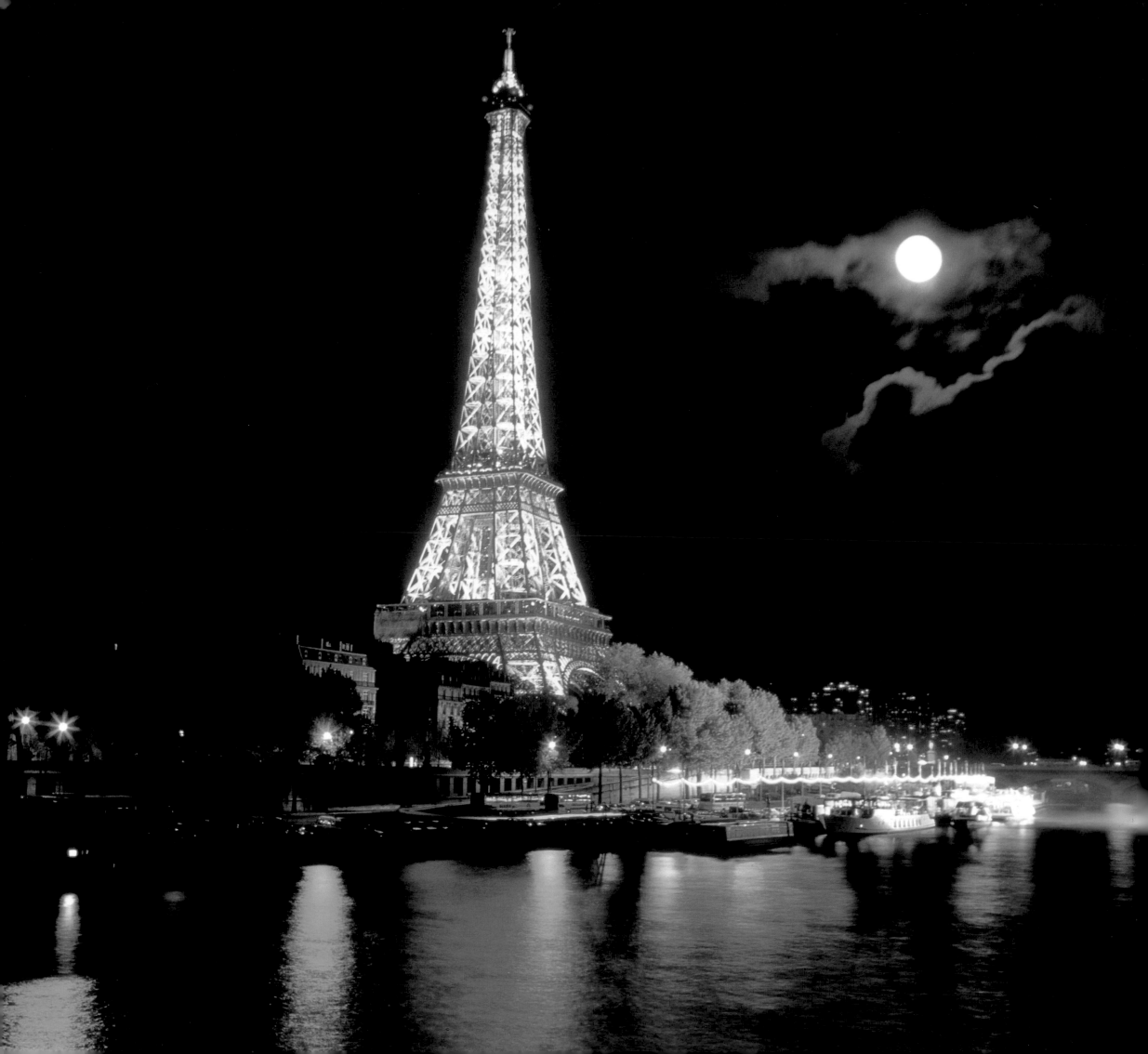

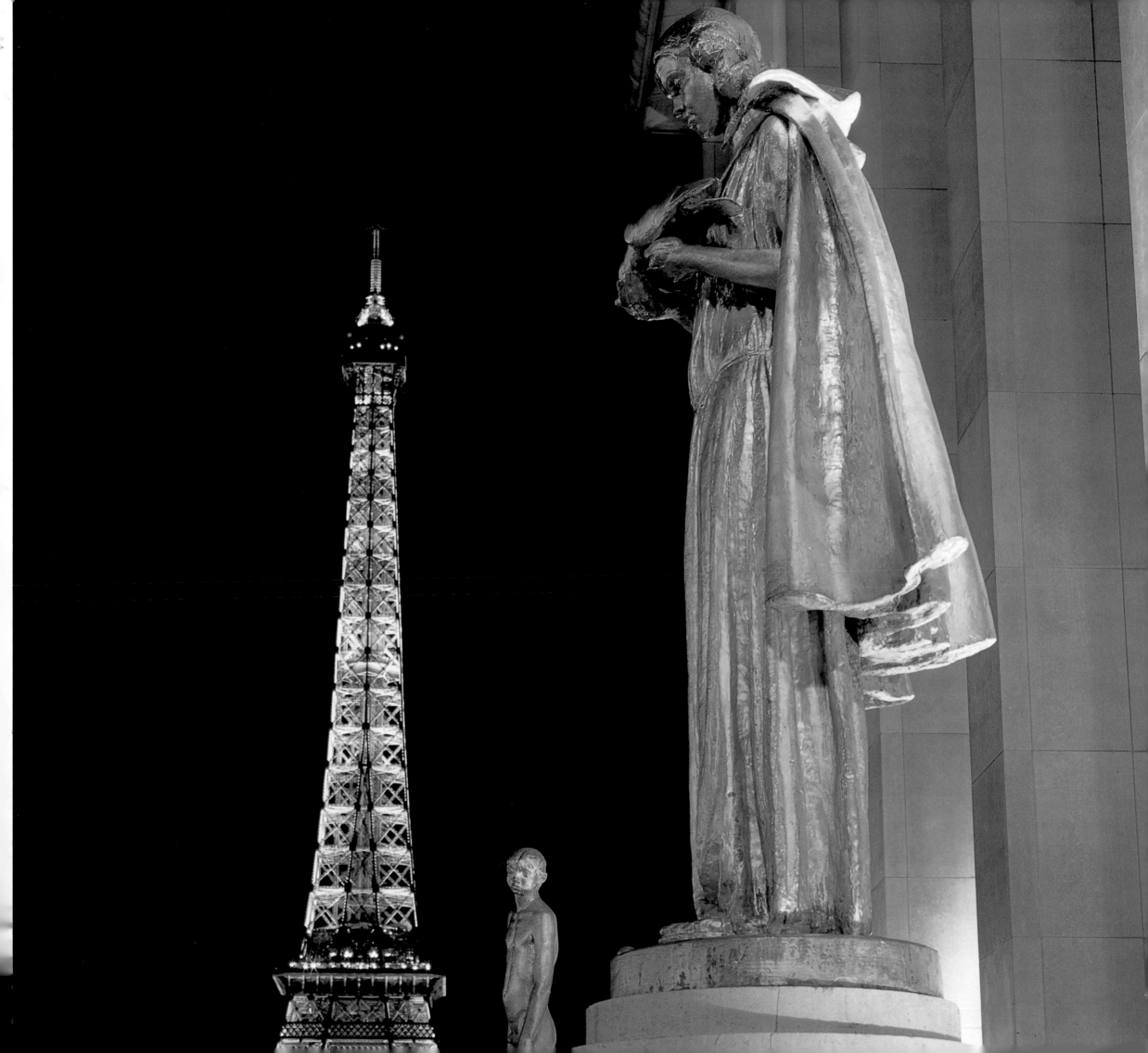

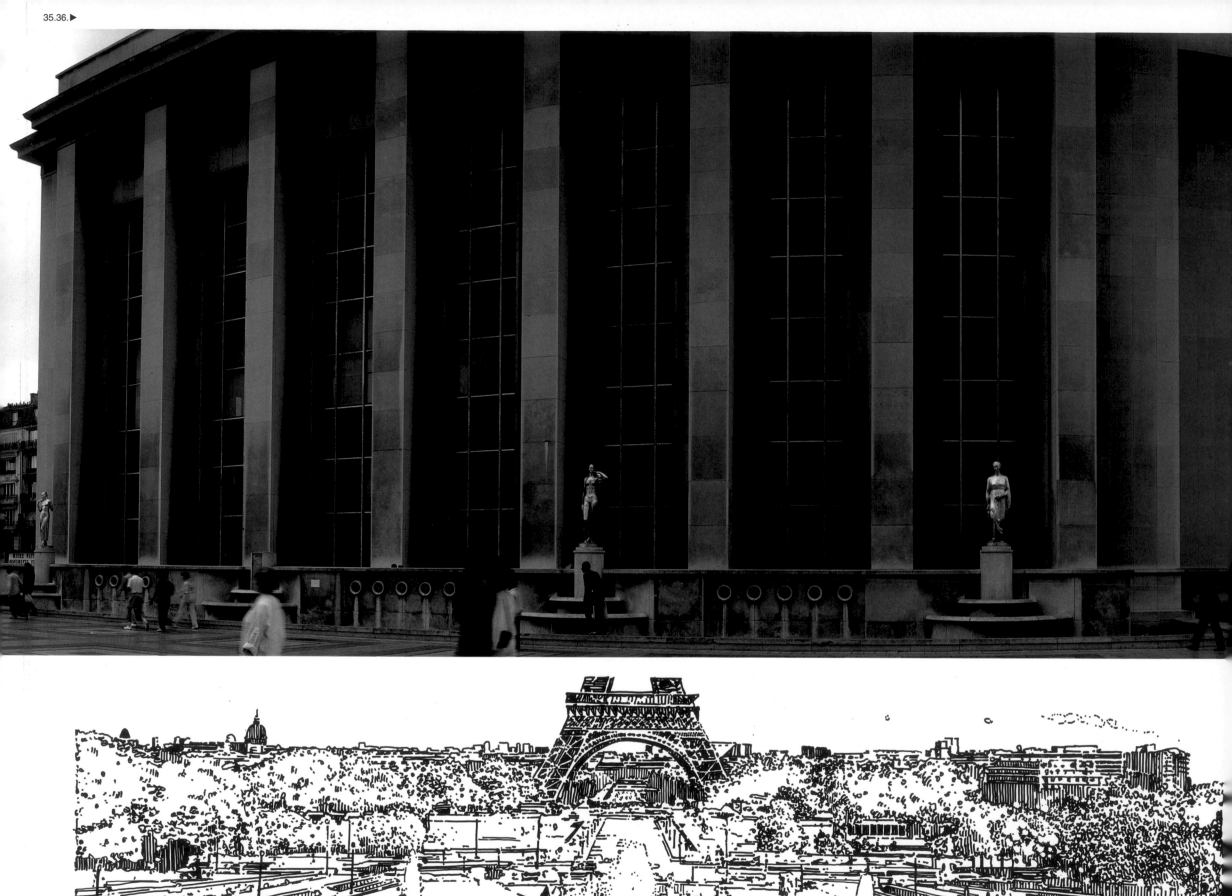

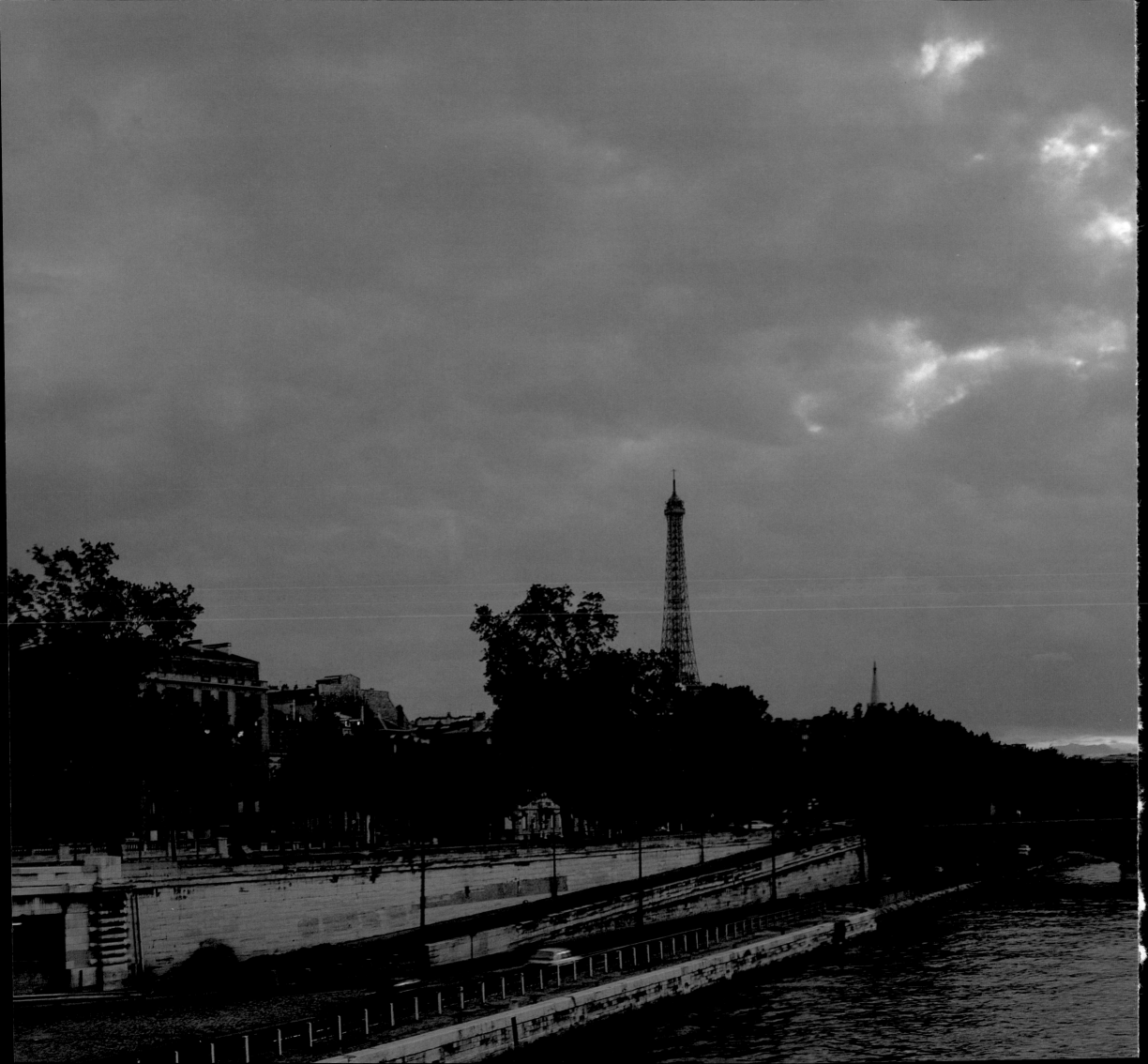

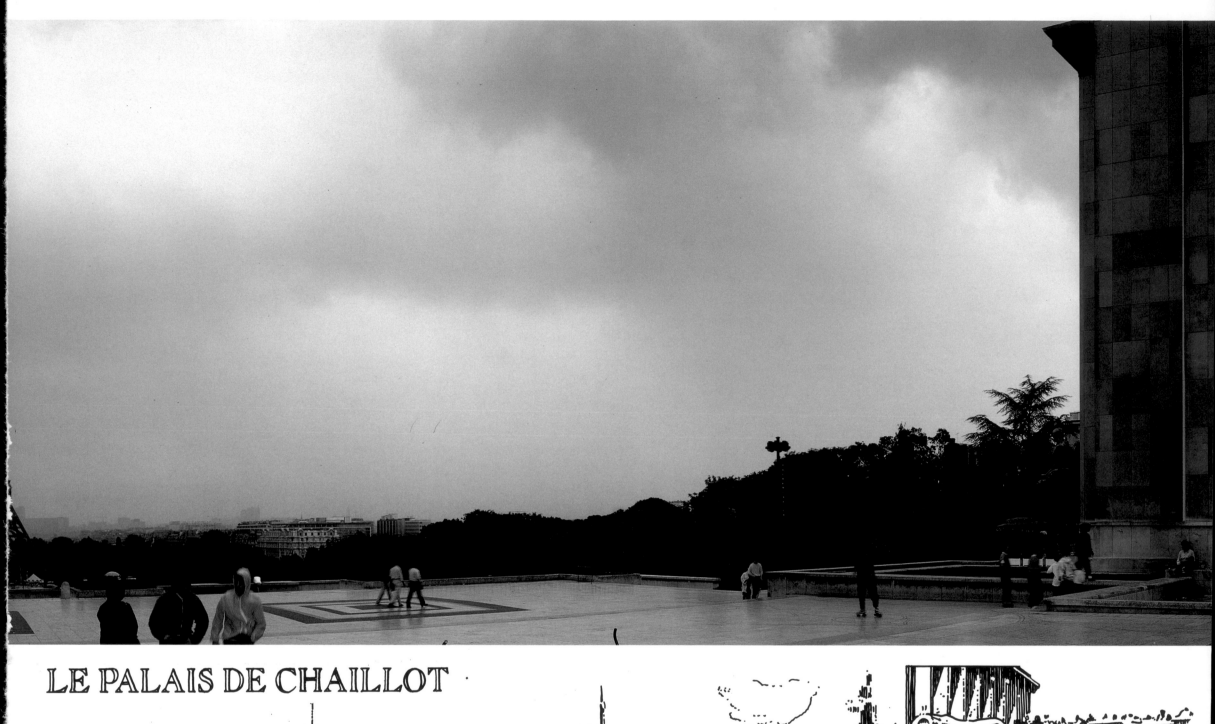

LE PALAIS DE CHAILLOT

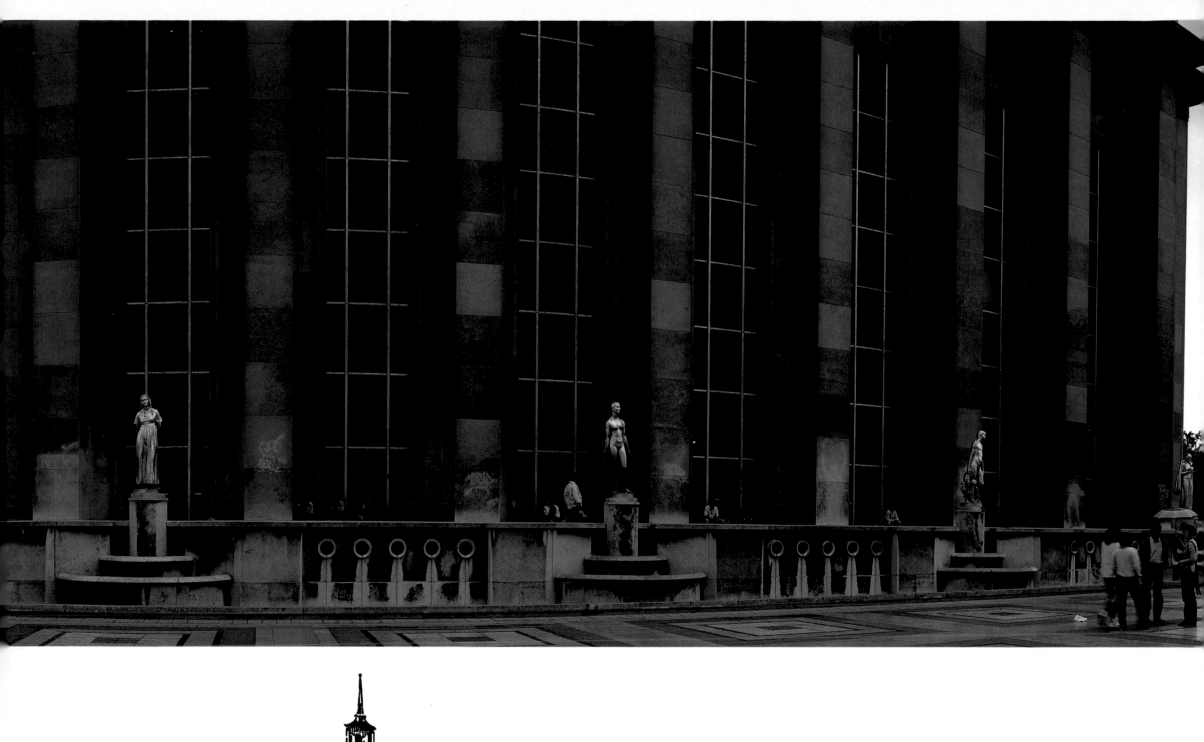

L'HOTEL DES INVALIDES

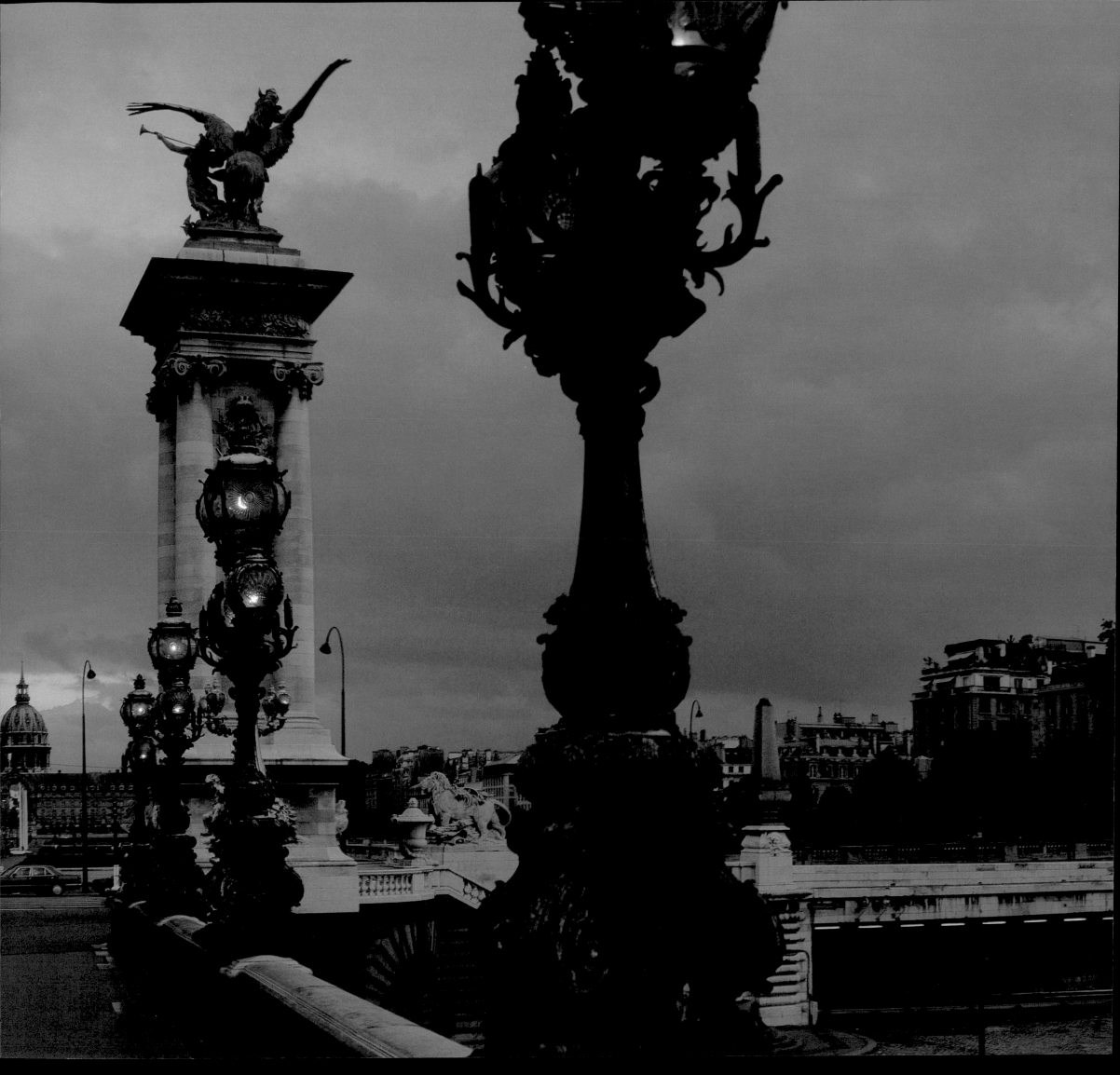

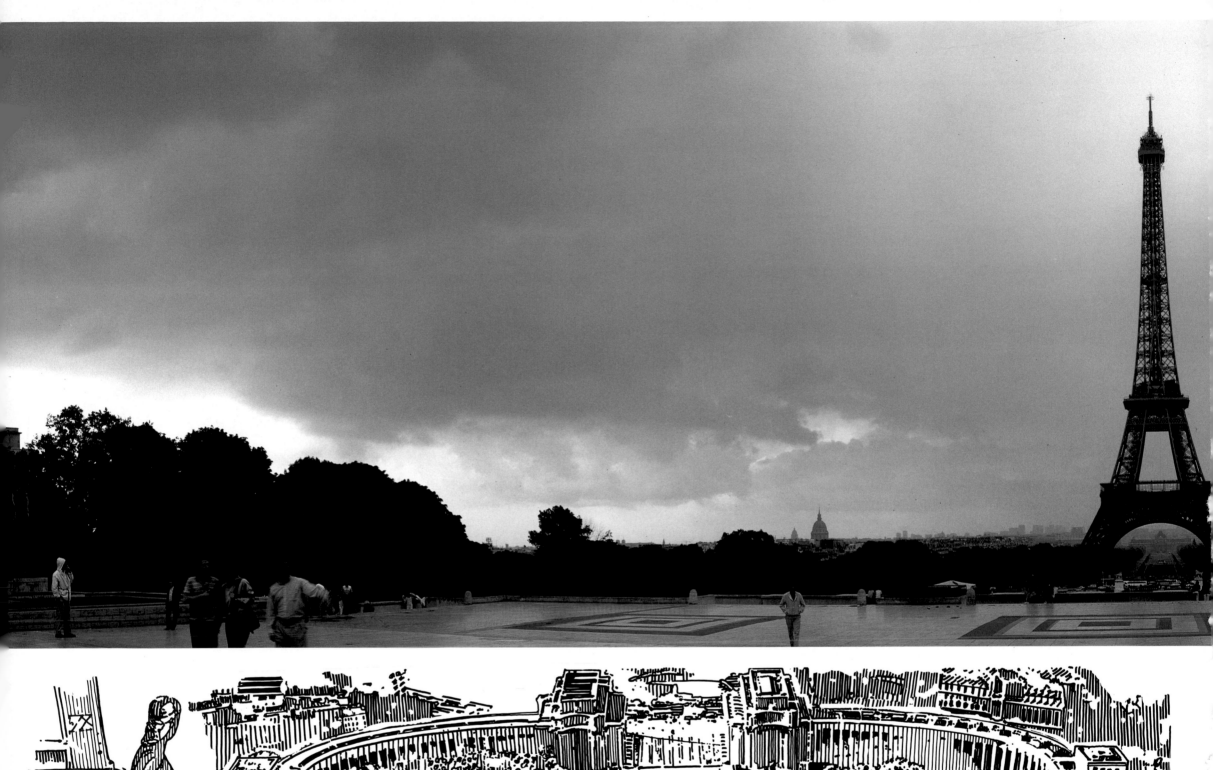

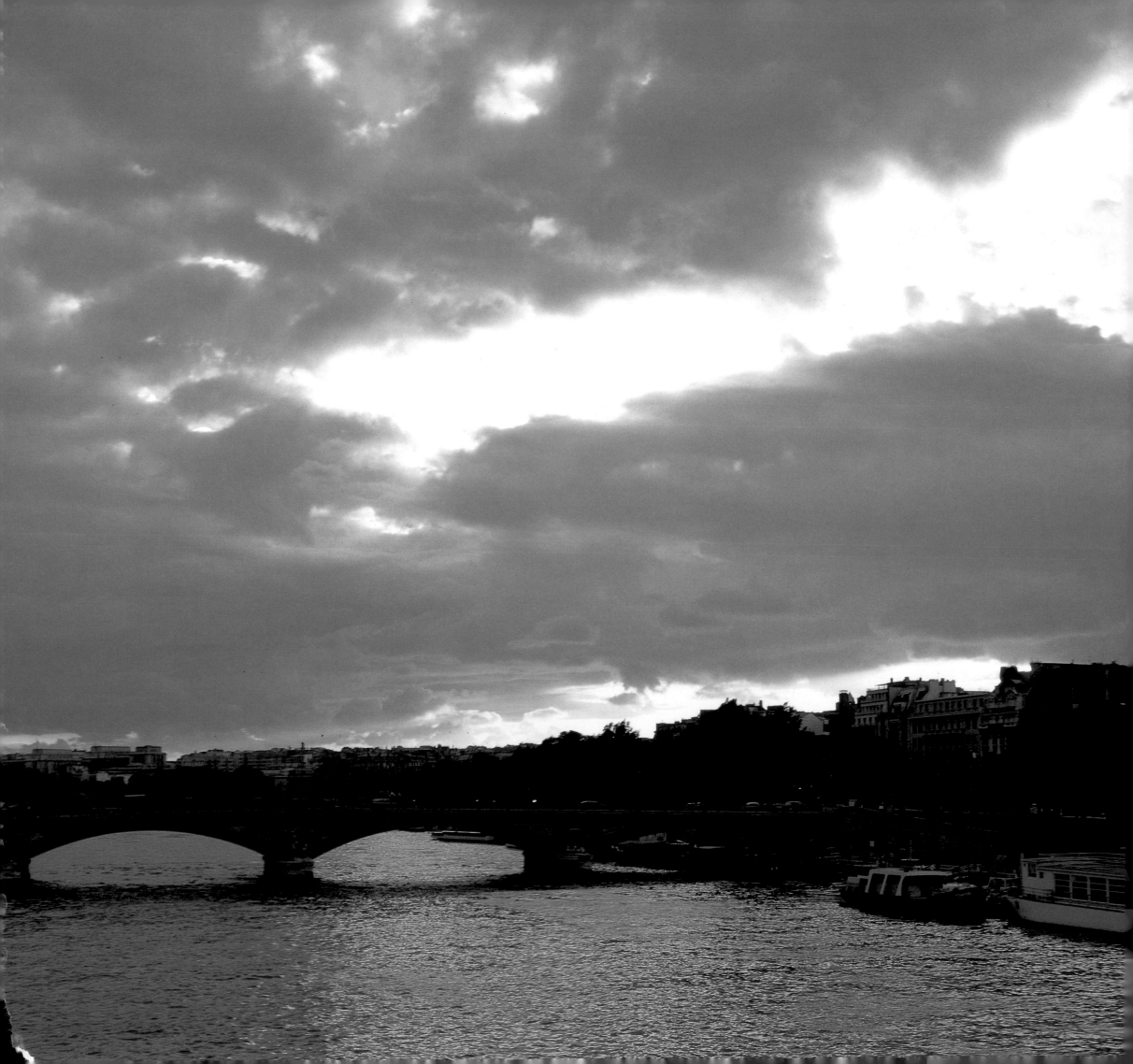

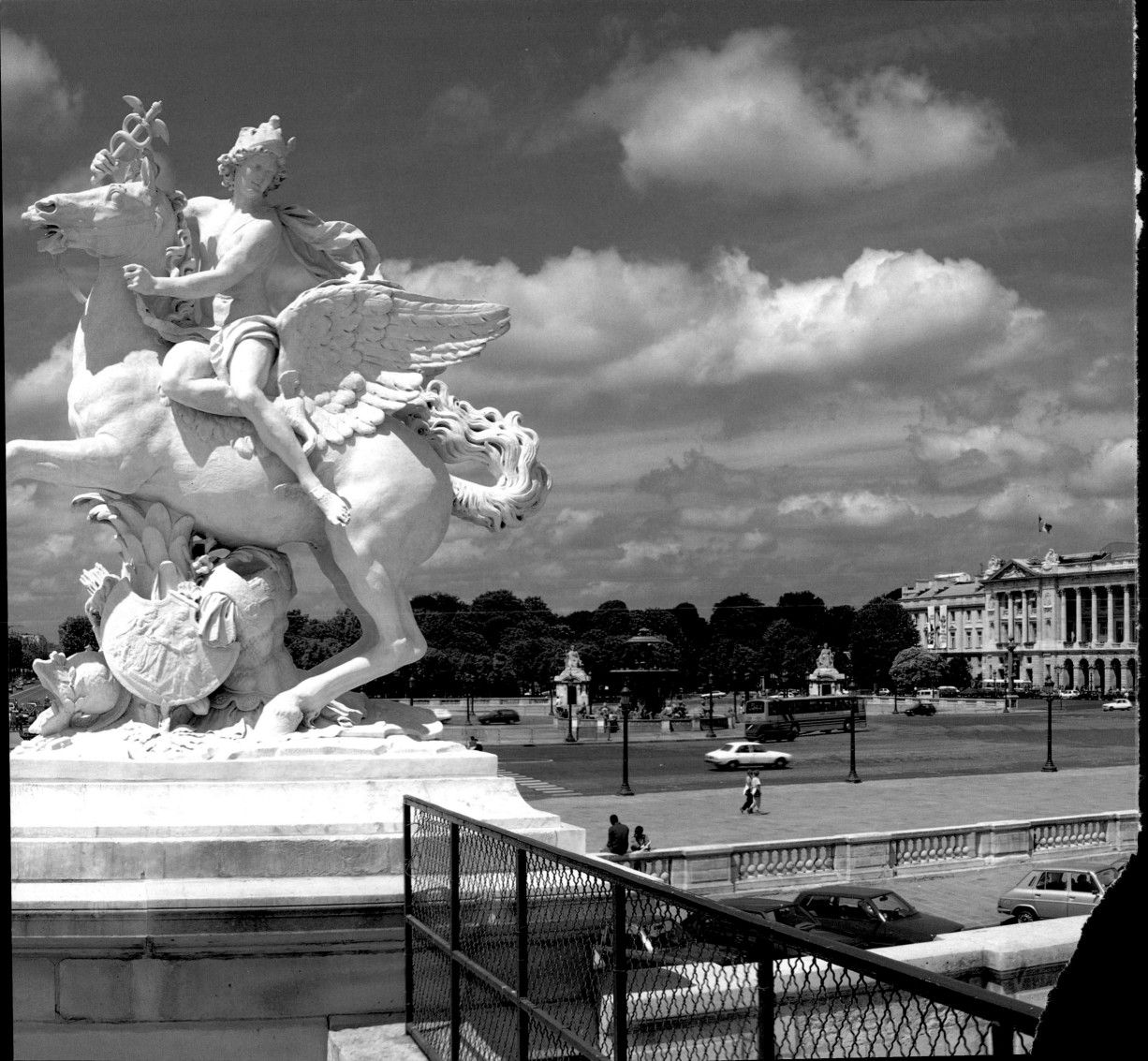

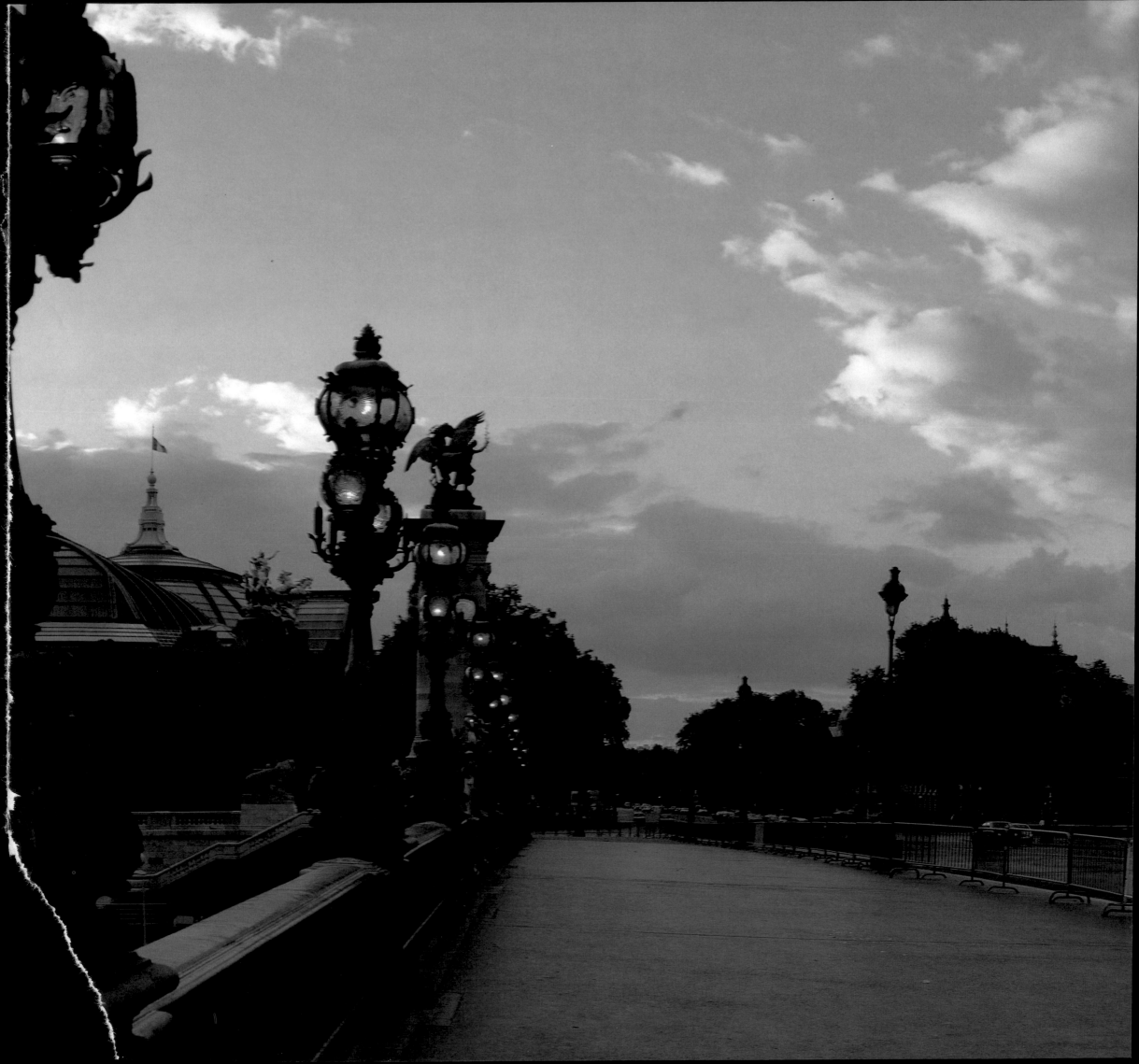

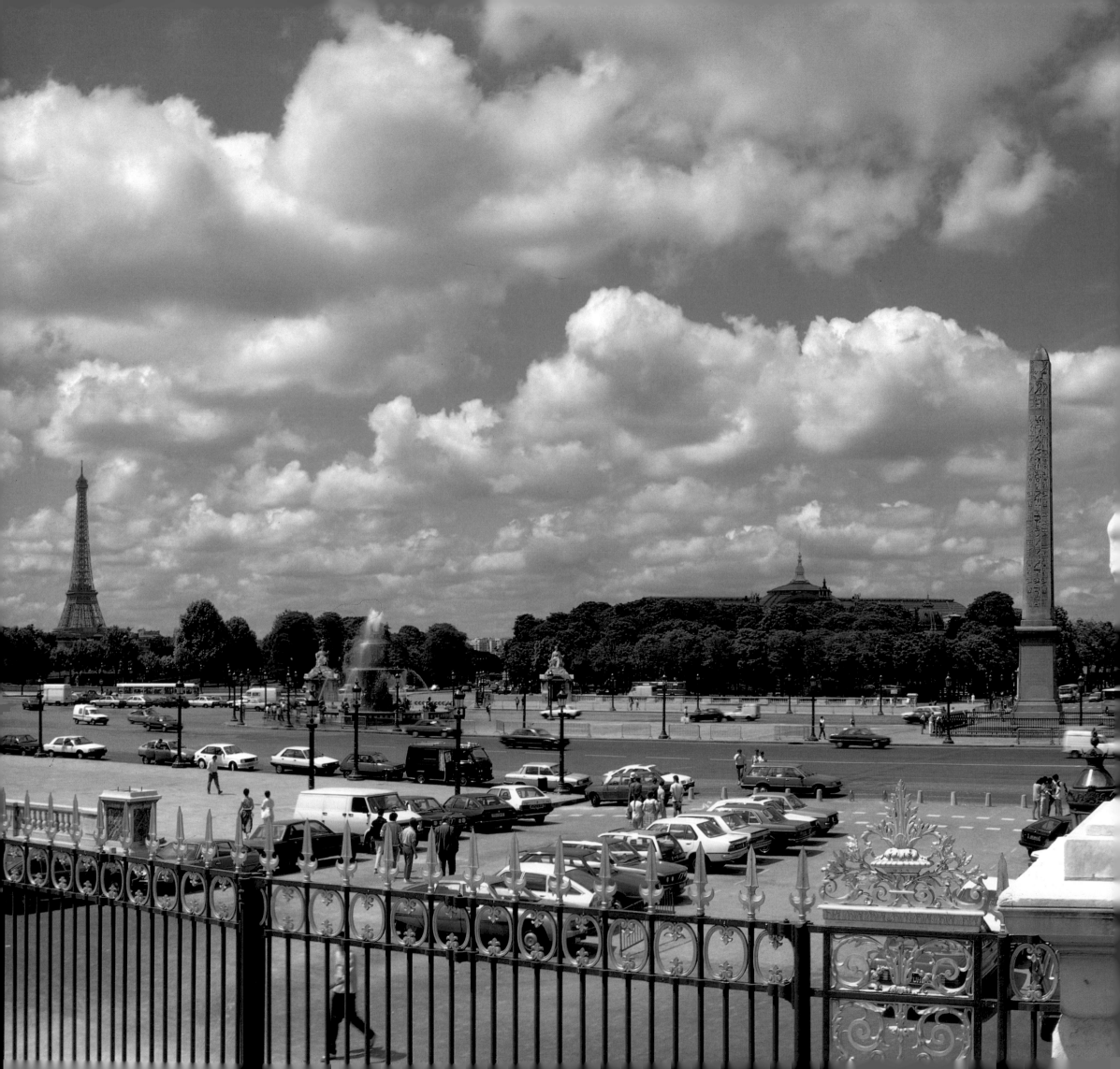

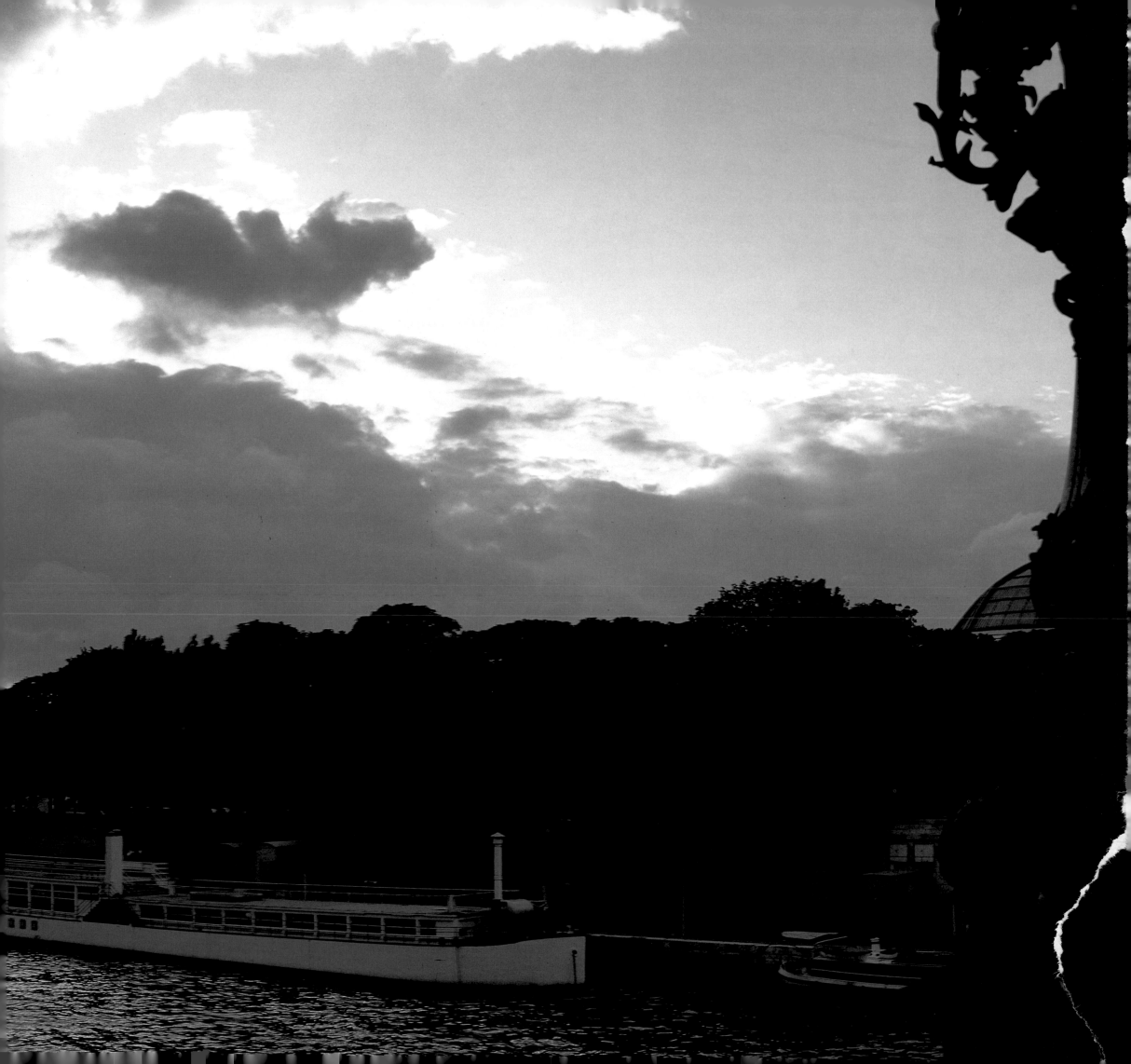

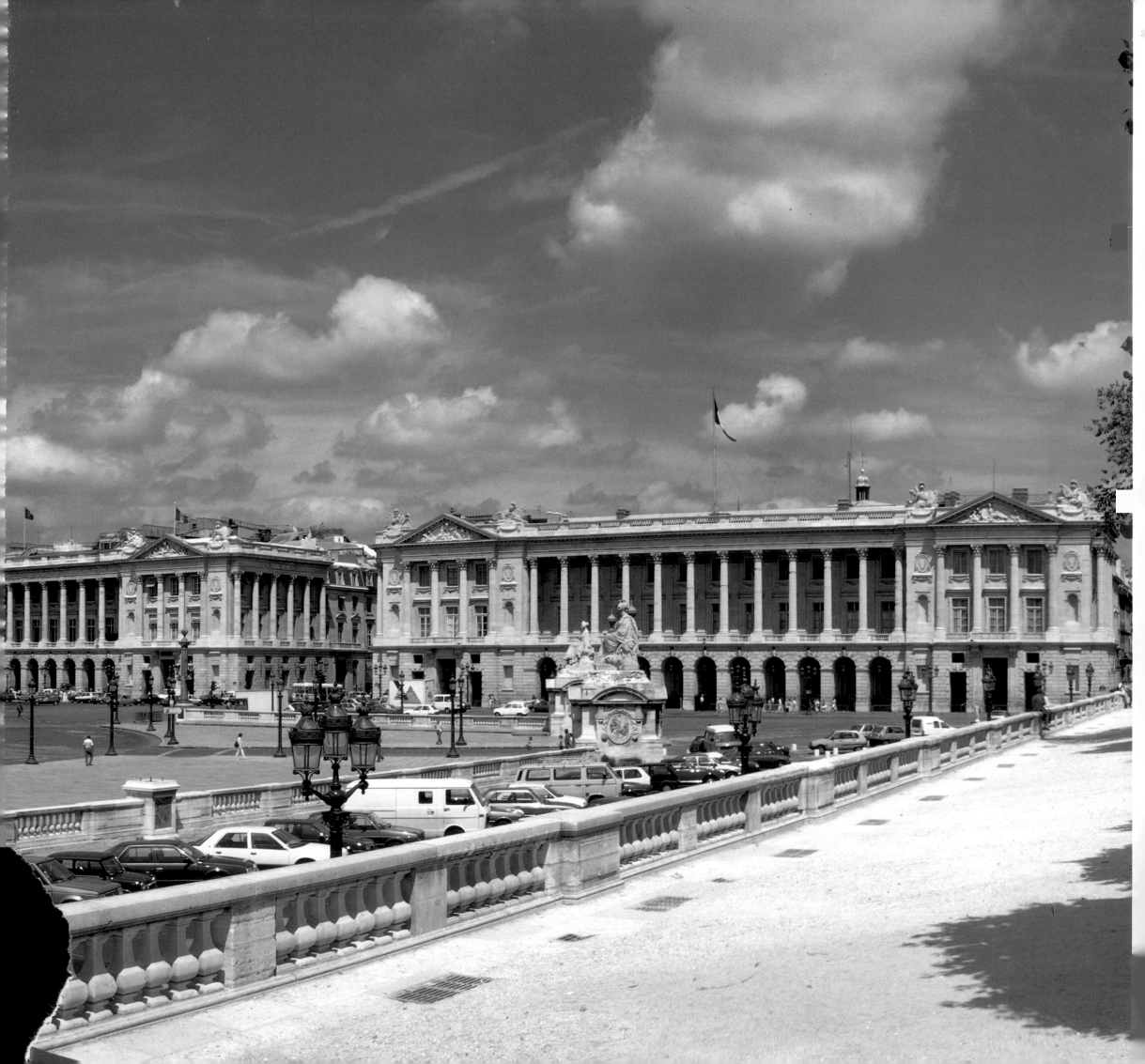

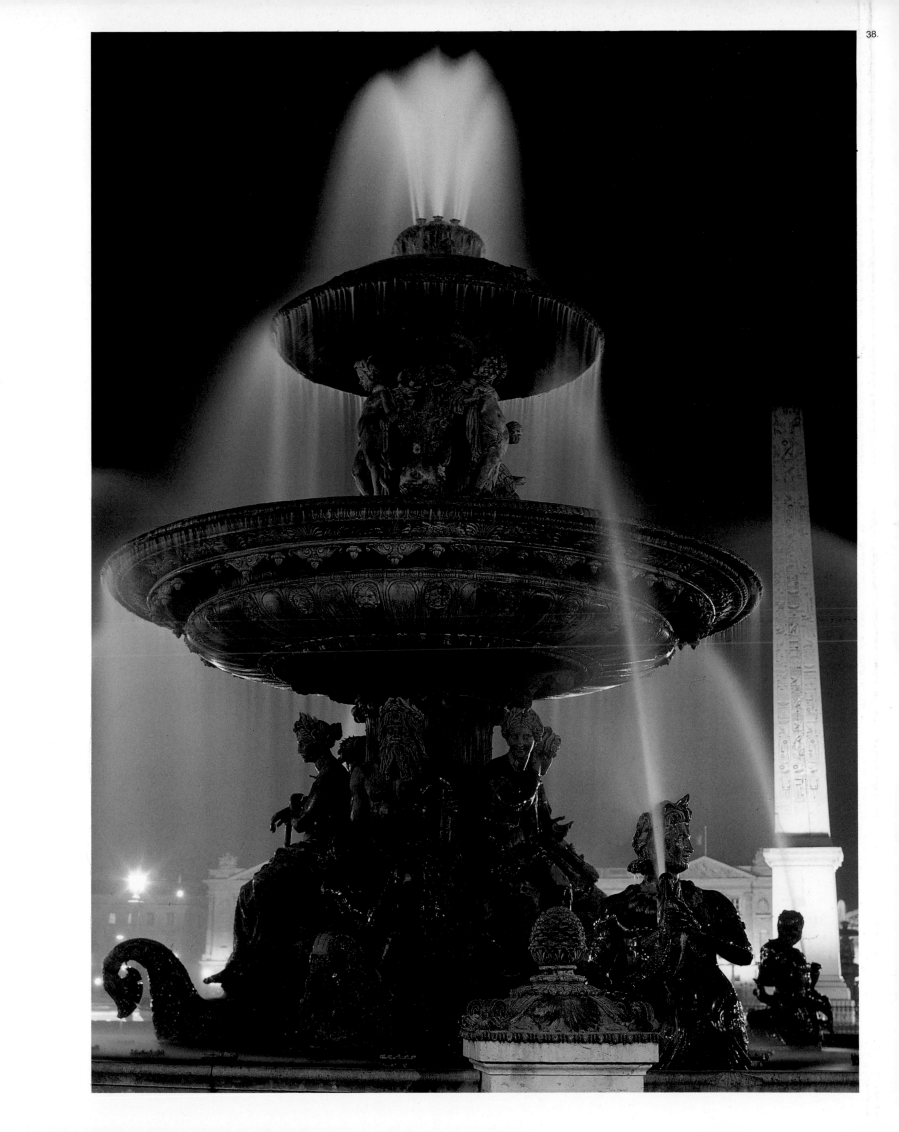

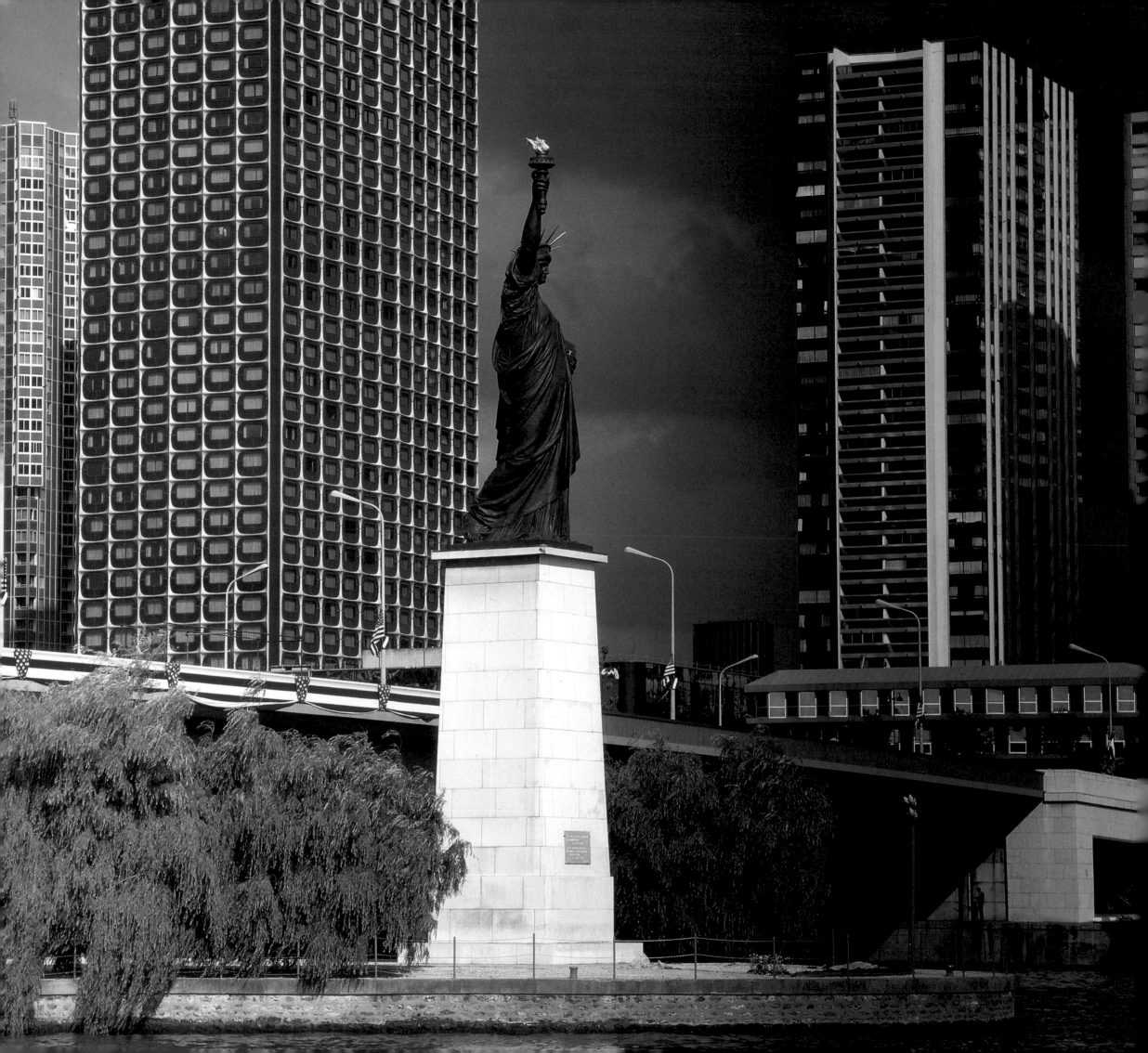

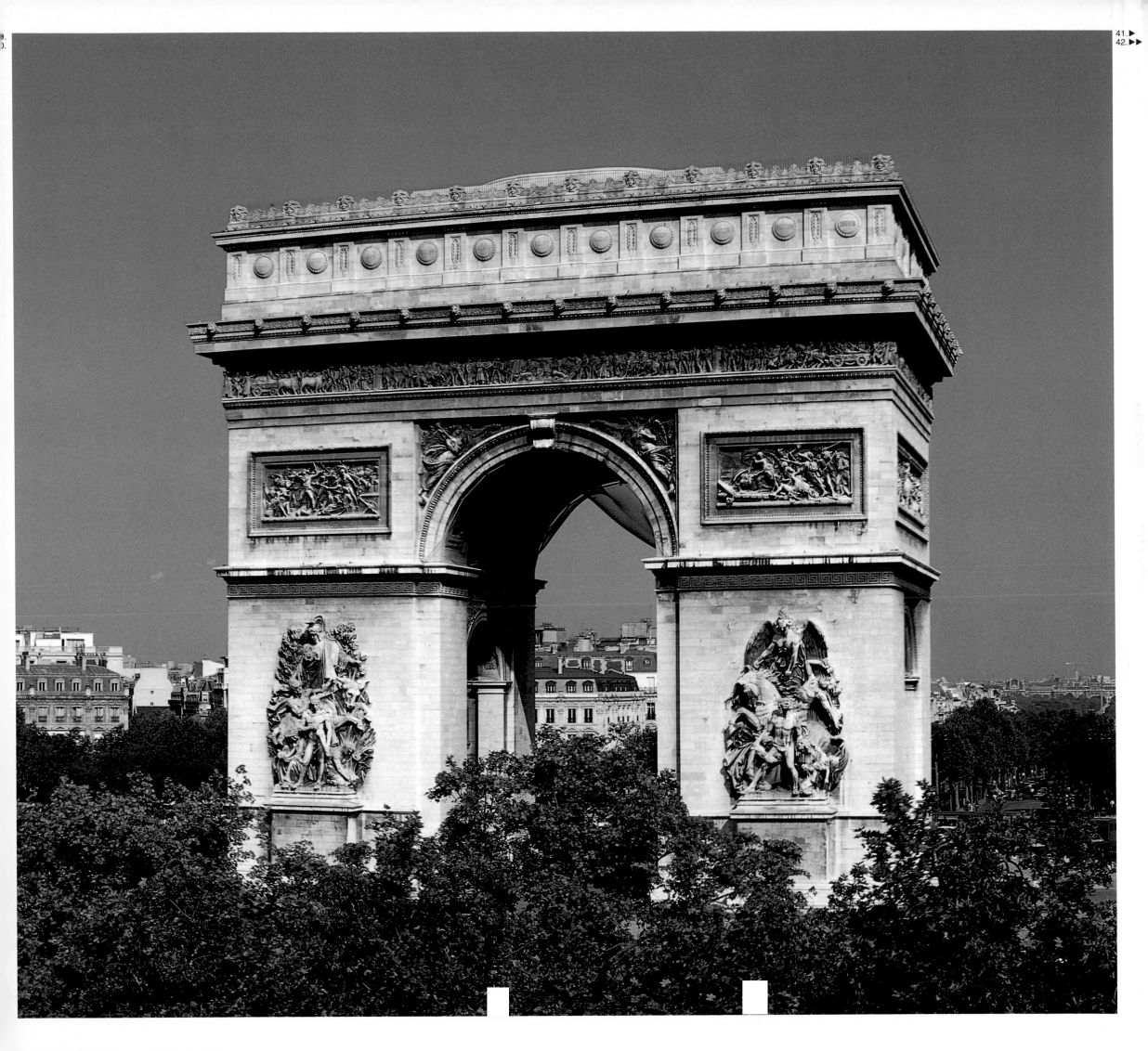

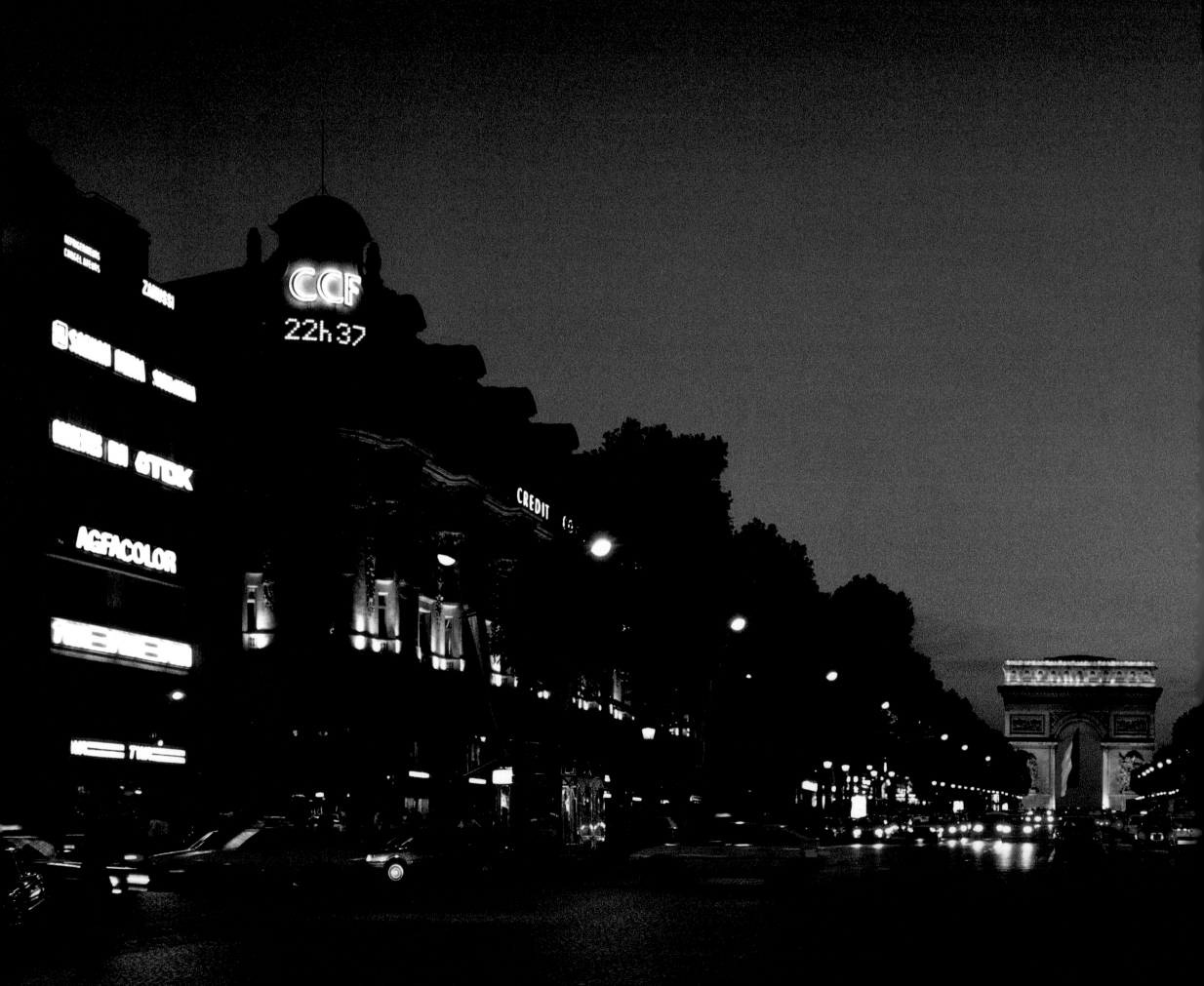

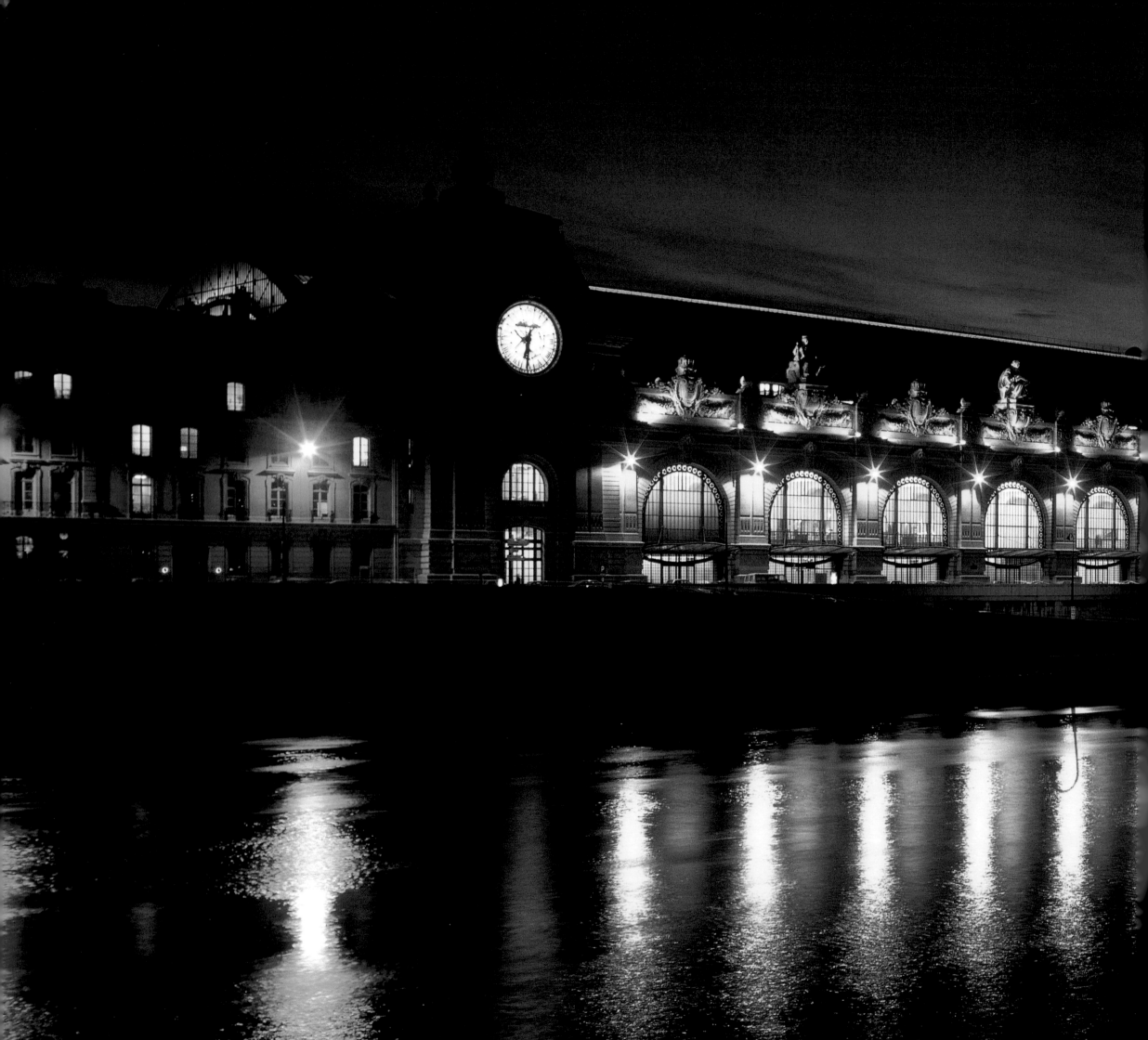

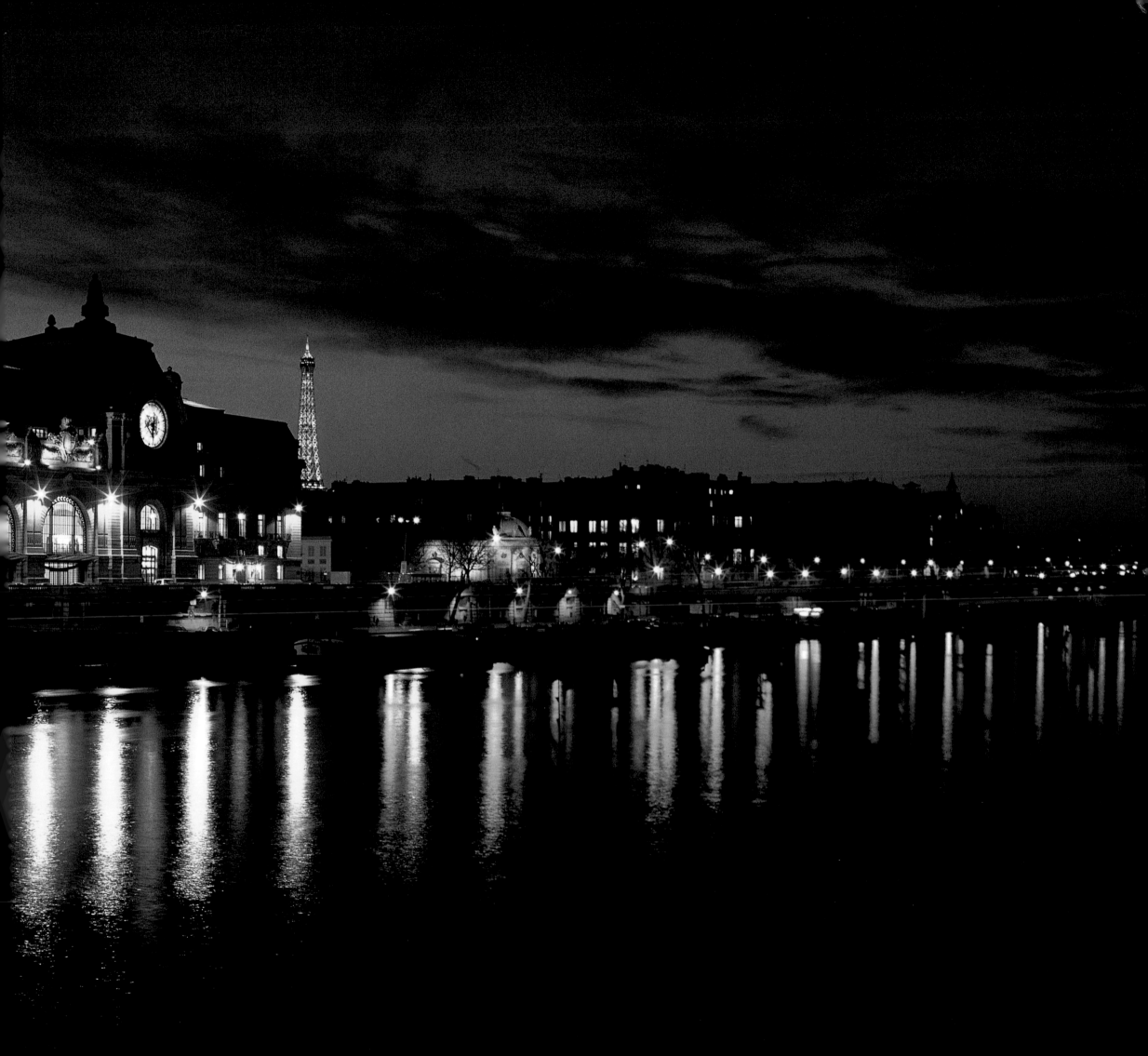

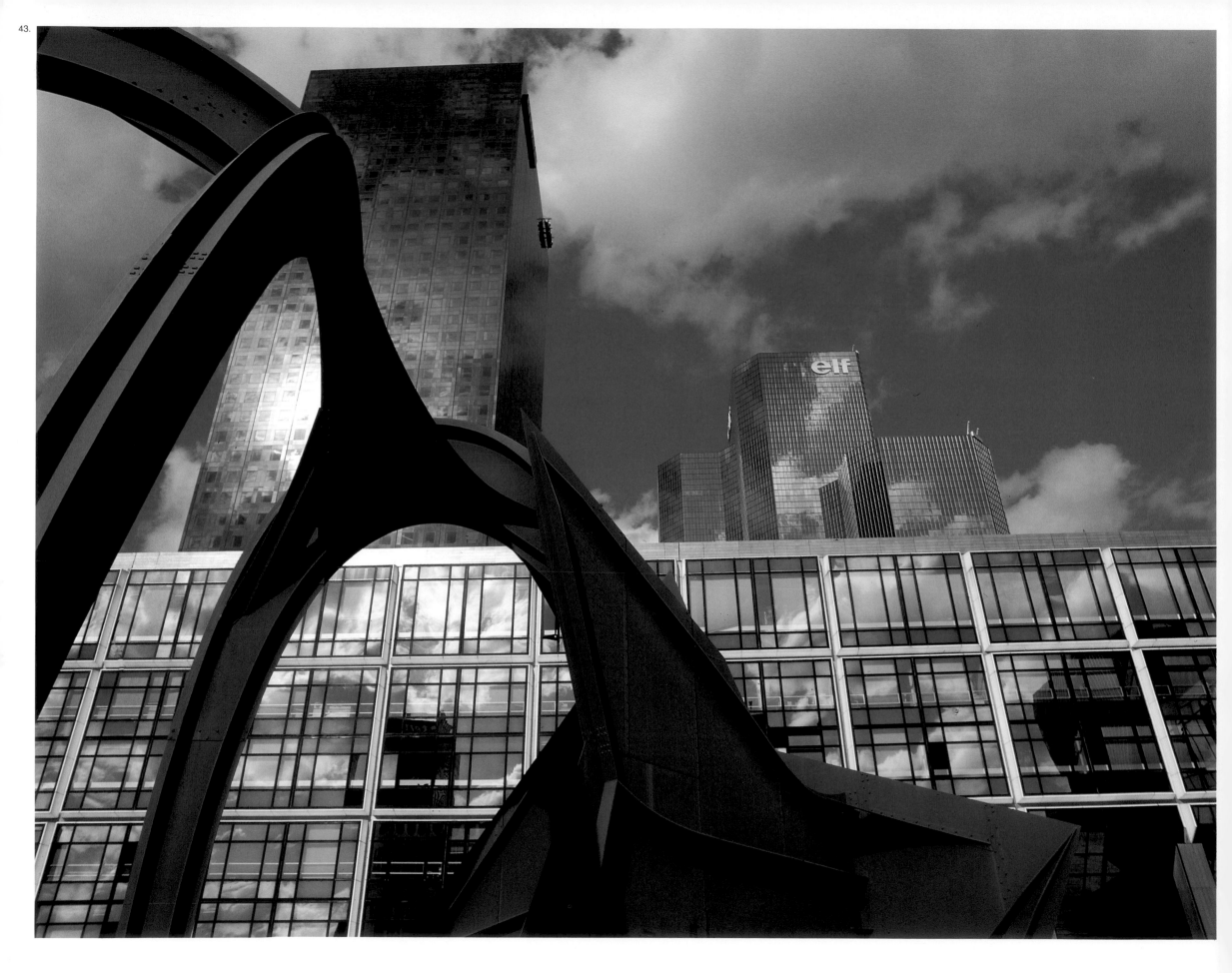

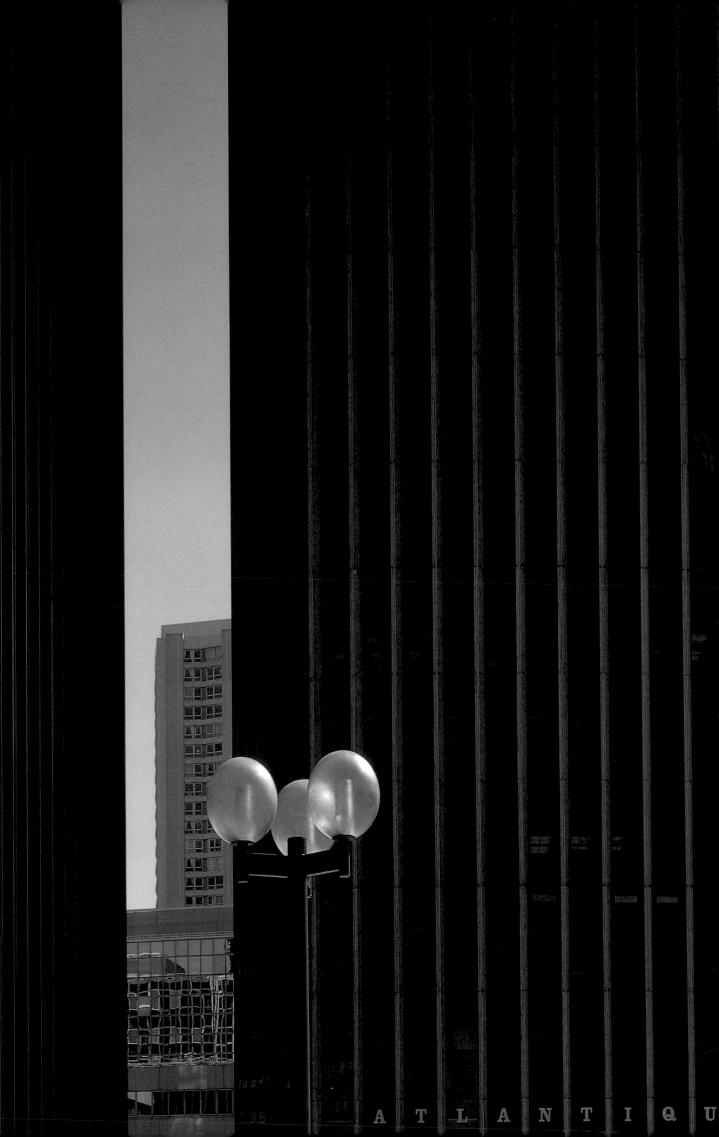

ATLANTIQUE

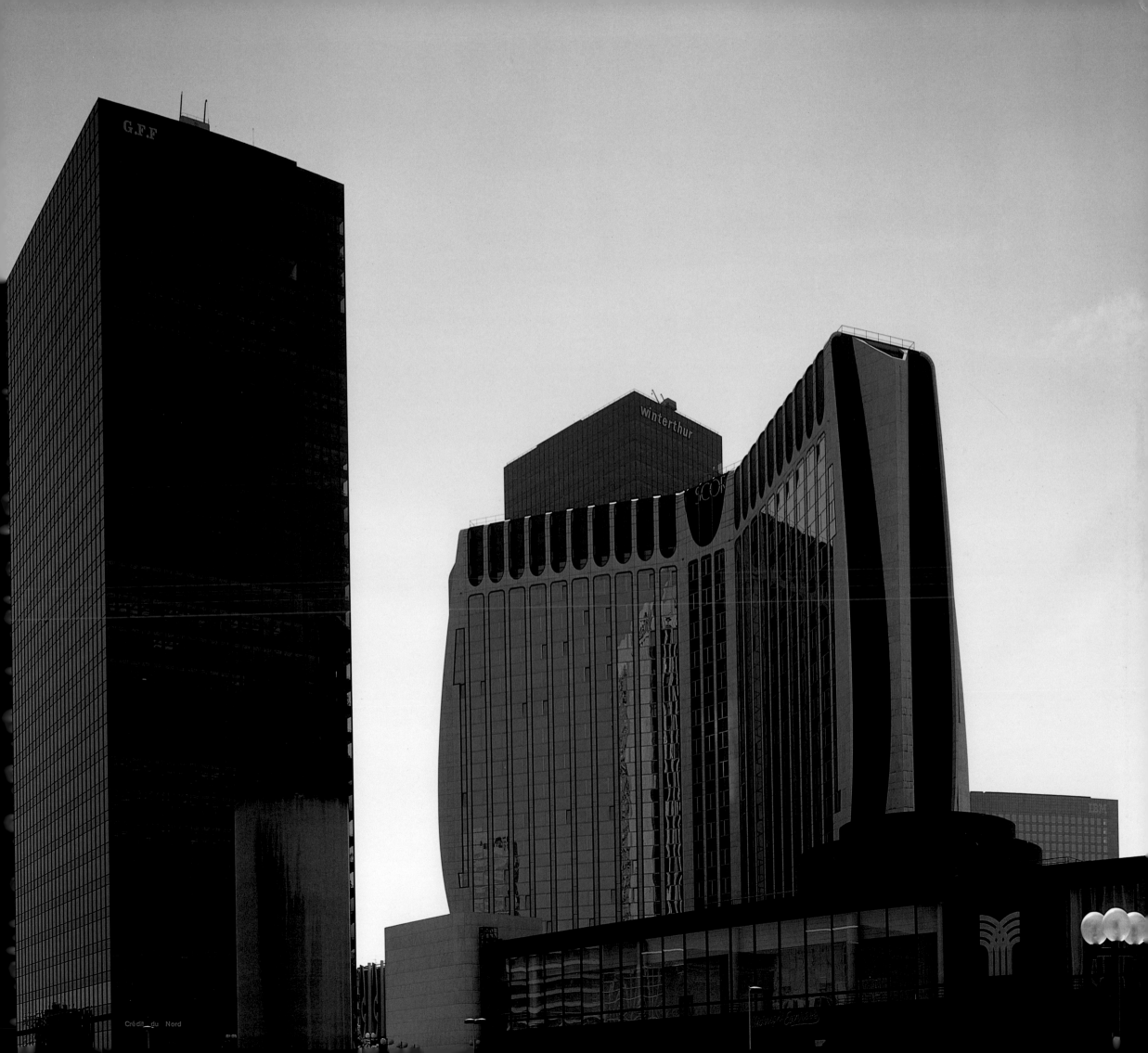

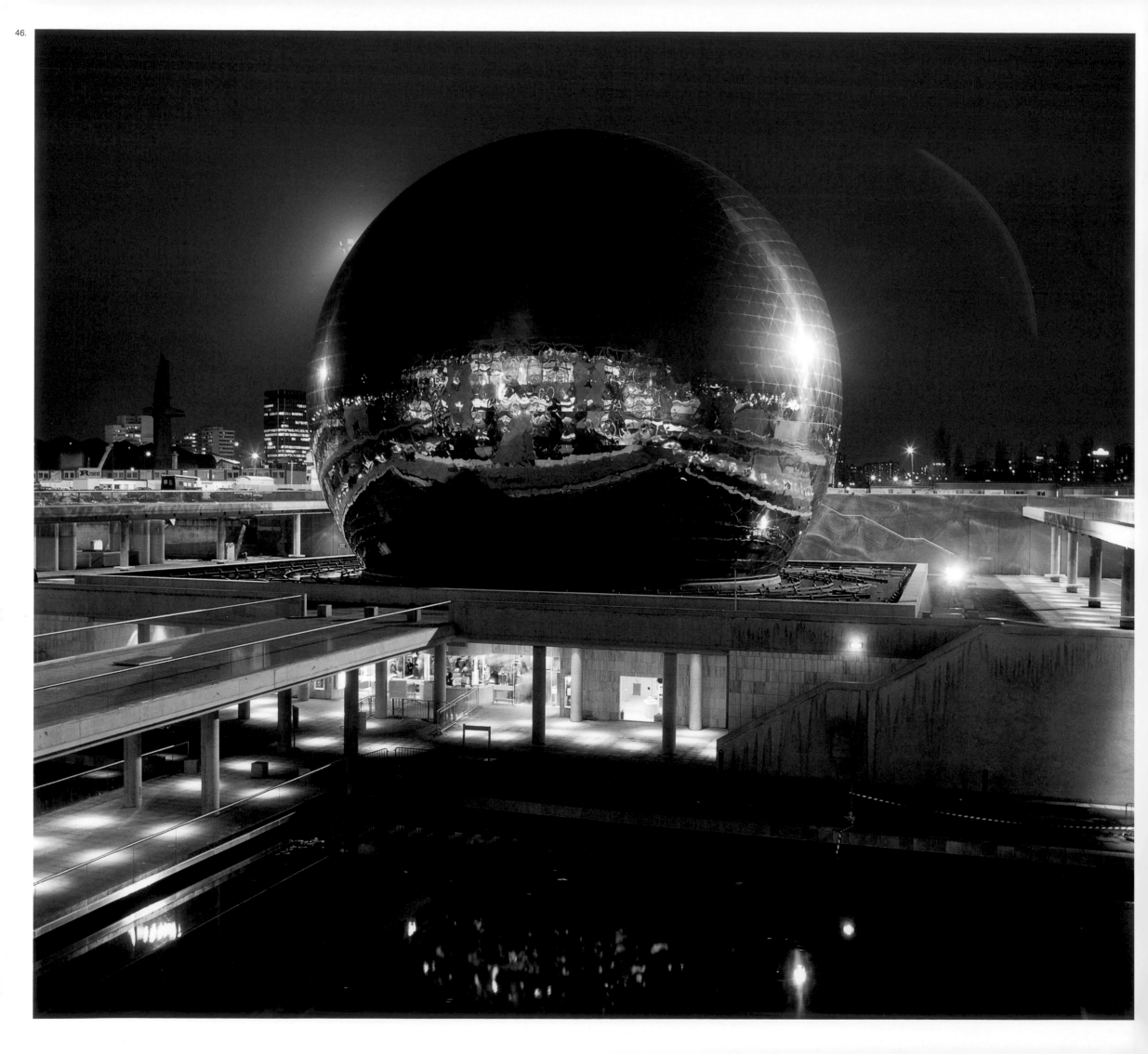

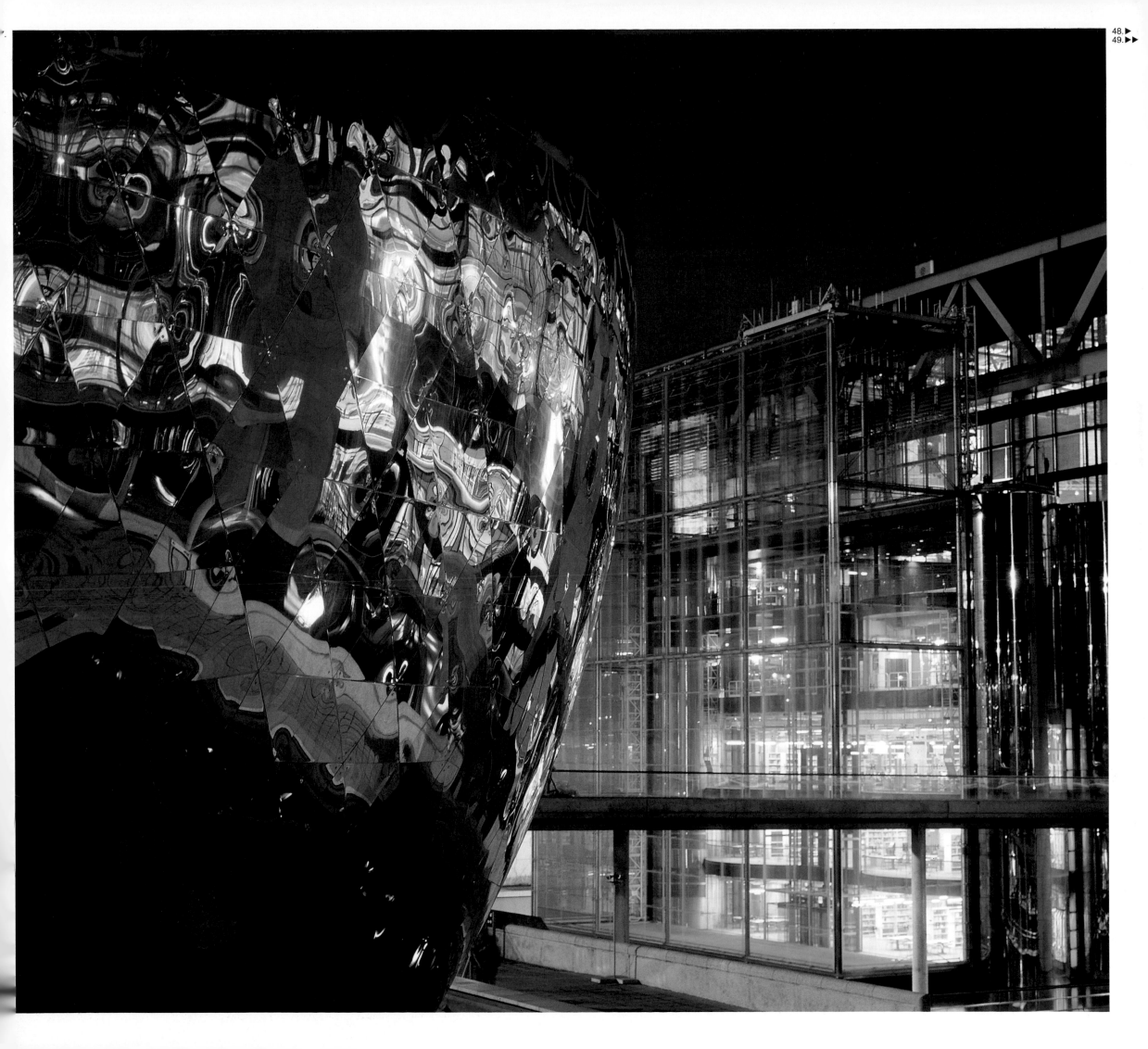

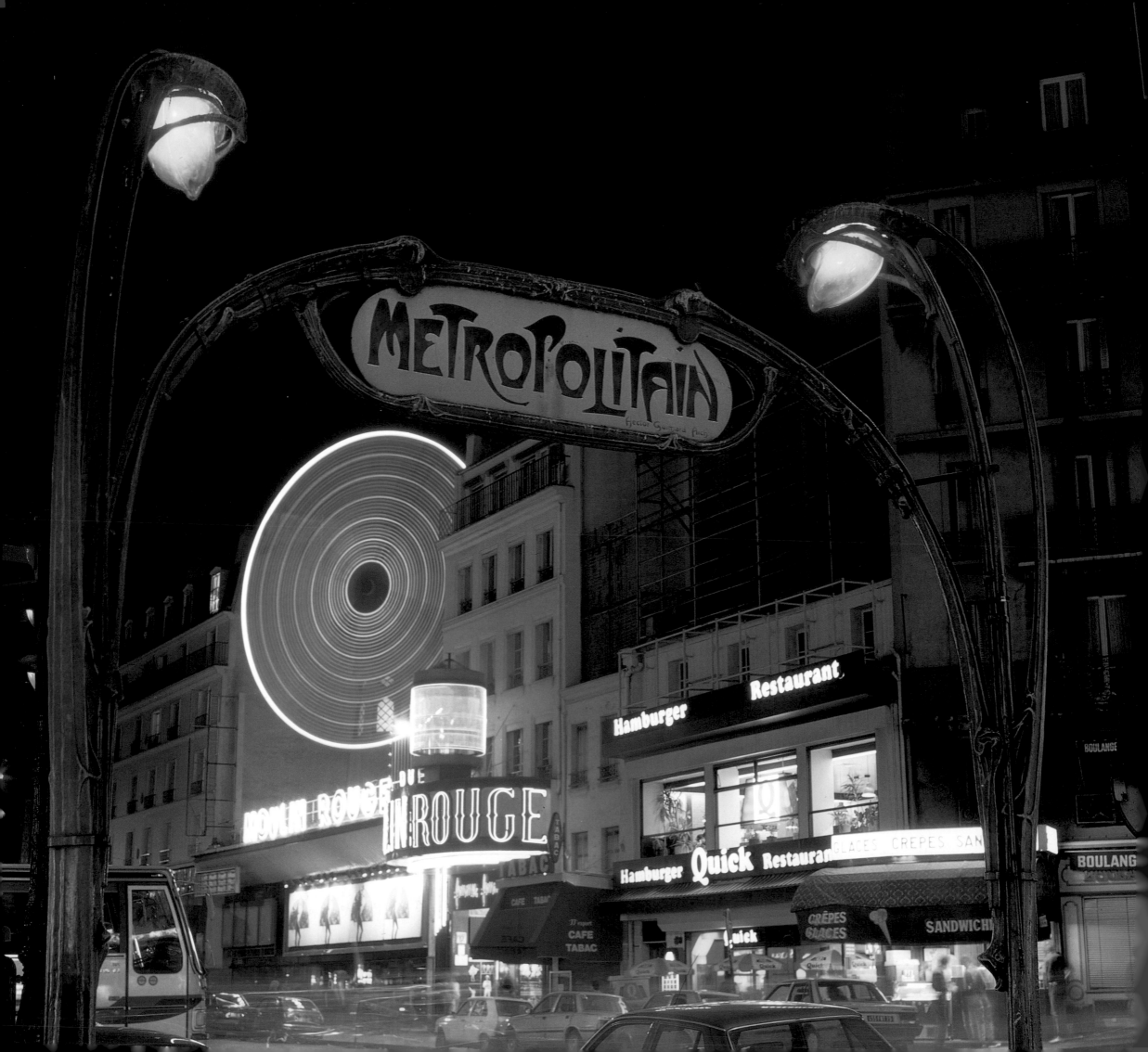

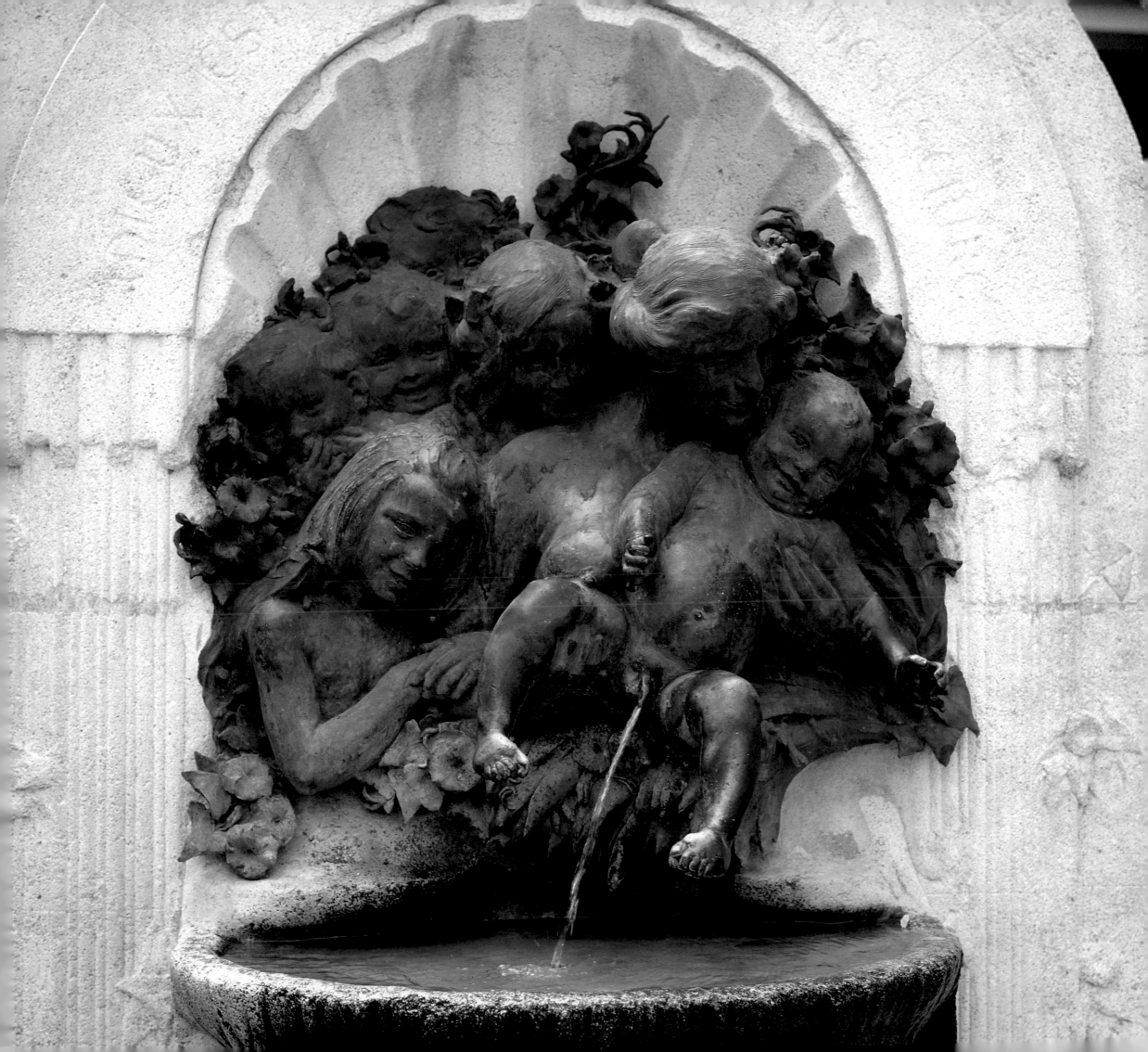

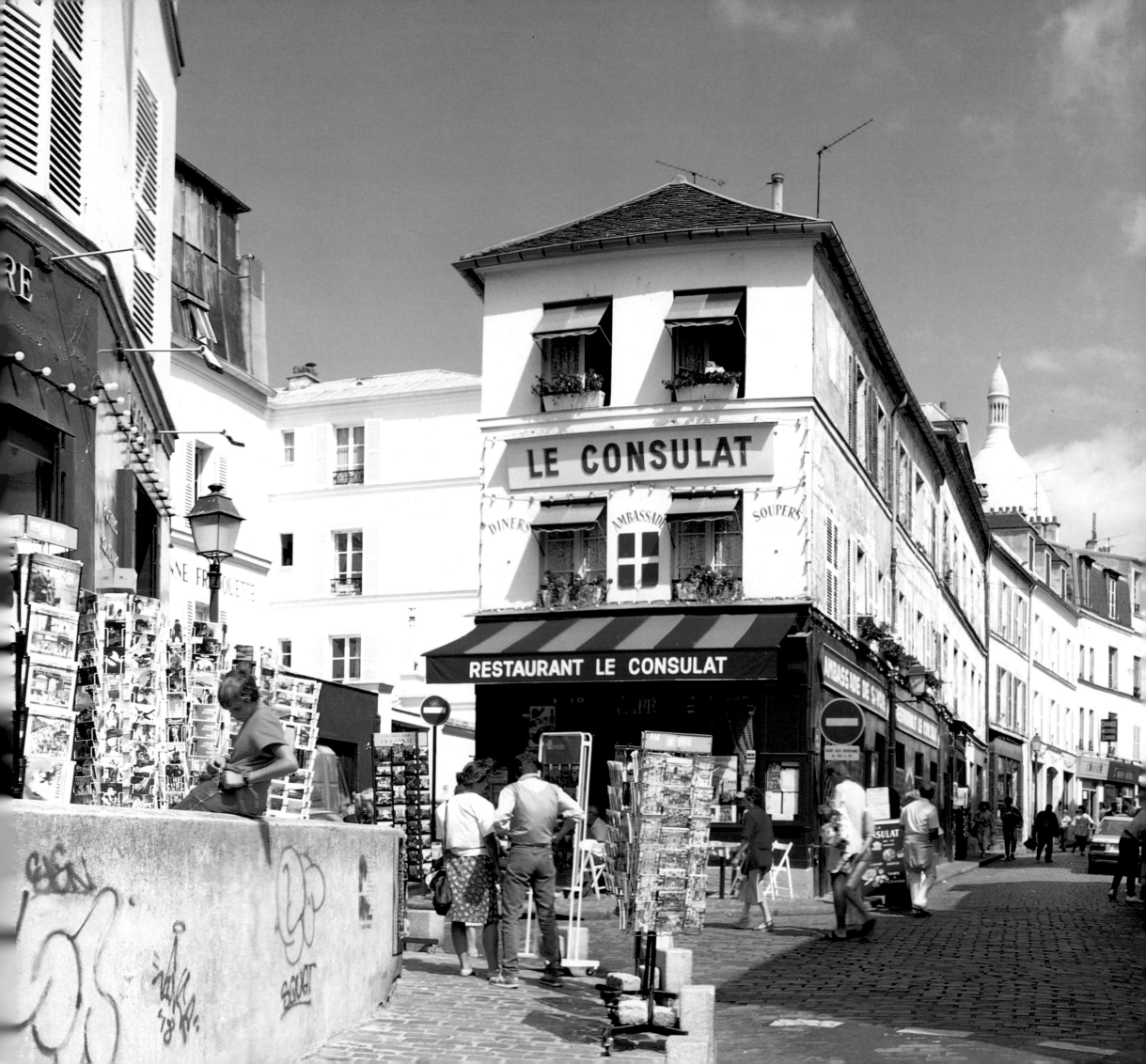

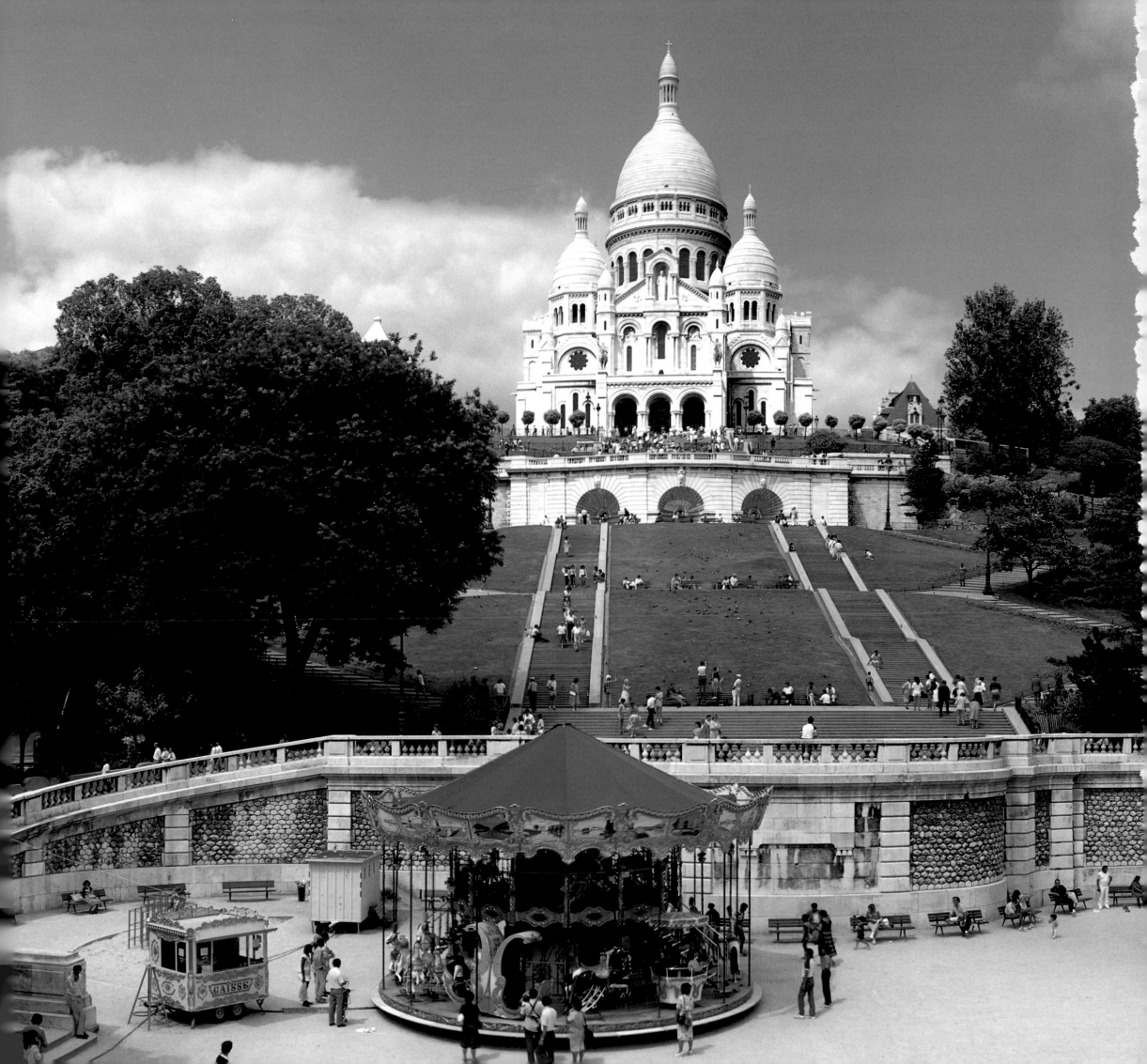

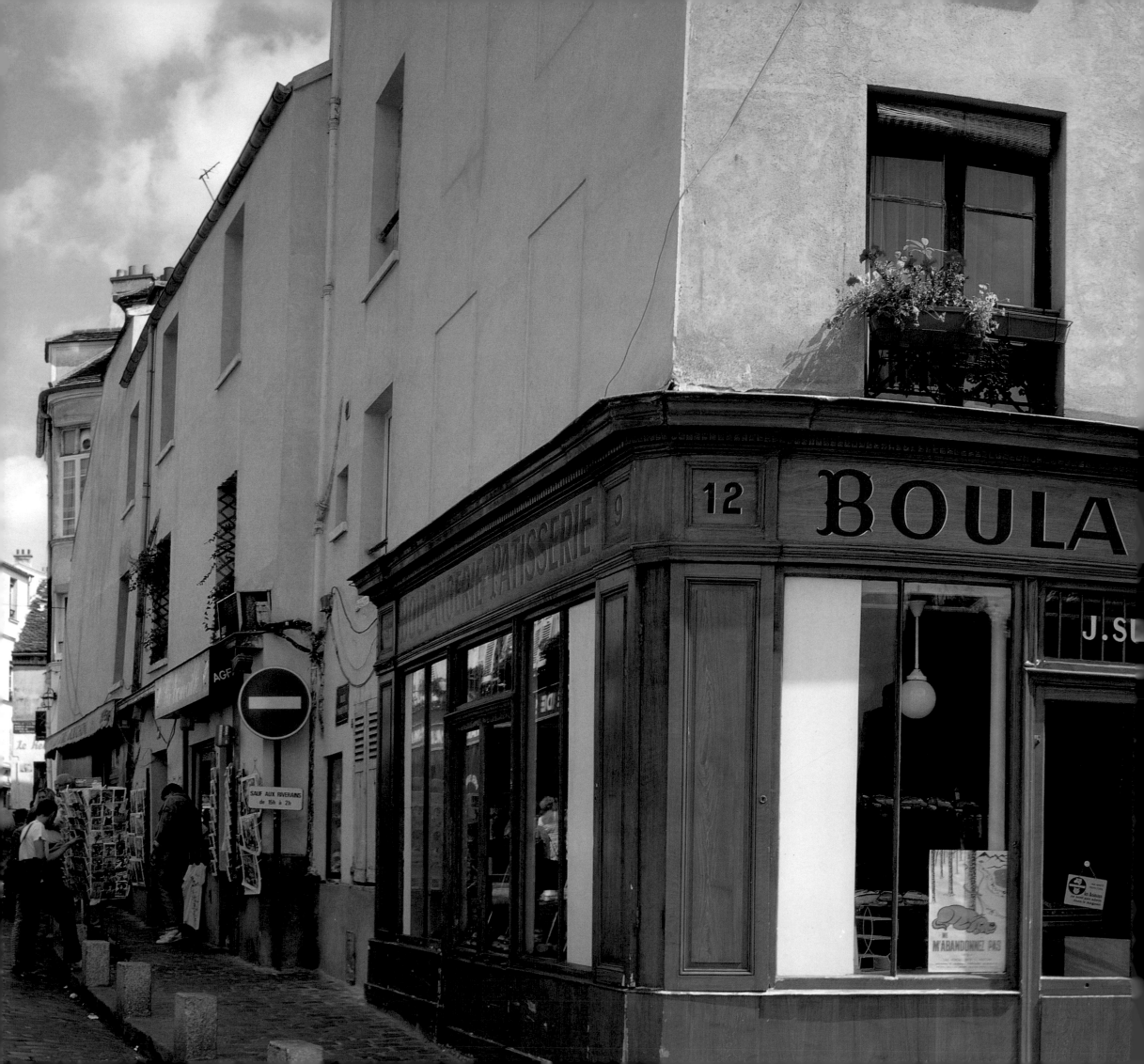

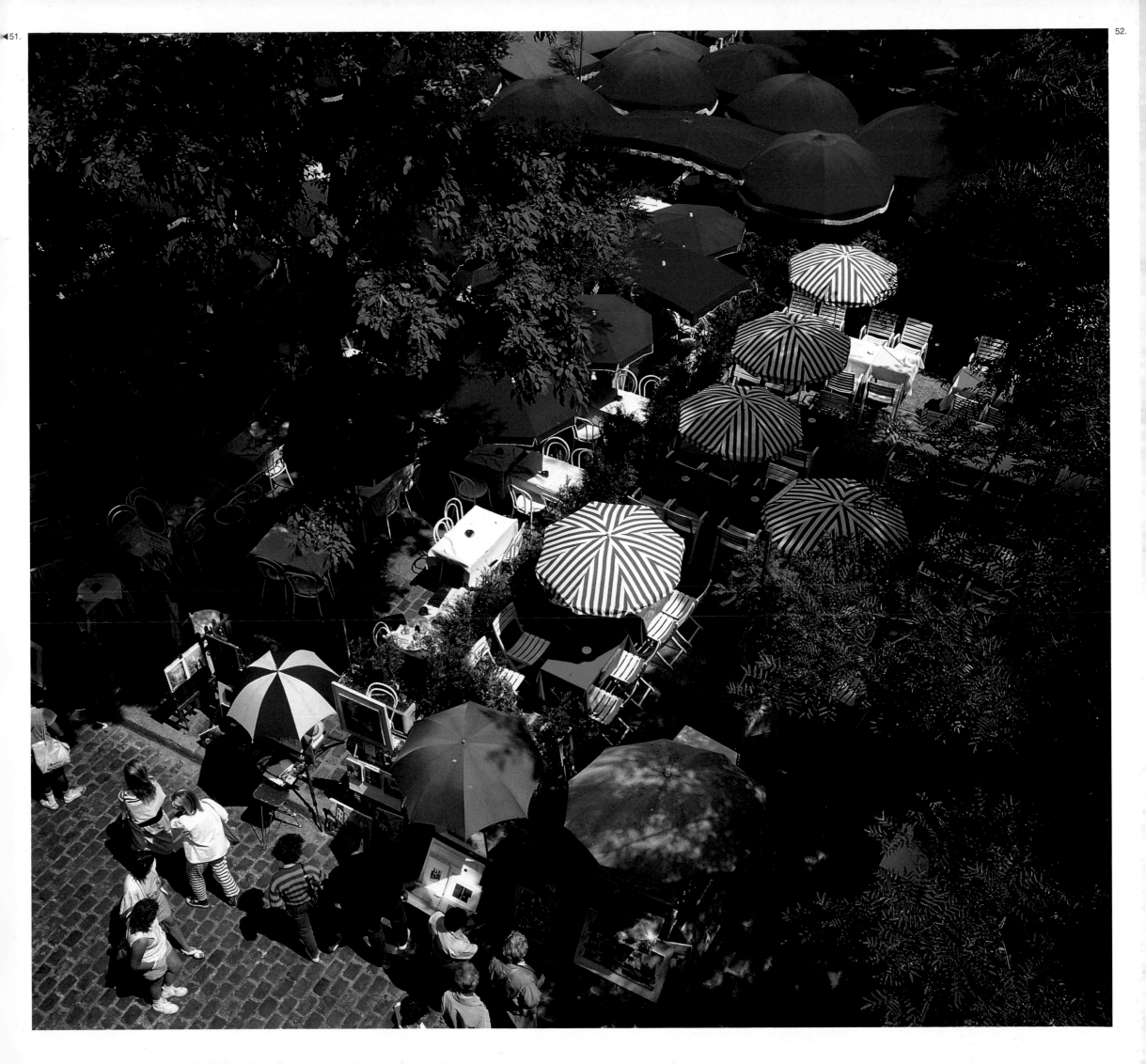

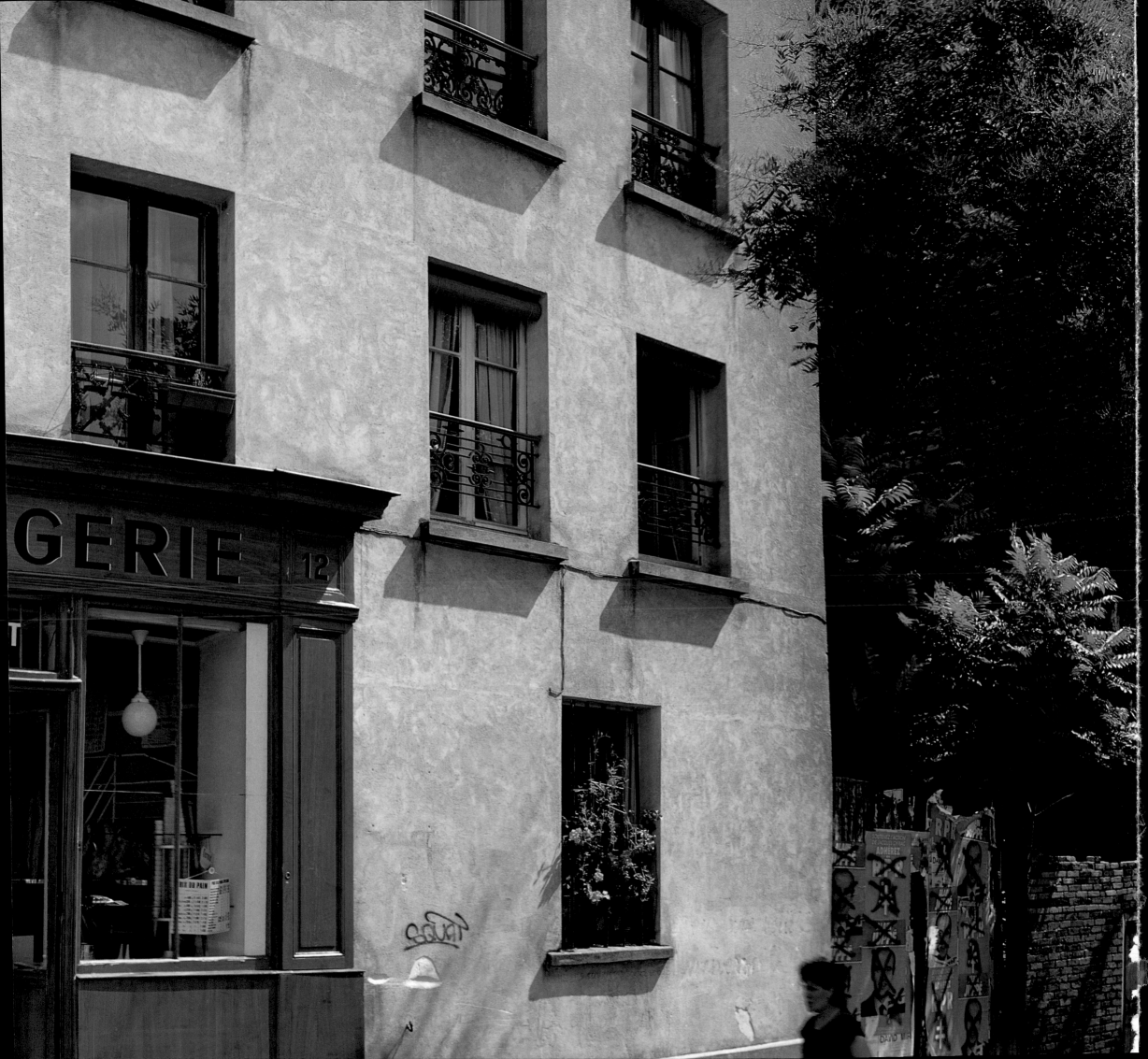

53.

LE SACRE COEUR

LE CONSULAT

MONTMARTRE

MOULIN ROUGE

PIGALLE

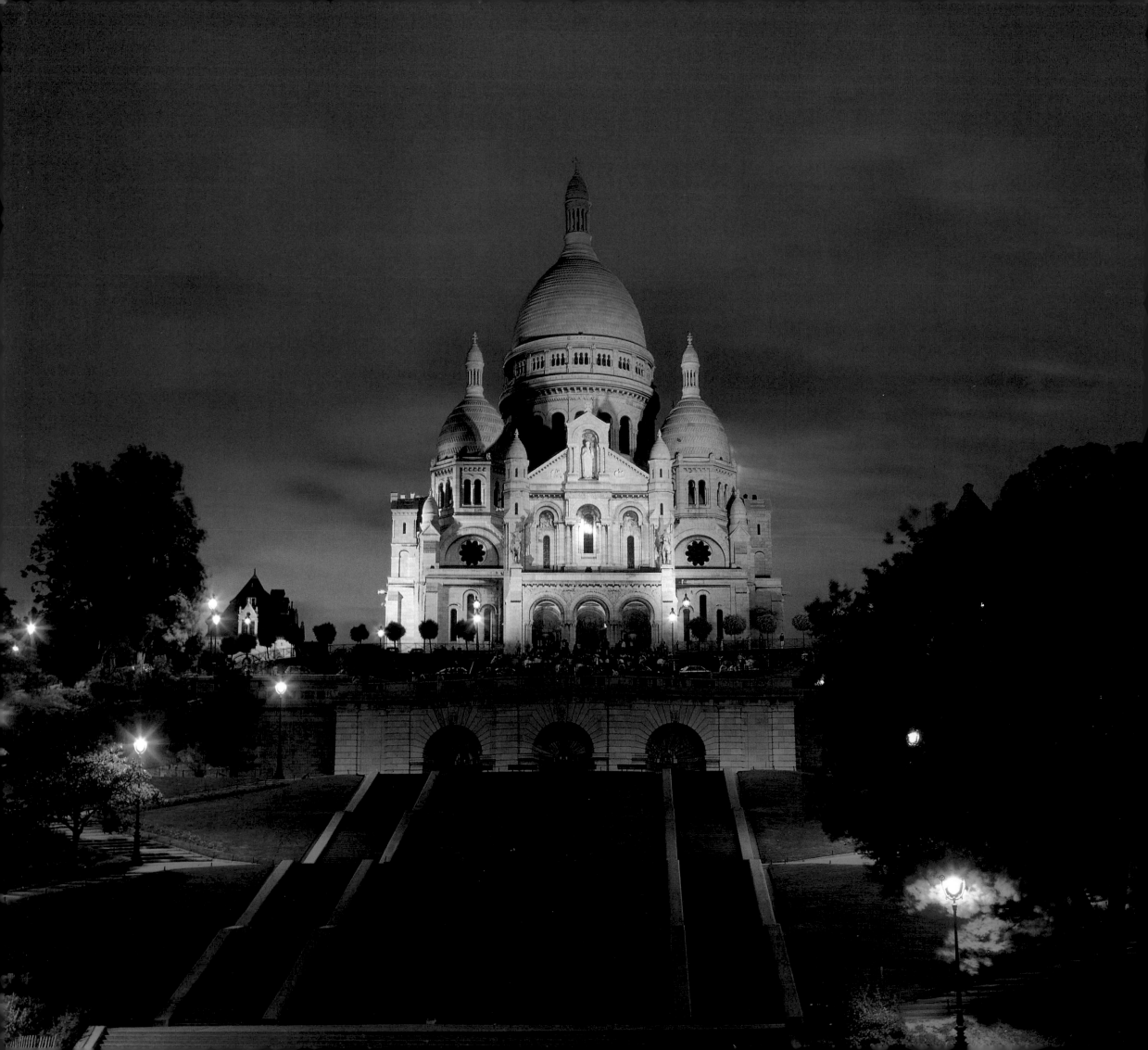

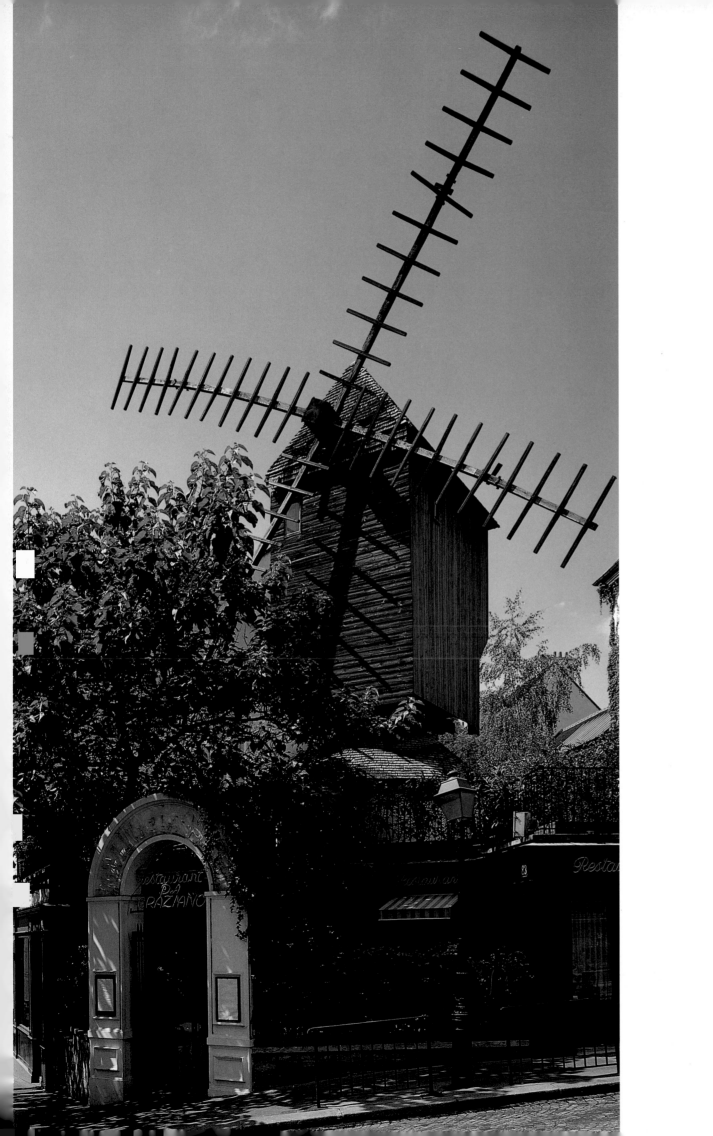

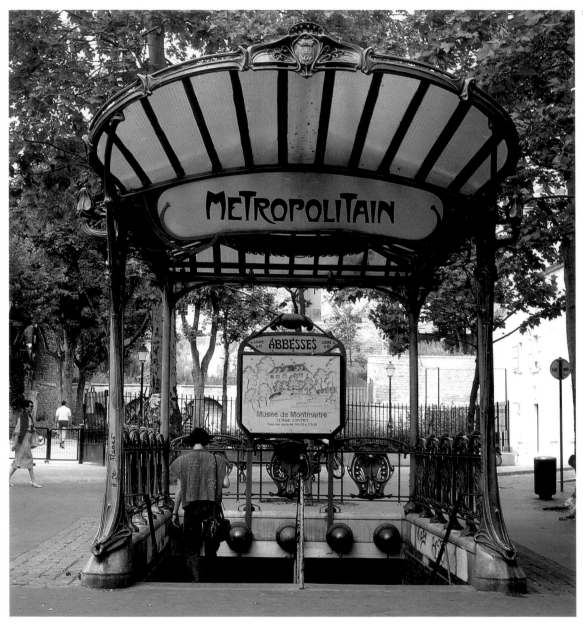

LA TOUR MONTPARNASSE

1.

The names of the gates of Paris recall ancient roads: Porte de Saint-Cloud, Porte de Saint-Denis, Porte d'Orléans. Paris has lost virtually all of its city walls, and it is only by chance that the odd fragment has survived in the Marais or Montagne Sainte-Geneviève. The heavy style of the old iron gates is replicated in window guards, courtyards, and city parks, and in ornate gates like the ones pictured in the Petit Palais that bear the seal of the City of Paris.

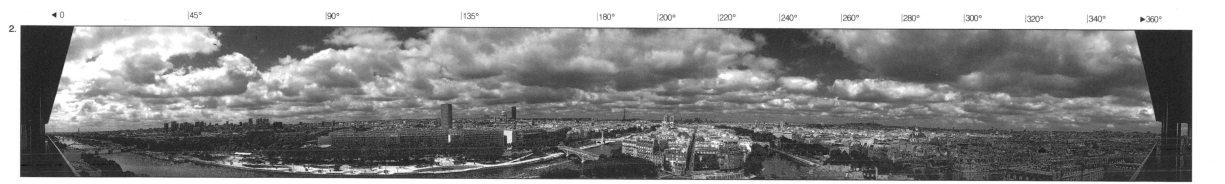

◀ 0 |45° |90° |135° |180° |200° |220° |240° |260° |280° |300° |320° |340° ▶360°

2.

This panorama of Paris is taken from the terrace of the Fourth Arrondissement Prefecture. Many of the great landmarks of the city are visible: from Sacré-Coeur in Montmartre past the Pompidou Center, Notre-Dame and the Eiffel Tower in the distance, to the Tour Montparnasse and the dome of the Panthéon. The scale of Paris is admirably represented: It is a city for walking, with the River Seine, which winds across the breadth of this photograph, always there as a guide.

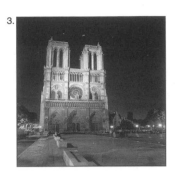

Notre-Dame Cathedral is one of the most familiar sights of Paris. It stands on what is now the place du Parvis, begun on the orders of Bishop Maurice de Sully eight centuries ago and completed in the fourteenth century. Its Gothic splendor came to be scorned, but the great building received literary and architectural help in the nineteenth century: Victor Hugo wrote about it, and Baron Haussmann tore down the old houses of Notre-Dame village that surrounded the cathedral on the Ile de la Cité, allowing the visitors that throng the square the room to gaze up at the spectacular façade.

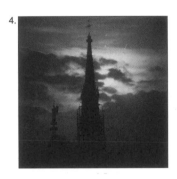

The spire of Sainte-Chapelle, the Gothic chapel built on the orders of Louis IX in the thirteenth century to house his collection of relics. It sits near Notre-Dame on the Ile de la Cité.

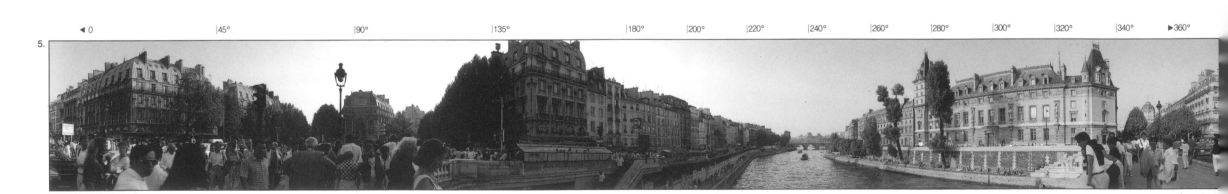

The Quai des Orfèvres, viewed from the Pont Saint-Michel.

6.
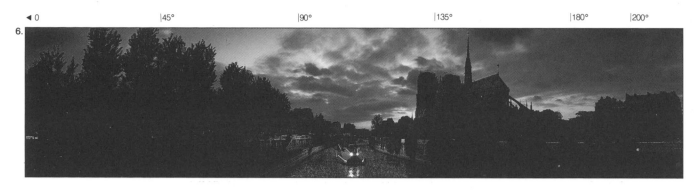

A *bateau-mouche* plies the Seine at nightfall between the Ile de la Cité and the Quai Saint-Michel.

7.
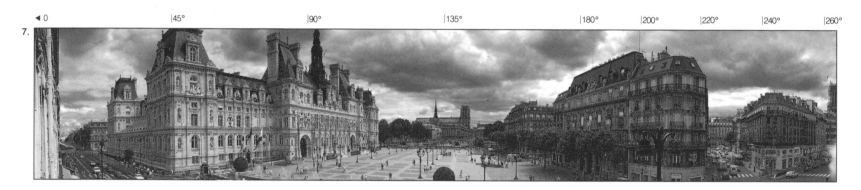

The town hall (the Hôtel de Ville) stands on what was once the ancient place de Grèves. Here the place de l'Hôtel de Ville is viewed from the corner of the rue de Rivoli and the rue de Renard. An architectural blend of the Third Republic and the Renaissance, the Hôtel de Ville has stood as a symbol of Parisian independence since the time of Etienne Marcel in the fourteenth century. In 1870, the Communards preferred to burn down the building rather than have it fall back into the hands of the government.

8.

The Tour Saint-Jacques is framed by a merry-go-round. Originally the tower belonged to the patron church of the butchers' guild, Saint-Jacques-la-Boucherie. The building has long since been destroyed and the tower has been used for a number of secular functions: Pascal performed experiments here, and munitions were manufactured on the site. The tower is set by the busy place du Châtelet along the rue de Rivoli.

The Forum des Halles has turned an entire quarter on its head. The throng of the old marketplace that had been on this site for eight hundred years has been driven underground into the new arcades and shopping centers.

These metal sculptures, designed by Nikki de Saint-Phalle and Jean Tinguely, sit in the Fontaine Stravinski at the Pompidou Center. They present a colorful contrast to the austere Gothic façade of the Eglise Saint-Merri behind.

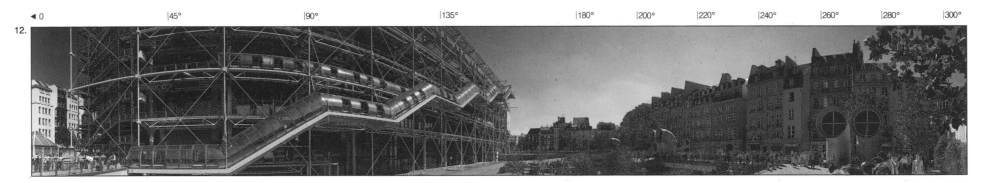

12.

The architects of the Centre Georges Pompidou, Renzo Piano, Gianfranco Franchini, and Richard Rogers, created one of the world's most distinctive art museums by exposing the functional mechanical structures on the outside of the building. The striking result makes the building an exhibit in itself. Also known as the Beaubourg, the Centre Georges Pompidou houses the National Museum of Modern Art, a library, and many popular galleries and music and art resources. The piazza in front is a busy public space often packed with entertainers and tourists.

13.

The Tour Montparnasse dominates this skyline, pictured from the rue de Rennes. The tower is one of the tallest in Europe at 209 meters (690 feet) and weighs in at 132,000 tons. It is clothed with 7,200 windows. The Montparnasse neighborhood has been a popular one for artists, sculptors, and writers since the turn of the century, when some of their number moved down from the Montmartre area. The colony of artists often included a large number of expatriate Americans and their visitors, like Gertrude Stein and Alice B. Toklas, the Fitzgeralds, and Ernest Hemingway, who would gather at the local cafés: Le Dôme, La Coupole, and La Rotonde.

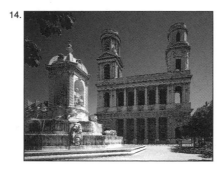

14.

The italianate façade of the church of Saint-Suplice is reminiscent of the nearby Palais du Luxembourg. The church is one of the largest in Paris and boasts in its interior Delacroix's *Jacob Wrestling with the Angel* and other murals and a magnificent eighteenth-century organ whose only rivals in the city are in Notre-Dame and Saint-Eustache.

16.

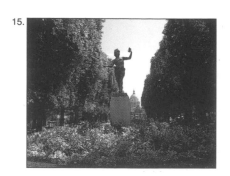

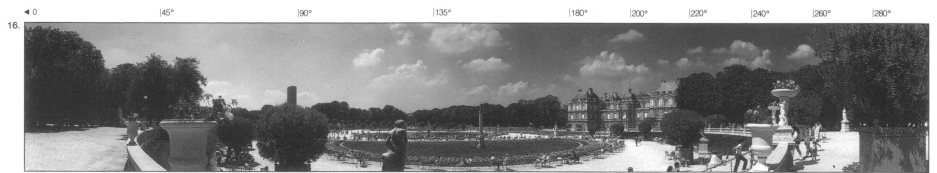

The Jardin du Luxembourg is the park dearest to the hearts of the people of Paris. It offers a welcome refuge of calm in the heart of the city. The park is adorned by the Palais du Luxembourg, the home of Marie de Médicis, who wanted to re-create the palaces she knew in Florence. The palace, now a government building, is decorated with Delacroix's interpretations of the *Divine Comedy*. The palace's gardens were turned over to the public after the Revolution.

17.

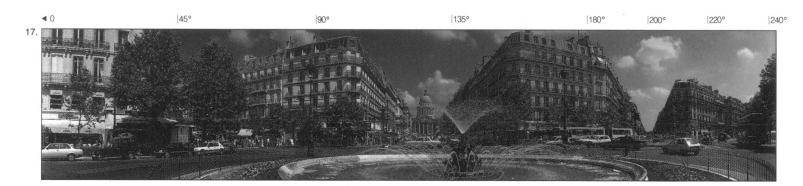

Here, the Panthéon is seen from the fountain in the place Edmond Rostand in the Boulevard Saint-Michel. The Panthéon, with its façade of a Greek temple, was designed by Jacques Germain Soufflot (1713–80). It originated as a church dedicated to the city's patron, Saint Geneviève, and became a temple of the Republic at the time of the Revolution, functioning as the ceremonial resting place for leading French citizens such as Victor Hugo, Voltaire, Jean-Jacques Rousseau, Emile Zola, and Marie Curie, the first woman honored with burial here in her own right.

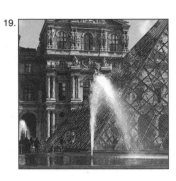

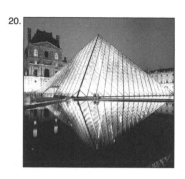

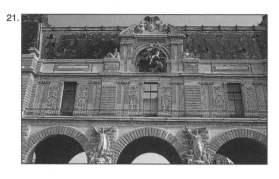

The area in front of the Seine near the Louvre is home to a variety of postcard sellers, bookstalls, and other curbside vendors. Inside the grounds of the Louvre itself sit the glass pyramids designed by I. M. Pei and installed in 1989. The Louvre has been built up and added to throughout its history. Much of what we see today was built for Louis XIV before he moved his court to Versailles. The former royal palace became the first museum of the Revolution in 1793. President Mitterrand initiated a major overhaul of the whole site in 1981. It is now one of the biggest and most visited museums in the world.

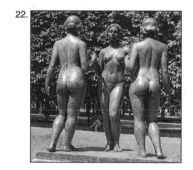

These nudes, the *Three Graces*, by Aristide Maillol (1861–1944), adorn Les Tuileries, the magnificent gardens set behind the Louvre that were designed on the instructions of Catherine de Médicis in the sixteenth century.

23.

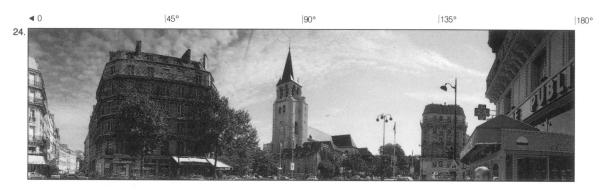

The Palais Royal as seen from its garden. This complex was originally owned by Cardinal Richelieu, who bequeathed it to the crown.

24.

The Church of Saint-Germain, a landmark of the Saint Germain-des-Prés area. Two other notable local sights are visible: the cafés Flore (to the extreme left) and Deux Magots, haunts of generations of intellectuals.

25.

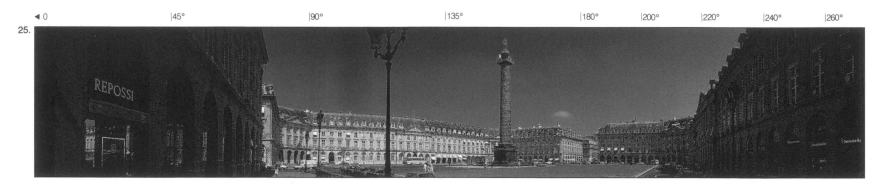

The place Vendôme, formerly the place des Conquêtes and also known as the place Louis-le-Grand, home to expensive boutiques and the Ritz Hotel.

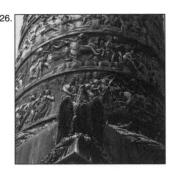

An imperial eagle, detail of the column in the place Vendôme. There are four of these on the pedestal of the column, symbols of the short-lived empire of Napoléon. An equestrian statue of Louis XIV was erected here in 1699. It was replaced in 1810 by the Grand Armée Column, modeled on Trajan's Column in Rome and made from the bronze of 1,250 cannons captured at the Battle of Austerlitz in 1805. On March 16, 1871, it was pulled down by the Communards under the direction of the painter Gustave Courbet. Courbet was made to pay for the statue to be put back up when the city was retaken, and he was exiled to Switzerland after serving out a jail sentence.

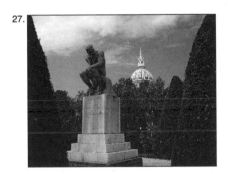

The Thinker in the garden of the Rodin Museum. Auguste Rodin (1840–1917) left his house and the sculptures in it to France when he died, creating one of the best of all the museums in the city. The cupola of the Hôtel des Invalides can be seen in the background.

28.

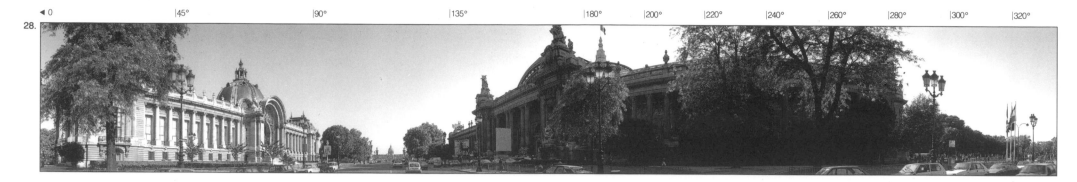

The Petit Palais and the Grand Palais were constructed for the Universal Exposition of 1900. Originally intended to be temporary structures built only for the duration of the Exposition, they survived, and each is now an exhibition hall.

29.

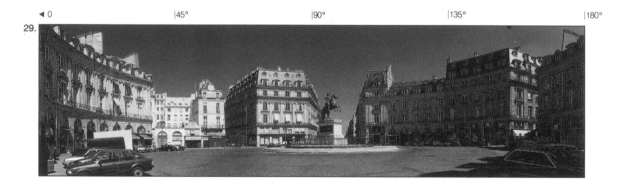

The statue of Louis XIV in the place des Victoires. An original statue was melted down in 1792, and its replacement suffered the same fate in 1815. The version pictured was erected in 1822. The square in its original form, as designed by Jules Hardouin-Mansart (1646–1708), was offered to the king by the duke de Feuillade. It was a fine example of the royal squares built in the seventeenth and eighteenth centuries. The symmetry of this particular example was destroyed by the construction of the rue Etienne Marcel, opened in 1883.

30.

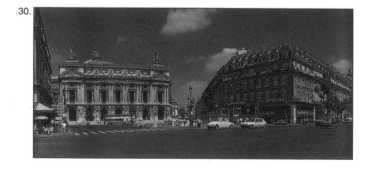

The Opéra, designed by Charles Garnier (1825–98), is one of the great buildings of the Second Empire. Garnier won a competition to design the building in 1861.

31.

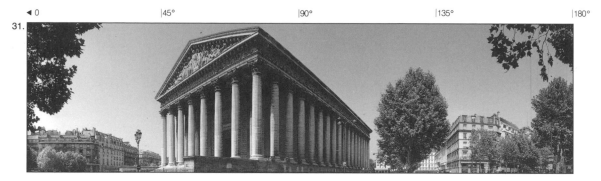

The neoclassical form of the Eglise de la Madeleine, an updated version of a Greek temple. The church, under construction for many years, was opened in 1842.

32.

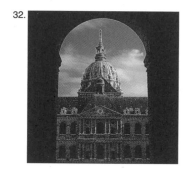

The dome of the chapel of the Hôtel des Invalides. The complex was built for Louis XIV on the design of Jules Hardouin-Mansart for soldiers wounded in battle. It now houses a local government authority.

33.

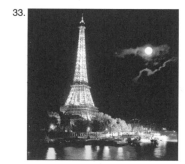

The Eiffel Tower, properly illuminated for the City of Lights. Gustave Eiffel won a contest to design a tower for the 1889 World Exposition. Many Parisians hated the sight of this startling and enormous monument (it was the tallest structure in the world for fifty years), but it now stands as the proud symbol of Paris and of the whole of France.

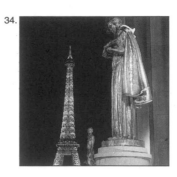

34.

These golden statues decorate the Palais de Chaillot, a building erected in 1937 for the Universal Exposition on the site of the former Palais du Trocadéro, which was it-self a remnant of the 1878 Paris Exhibition.

35.

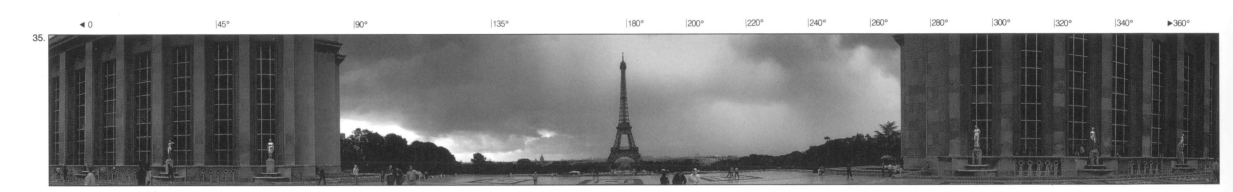

The Eiffel Tower stands at the center of this panorama taken from the place Tro-cadéro and the Palais de Chaillot. The dome of Les Invalides is visible on the hori-zon.

36.

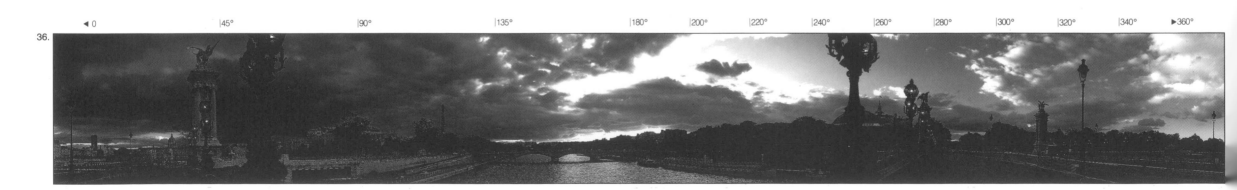

Night falls over this scene taken from the Pont Alexandre III, named for a tsar of Russia and inaugurated by his successor, Tsar Nicholas II, in 1900.

37.
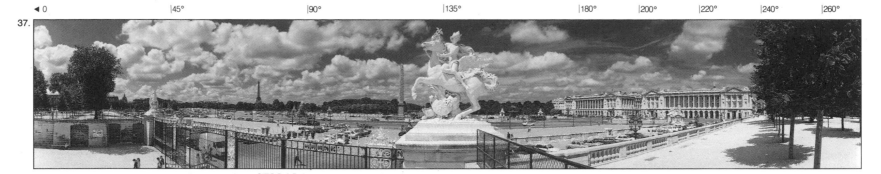

The place de la Concorde, pictured from the Tuileries gardens. The square was built and originally named for Louis XV. It was the scene of the executions of Louis XVI and Marie-Antoinette and was renamed the place de la Concorde in 1795. In the middle of the square now stands the Obelisque de Luxor, an 1831 gift from Mehemet Ali, the viceroy of Egypt, to Louis-Philippe.

38.
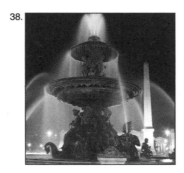

A detail of one of the fountains in the place de la Concorde.

39.
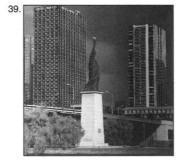

This replica of Auguste Bartholdi's Statue of Liberty, a gift from the people of France to the United States, stands on the banks of the Seine.

40.

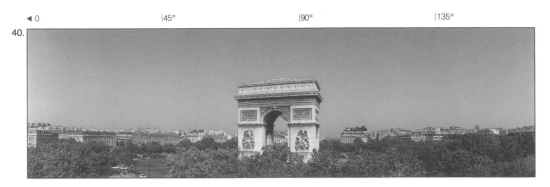

The Arc de Triomphe rises above the place de l'Etoile. The arch stands at the end of a line that begins at the Louvre and the Tuileries gardens, continues through the place de la Concorde, and runs along the Champs-Elysées. The arch owes its origins in 1806 to Napoléon, who wanted a ceremonial monument to honor his armies. It was completed in 1836, during the reign of Louis-Philippe, and is the site of France's Tomb of the Unknown Soldier.

41.

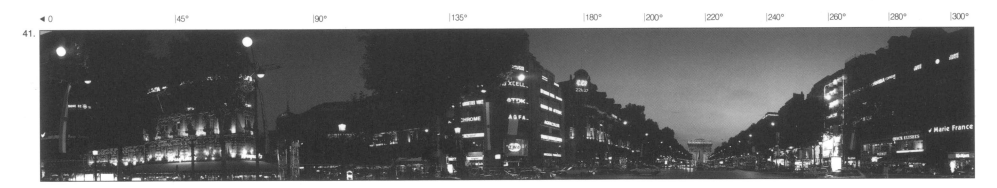

The Champs-Elysées at night.

42.

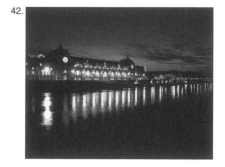

The former Gare d'Orsay, set near the Tuileries gardens on the Left Bank, once one of the main railway stations of the city, became the Musée D'Orsay in 1986. The station's architect, Victor Laloux, disguised the function of the building by cloaking the framework in a series of sculptures, statues, and pillars. It now serves as a magnificent exhibition space for many of France's artistic treasures, prominent among them the paintings of the Impressionist school that were formerly housed in the Museé du Jeu de Paume.

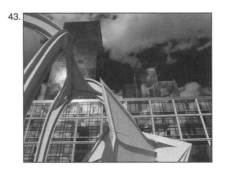

43.

Two sculptures by two great artists set among the towering buildings of La Défense: First, Alexander Calder. (See also photo 45).

◄ 0 |45° |90° |135° |180° |200° |220° |240° |260° |280° |300° |320° |340° ►360°

44.
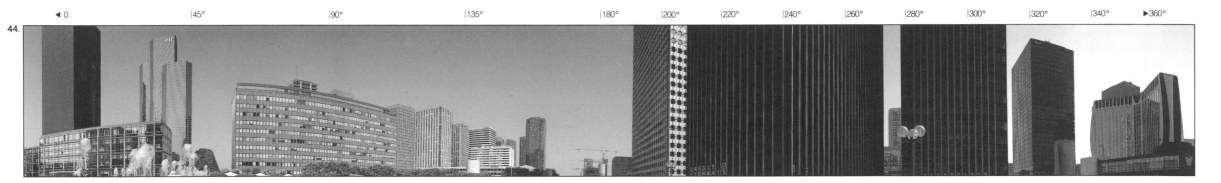

La Défense, somewhat reminiscent of downtown Manhattan. The development was begun in 1958 on the site of old fortifications against the Prussians. It combines high-rise apartment buildings with shopping precincts and commercial office space.

45.
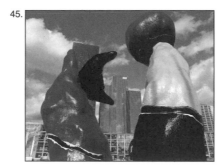

And Joan Miró.

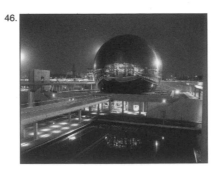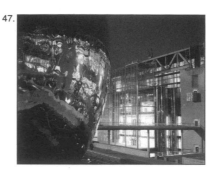

The Géode of the Cité des Sciences et de l'Industrie. This complex is set in the recent development of La Villette in the northeast corner of the city, an area reclaimed from a run-down section of old slaughterhouses and warehouses. The Géode, a cinema-in-the-round, and the Grande Halle (at right) represent the modern, technological aspect of the new city.

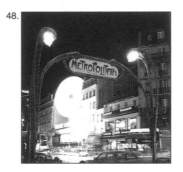

The boulevard de Clichy, between Blanche and Pigalle, is a place where for decades citizens of Paris and, more frequently, tourists have come to find nightlife. Much of their attention has been focused on the grand old nightclub the Moulin Rouge.

A fountain in the park at Sacré-Coeur.

50.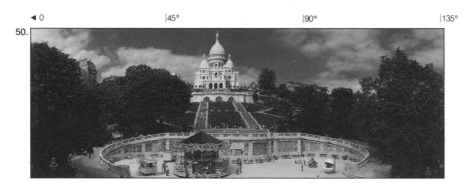

From its hilltop perch in Montmartre, the basilica of Sacré-Coeur commands the best view in all of Paris. The church was designed by Paul Abadie, and work on its construction continued from 1876 to 1919, often set back by technical problems.

51.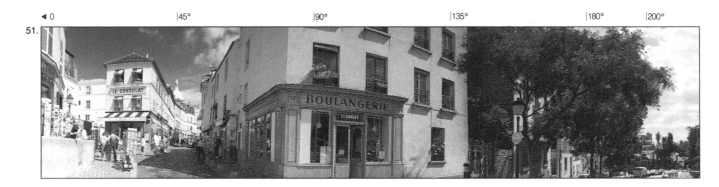

The winding streets, art shops, and cafés of Montmartre are a lively contrast to the grand boulevards of Paris. After the development of much of the center of Paris, artists came to Montmartre, attracted by the cheap, available accommodations and the lively, artistic atmosphere. Among those who worked here were Renoir, Picasso, and Salvador Dalí, who has a museum dedicated to his work here.

52.

The place du Tertre, the heart of Montmartre.

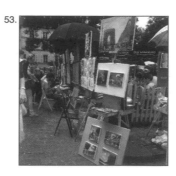

Painters in the place du Tertre.

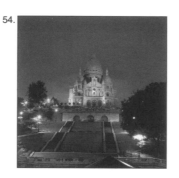

Sacré-Coeur at night.

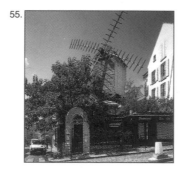

The Galette windmill, another symbol of Montmartre. Windmills once covered the hill when Montmartre was a village surrounded by vineyards, but this is the last one that remains.

56.

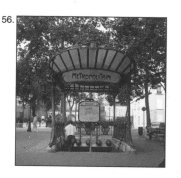

One of the very few surviving Art Nouveau métro entrances is at the Abbesses station—one of the principal entry points to the Montmartre area.

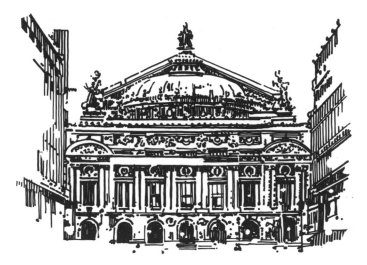

L'OPERA